DIGITAL LANDSCAPE PHOTOGRAPHY

IN THE FOOTSTEPS OF
ANSEL ADAMS AND
THE GREAT MASTERS

BY MICHAEL FRYE

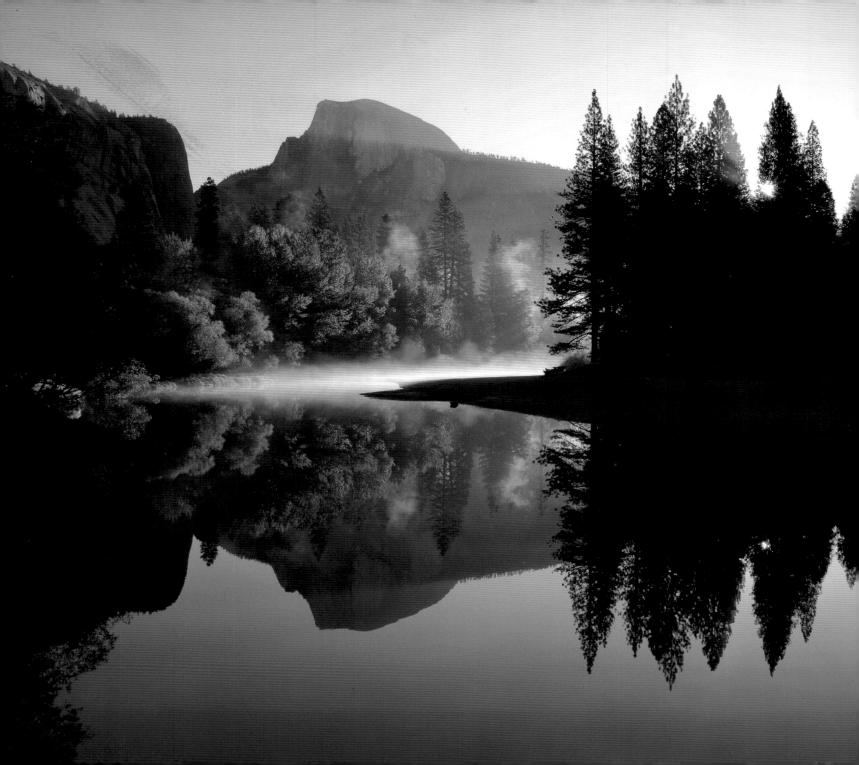

DIGITAL LANDSCAPE PHOTOGRAPHY

IN THE FOOTSTEPS OF
ANSEL ADAMS AND
THE GREAT MASTERS

BY MICHAEL FRYE

ELSEVIER

AMSTERDAM • BOSTON • HEIDELBERG • LONDON
NEW YORK • OXFORD • PARIS • SAN DIEGO
SAN FRANCISCO • SINGAPORE • SYDNEY • TOKYO

Focal Press is an imprint of Elsevier

Focal Press

Focal Press is an imprint of Elsevier
30 Corporate Drive, Suite 400, Burlington, MA 01803, USA
Linacre House, Jordan Hill, Oxford OX2 8DP, UK

Copyright © 2010, The Ilex Press. All rights reserved.
210 High Street
Lewes
East Sussex
BN7 2NS
www.ilex-press.com

Publisher: Alastair Campbell
Creative Director: Peter Bridgewater
Managing Editor: Chris Gatcum
Commissioning Editor: Adam Juniper
Art Director: Julie Weir
Senior Designer: Emily Harbison
Designer: Richard Wolfströme

Library of Congress Cataloging-in-Publication Data
A catalog record for this book is available from the
Library of Congress.

ISBN: 978-0-240-81243-4

For information on all Focal Press publications
visit our website at www.focalpress.com

Printed in Dubai

Contents

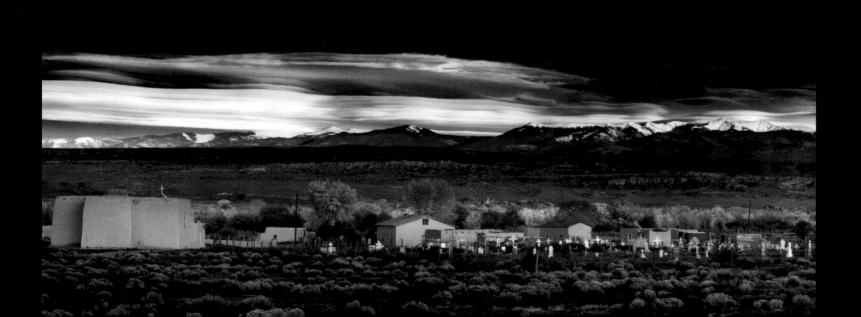

Introduction

This photograph exemplifies Ansel Adams' vision, camera technique, and darkroom mastery. While driving to Santa Fe he glanced to his left and saw what he described as "an inevitable photograph." And while it seemed inevitable to him, how many photographers would have realized the potential of this scene? And how many would have chosen this composition? More than half of this famous image is blank sky. Most people would have used a longer lens and zoomed in on the crosses and moon, but Adams instinctively knew that the expanse of sky would add to the majestic mood of the scene.

Having visualized his image, he encountered a problem: He couldn't find his light meter! Yet he somehow remembered the luminance of the moon in foot candles, and was able to calculate the exposure based on that. His decisions were swift, instinctive, and accurate. Years of experience had made technique second nature to him.

Despite his mostly accurate calculations, the negative proved troublesome. Adams intensified its foreground to increase contrast, and used extensive dodging and burning during printing. In early prints he left the sky light. He gradually darkened it over the years until it became nearly black, enhancing the stark drama of the scene. As new papers and chemicals became available, Adams' interpretation evolved. He always welcomed new tools and the possibilities they offered.

"I am sure the next step will be the electronic image, and I hope I shall live to see it. I trust that the creative eye will continue to function, whatever technological innovations may develop."
—Ansel Adams

When Ansel Adams wrote this, digital photography was in its infancy. Today most photographs are captured on digital sensors, and film consumption has dwindled. In this digital age, do the landscape masters of the past like Adams, Edward Weston, and Eliot Porter still have anything to teach us? Can the lessons they learned through trial and error with film, paper, and chemicals still apply to photographers checking the histogram on their camera's LCD or making a Curves adjustment on their monitor?

The answer is yes. When Ansel Adams developed the Zone System with Fred Archer in 1940, he gave photographers a great tool for controlling their images—but only with black-and-white film, and only with view cameras, where sheets of film could be processed individually. Today any photographer with a digital camera can have even more control—even in color.

Such unprecedented power creates wonderful opportunities, but can also lead to confusion. How do you apply these controls? How far should you go? Do you have to reinvent the wheel, start from scratch? No, because while the tools may be different, the basic principles that Adams, Weston, and Porter developed still apply.

Moonrise, Hernandez, New Mexico, 1941, by Ansel Adams

Visualization and Technique

Adams, Weston, and Porter all stressed the importance of visualization—the ability to imagine the final print, and use all the tools at your disposal to achieve that result.

Visualization might seem less important in an age when photographs can viewed an instant after pressing the shutter, but the tremendous control available to digital photographers means that it is more important than ever, because the possibilities are so vast. Do you visualize having highlight and shadow detail in a high-contrast scene? No matter how much contrast you're facing, it's now possible to show detail throughout the image by merging several images together in Photoshop or with HDR (High Dynamic Range) software. But you have to visualize this in advance in order to make several different exposures that will be aligned and exposed correctly. Do you want great depth of field, beyond what your lens is capable of? Again you must foresee this and take several frames focused at varying distances. Unless you have a clear idea in your mind of what you want to achieve, you might forget a vital step in making your image.

Once you've visualized the desired result, you have to be able to execute the necessary steps. Weston said, "One cannot emphasize too greatly the importance of technique, for no matter how fine the innate sensitiveness, without technique, that 'means to an end,' one must continually falter and stumble and perhaps collapse in a mire of unrealized aspirations."

Adams developed the Zone System to deal with the most difficult technical issue in photography—exposure. While the instant feedback from digital cameras has made this problem easier, the Zone System remains the only way to truly understand and master exposure. It also gives us a vital framework for understanding and controlling contrast in our images, and a path to making prints with a full, rich, full range of tones—the range of tones that Adams' prints are so famous for.

El Capitan and the Merced River, Winter, Yosemite National Park

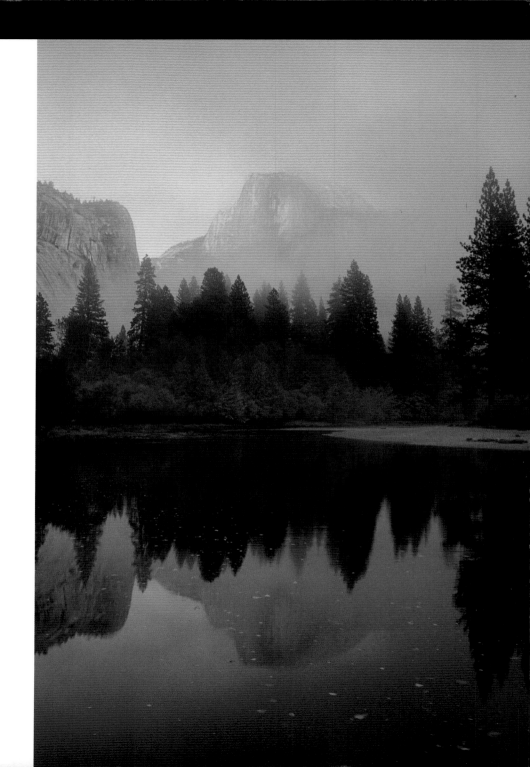

The Art of Seeing

But while technique is important, it is only the foundation. Weston said, "Art is an end in itself, technique a means to that end; one can be taught, the other cannot." He knew that technique served a higher purpose.

And while "Art" may not be teachable, anyone can improve his or her ability to see light and create stronger compositions. By training your eye to see light, color, tones, lines, and shapes, you can hone the visual tools necessary to make expressive photographs.

In this realm, the realm of vision and creativity, nothing has changed. Cameras, whether digital or analog, are just tools. The "creative eye" continues to function, as Adams hoped. In fact digital cameras can be a boost to creativity, allowing experimentation and instant refinement without consulting a film budget.

Ideally your vision and technique work together to create a strong mood. Eliot Porter said, " The essential quality of a photograph is the emotional impact that it carries, which is a measure of the author's success in translating into photographic terms his own emotional response to the subject." It's not enough for a landscape photograph to be pretty. The best photographs evoke a response, a feeling, in the viewer. You must use all the available tools—lines, shapes, colors, tones, exposure, depth of field, and so on—to convey that mood.

Printing and the Digital Darkroom

Making the print is the final, vital step to achieving your vision. Adams said, "I think of the negative as the 'score,' and the print as a 'performance' of that score, which conveys the emotional and aesthetic ideas of the photographer at the time of making the exposure."

Not long ago this performance required having your own well-equipped darkroom, along with many years of trial, error, and experience. Today all you need is a computer and a printer. Yes, experience is still required to make great prints, but the learning curve is less demanding. And while the tools are easier for most people to master, it's judgment and vision that will always separate great prints from mediocre ones. How much contrast is enough? Should there always be areas of black or white in a print? How much saturation is too much? It's here, in developing that judgement and vision, that the past masters have much to teach us.

The Author's Digital Journey

Early in my photography career I used mostly color transparency (slide) film. It was, and still is, a high-contrast, inflexible medium. Printing from transparencies is difficult and offers limited controls. So I and most other color photographers treated the transparency as the final product. The right exposure was the one that looked best on a light box, and a good print simply matched the transparency.

Long before digital cameras were serious tools I started having my film drum-scanned, adjusting those scans in Photoshop, and printing them on some of the earliest digital printers. That process offered much more control and changed my approach. Even with transparency film it became possible to combine several scanned exposures to capture a greater range of contrast. I began to treat the film not as a final product, but as an intermediate step. The important thing was to capture as much highlight and shadow detail as possible, knowing that I could fine-tune the image later.

With digital cameras my approach has evolved further. Even more than with scanned transparencies, I treat the Raw file as just that—raw information. It may take several exposures to capture all the detail in the lightest and darkest parts of the scene. The intended result is visualized in my mind and processed into the finished image. I've been struck by the almost eerie similarity in this new (for me) approach to that used by Adams, Weston, Porter, and other landscape masters of the past. The raw digital file is a like a negative—an intermediate step. The final image may be printed or just viewed on a screen, but either way it's been visualized and interpreted into existence. I have even more control of this interpretation than Adams or Weston had.

It's the dawn of the digital age, and the possibilities are limitless. Armed with modern technology and knowledge from the past, I hope that together we can all take the art of landscape photography to the next level. I trust that our "creative eyes" will continue to function in this digital age, as Adams hoped.

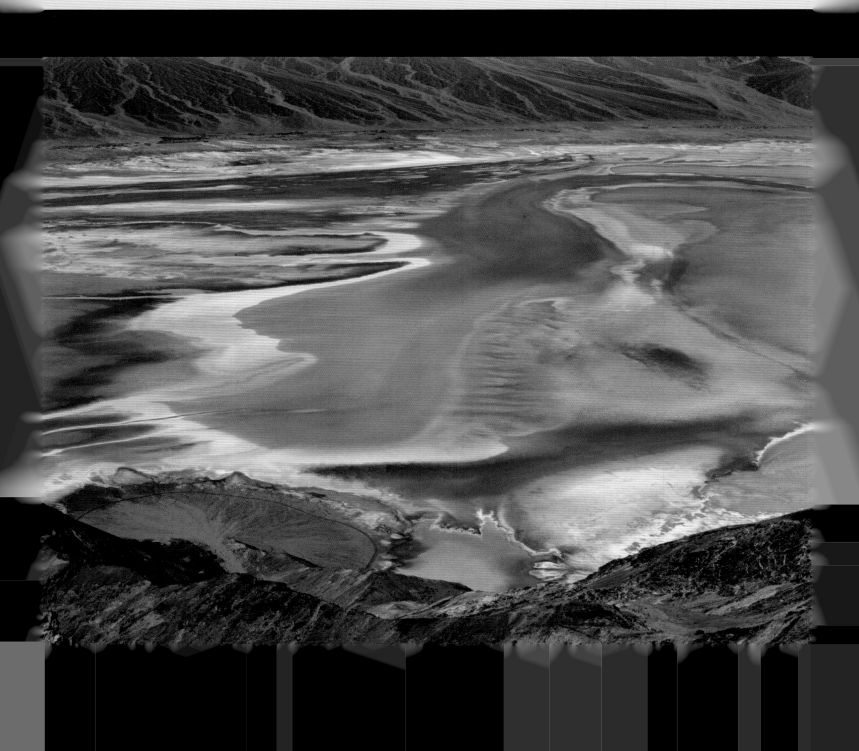

**Dante's View, Death Valley, 1938,
by Edward Weston**

Whether photographing nudes, peppers, or the landscapes of Point Lobos and Death Valley, Edward Weston had a simple, direct, abstract style that has influenced generations of photographers. He strove to capture the essence of his subject, rather than express himself through it: "Without subterfuge, nor evasion, neither in spirit, nor technique, I have recorded the quintessence of the object or element before my lens—rather than an interpretation—a superficial phase, or passing mood."

Sixteen years older than his friend Ansel Adams, Weston learned his craft before Adams codified the Zone System. But he mastered the materials of his era and created a body of prints that are highly valued today, selling at auctions for up to 1.6 million dollars.

Weston knew that good technique was essential: "A photographer perfects his technique for the same reason a pianist practices—that through complete mastery of his chosen tool he may better express what he has to say." But he also knew that technique served a higher purpose: "My work is never intellectual. I never make a negative unless emotionally moved by my subject. And certainly I have no interest in technique for its own sake. Technique is only the means to an end. If my technique is adequate for my seeing, that is enough."

"An excellent conception can be quite obscured by faulty technical execution, or clarified by flawless technique."
—Edward Weston, 1934

Technique is the foundation on which a photograph is built. The most profound visual message will be lost if the image is blurry, or three stops overexposed.

Landscape photography icons like Weston, Eliot Porter, and Ansel Adams were all great artists—men with vision and imagination—but they were also expert craftsmen. By today's standards their equipment and materials were rudimentary, but they mastered them. If they hadn't, their work would have been forgotten long ago.

But is technique as important in the digital age? Can't we just leave the camera on autofocus and program mode? Even if the exposure isn't quite right, or the image isn't quite sharp, can't we just fix that in Photoshop?

Ansel Adams faced the same questions. If the negative isn't perfect, why can't you just fix that in the darkroom? He answered, "We cannot create something from nothing—we cannot correct poor focus, loss of detail, physical blemishes, or unfortunate compositions." Perhaps one thing has changed—a skilled digital retoucher can correct some physical blemishes. But Photoshop does not yet have an "unfortunate composition" filter. There is no software fix for a blurry, out-of-focus image. And while slightly over- or under-exposed originals can be corrected, perfect exposures yield the best results. Adams knew that precise technique at the beginning was the only way to create a beautiful print in the end.

Image Quality

Adams and Weston were founding members of Group f/64. This group reacted to the soft-focus "pictorial" style popular in the 1920s by advocating a pure photographic look. They thought everything in a photograph should be sharp, with great depth of field (hence "f/64," a very small aperture, for the name), and printed on glossy papers to show maximum detail.

To convey this detail, Porter, Adams, and Weston used either 4×5, 5×7, or 8×10 view cameras through most of their careers. Today's digital cameras can render extraordinary detail in smaller packages, but they must be used with care to maximize their capabilities. The modern landscape master Galen Rowell wrote about squeezing as much detail as possible out of his 35 mm camera by using it like a view camera. This meant using a tripod, small apertures for depth of field, and slow, fine-grained film. The same procedures—tripod, small apertures, low ISO—produce great results with today's 35 mm-style DSLRs.

Visualization and the Zone System

Adams wrote, "The term visualization refers to the entire emotional-mental process of creating a photograph, and as such, it is one of the most important concepts in photography. It includes the ability to anticipate a finished image before making the exposure, so that the procedures employed will contribute to achieving the desired result."

For Adams, technique, visualization, and the Zone System were inseparable. He used a spot meter to measure the contrast range of a scene, then exposed and developed the negative to control the values—to increase or decrease contrast. Digital methods are obviously different, but visualization is still vital. It's where imagination meets technique. You conceive the photograph in your mind, then use your best technique to give it life.

Adams' mastery of printing informed the choices he made behind the camera. He knew both the possibilities and limits of his darkroom controls. In the digital age, familiarity with the tools available at the end—Photoshop, HDR software, or other applications—affects how you approach the beginning. As you learn more advanced software techniques, you see new image possibilities, and can then make choices in the field to take advantage of your new skills.

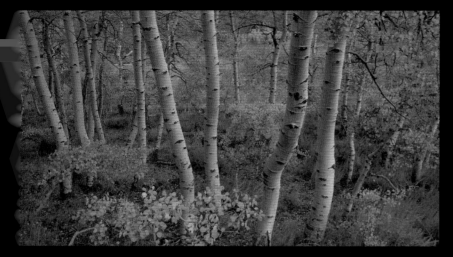

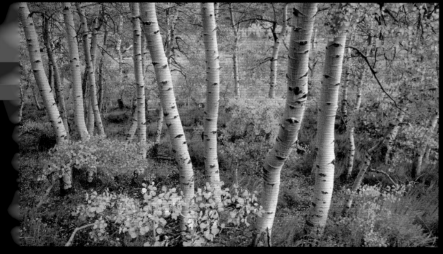

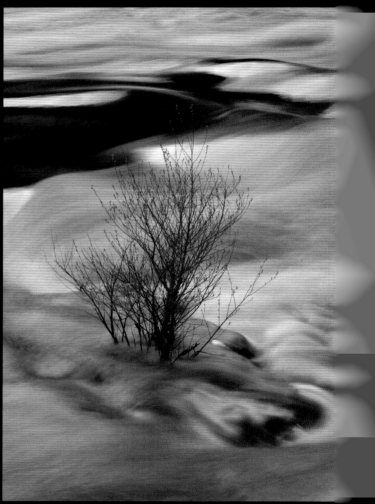

The flat, bluish light from a dusk sky muted the colors and contrast of these aspens, but I visualized a more dynamic photograph. The first image shows the unprocessed Raw file; the second was processed with a warmer color balance, more contrast, and increased saturation.

Visualizing Motion

Here I needed to visualize the effect of a slow shutter speed. Experience made it easy to imagine that a long exposure would blur the water, but I also guessed that the smoother water would allow the small shrub to stand out clearly against the background. A digital camera was a great aid, as it showed the effect of blurring the water exactly, and allowed me to fine-tune the shutter speed and composition. Of course a tripod was essential to keep the bush sharp during the two-second exposure.

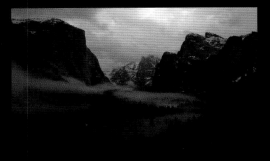

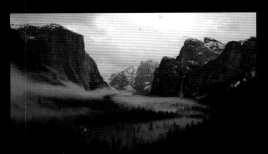

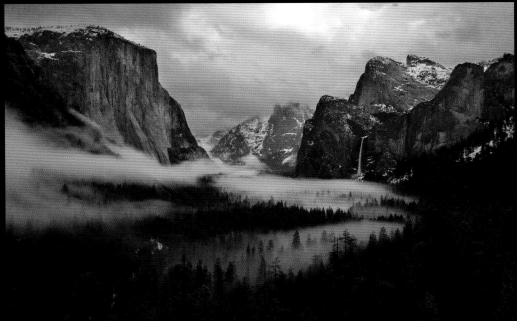

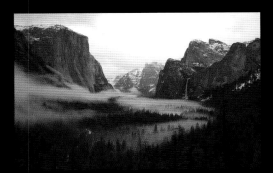

Visualizing Decreased Contrast

This high-contrast scene from Yosemite's Tunnel View required visualizing reduced contrast and a shift in the tonal relationships. Of the three original exposures, each one stop apart, the middle exposure is perhaps the best compromise, but shows washed out highlights in the clouds at the top of the frame, and inky shadows in the trees. I used Photomatix HDR software and Photoshop to blend these images, then converted the composite file to black and white with the digital equivalent of a red filter. The result was a dramatic shift in the tonal relationships: the sky in the final version is much darker relative to the foreground, while the HDR merge created an open, luminous quality to the trees and mist.

Image Quality

Megapixels and Sensor Size

"The kind of equipment used is not what matters. The important thing is that you stay with whatever equipment you choose until it becomes an automatic extension of your own vision, a third eye."
—Edward Weston

Manufacturers love to tout the number of megapixels in their cameras. This is an important consideration for landscape photographers, but not the only one—noise can degrade an otherwise sharp image file. But other things being equal, high-resolution cameras can render finer detail in leaves, pine needles, and grasses.

Resampling a small file will create more pixels, but doing so won't create any more actual image detail. Never throw away pixels needlessly. Always use the highest resolution your camera is capable of, and keep your master files at this resolution (more about master files on page 111).

Noise

Noise is like film grain—a pattern of dots most visible in smooth areas like sky or water. Unlike film grain, noise is not evenly distributed: it's more prominent in shadows. It's also exacerbated by high ISOs and long exposures.

35 mm-style DSLRs come in three main varieties: those with "full-frame" sensors the size of 35 mm film (24×36 mm), and those with sensors about two-thirds that size (around 15×22 mm to 16×24 mm). Full-frame sensors generally show less noise than the two-thirds size sensors, because the individual photosites can be larger, with more light-gathering capacity. But the newest two-thirds size sensors control noise very well, and can produce excellent images.

Serious landscape photographers should also consider a "medium-format" digital camera. These have even larger sensors, from 33×44 mm to 40×54 mm, with high megapixel counts and generally low noise. On the other hand, "point-and-shoot" digital cameras have tiny sensors, and are plagued with noise.

Noise Reduction

First, a sturdy tripod allows you to use low ISOs without worrying about camera shake.

Noise often becomes more visible when trying to lighten dark shadows in software, so the next step to controlling noise is proper exposure, which generally means making the image as light as possible without losing detail in highlights. When a scene has too much contrast to retain both good highlight detail and good shadow detail, it may be necessary to combine two or more images in software.

Many cameras have a noise-reduction setting for long exposures. Using this takes time—after a 30 second exposure, the camera then processes the image for another 30 seconds—and it may or may not help. You have to test your own camera to see if the noise-reduction setting is worth the trouble.

As a last resort, specialized noise-reduction software can help. See more about exposure on page 34, about reducing noise in software on page 120, and about combining multiple images on page 144.

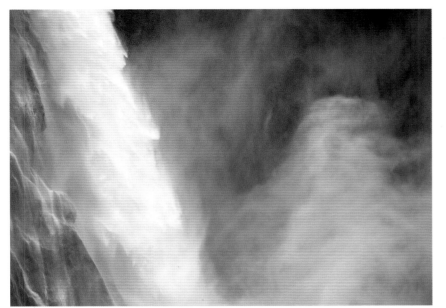

High ISO Noise

Low light required pushing the ISO to 400 to freeze the waterfall's motion. Although the noise was not terrible, I was able to reduce it in software.

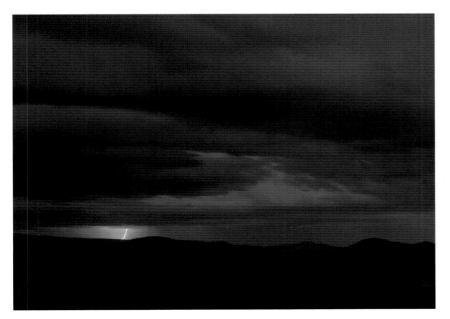

Long-exposure Noise

A long, 15 second exposure at 100 ISO introduced considerable noise, especially in the shadows. Noise reduction software was able to reduce it partially.

Highlight Recovery

A section of the clouds above the mountain El Capitan was washed out, but this was easily fixed with one of the recovery tools available in many Raw processors. The same tools can also work with JPEGs, but because some information has already been discarded, there is less chance of rescuing overexposed highlights like these.

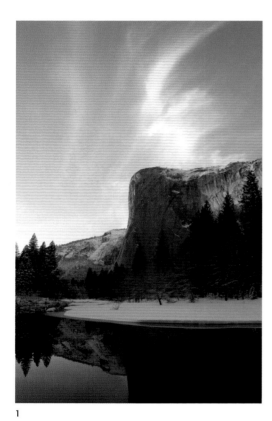

1

2

3

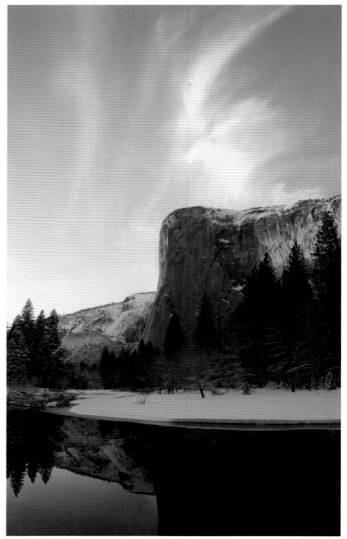

4

1 Original Raw file
2 Close-up of overexposed clouds
 from original file
3 Close-up of recovered highlights
4 Processed Raw file

Camera Settings

Raw versus JPEG

This topic has been hotly debated, with passionate advocates on both sides. The truth is that there are advantages and disadvantages to each mode. JPEGs are Raw files that are processed in the camera and compressed into the JPEG format. Some of the decisions the camera makes in processing the image may be difficult to change later, but the file sizes are much smaller.

Raw

Advantages:

- It's easier to correct exposure mistakes. Overexposed highlights can sometimes be rescued.

- Higher dynamic range (better ability to preserve both highlight and shadow detail).

- White balance corrections are easier.

- Decisions about sharpening, contrast, and saturation can be deferred until the image is processed, then tailored to the individual image.

- All the original image data is preserved

- More color space choices (Adobe RGB, sRGB, etc.).

Disadvantages:

- Larger file size requires more storage space. This includes Compact Flash or SmartMedia cards plus hard drive space.

- Images take longer to write to disk; shorter bursts of continuous shooting.

- Not all programs can read Raw files. This used to be more of a problem, but there are now some excellent applications that work directly with Raw files, such as Adobe's Photoshop Lightroom and Apple's Aperture.

JPEG

Advantages:

- Requires less storage space.

- Images write to disk more quickly; longer bursts of continuous shooting.

- Files can be instantly viewed by many programs, including web browsers, PowerPoint, etc.

Disadvantages:

- Harder to correct exposure mistakes.

- Smaller dynamic range (less ability to preserve both highlight and shadow detail).

- White balance corrections are more difficult.

- Decisions about sharpness, contrast, and saturation are set in the camera, and in some cases may be difficult or impossible to change later.

- Data is thrown out as the image is processed in the camera.

- Fewer color space choices.

JPEGs are like slides or transparencies, and Raw files are like negatives. With JPEGs, most of the decisions about how the image will look are made before the shutter is pressed, and there are fewer options for later changes—just like slides. Raw files always require further processing, and retain more shadow and highlight detail—just like negatives. Raw images can be interpreted in a variety of ways: high contrast, low contrast, high saturation, low saturation, etc.

If Adams, Porter, or Weston were wielding a digital camera today, they would surely all be using Raw mode. These masters of craft would insist on getting the highest quality images, with the most information in the file and the greatest potential for making later adjustments. This applies especially to landscapes, where the ability to write images to disk quickly is less important than when photographing people, sports, or wildlife. Henri Cartier-Bresson might have used JPEG mode, but not Adams.

Many photographers are unnecessarily intimidated by Raw. It's actually easy to use. I always photograph in Raw, even for snapshots or wildlife, as mistakes are easier to correct, and mistakes, especially in exposure, are more common with fast-moving subjects. Two of Raw's biggest disadvantages have almost disappeared: the price of storage media seems to drop daily, and new software makes working directly with Raw files easy. The remaining drawback to Raw is the time it takes to write files to disk. If your camera can capture a burst of 27 images as JPEGs, then the likelyhood is that a burst of Raw is limited to 9. This makes JPEGs a more attractive option files for the serious sport or wildlife photographer, though they must be even more careful with exposure.

Most cameras can capture both Raw and JPEG files simultaneously, but this gobbles even more storage space and further slows writing the files to disk. You're better off picking one or the other. If you choose JPEG mode, make sure you're using the largest file size and highest quality setting. Don't sacrifice any more quality than necessary.

Sharpening

Although you should strive for sharpness in other ways, I recommend applying little or no sharpening in the camera. Oversharpening can create ugly artifacts like halos around edges, and is impossible to fix later in software. It's best to be conservative at the start. With JPEGs, find the menu that deals with sharpening, and use the lowest setting. This option doesn't affect Raw images. With Raw you can decide later, in software, how much initial sharpening to apply.

Contrast

Most cameras have a contrast setting buried deep in the labyrinth of their menus. Again, this option only applies to JPEGs; the contrast for Raw images is set later in software. With JPEGs I recommend using the lowest contrast setting possible. One of the basic rules of digital imaging is that it's easy to increase contrast, but difficult to decrease it. While using a low contrast setting in the camera will make some images look flat, that's easy to fix later, and you'll benefit by getting more highlight and shadow detail in high-contrast scenes.

Even in Raw mode I recommend setting the contrast as low as possible to get the most accurate histograms. The camera's histogram is based on the JPEG preview, so using the lowest contrast setting will make the histogram closer to what the Raw file really looks like. It's worth making some test images using JPEG and Raw simultaneously to compare the contrast and histograms.

2

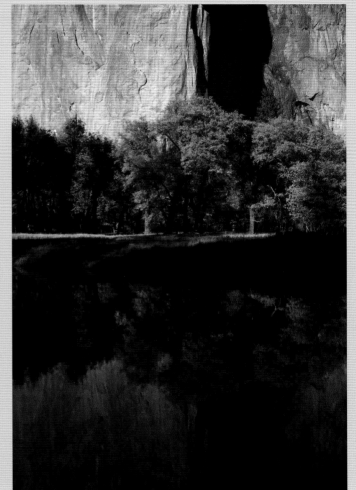

3

1 Processed Raw file
2 Raw original
3 JPEG original

Contrast in Raw and JPEG Files

The original JPEG has more contrast than the Raw file, even though the lowest contrast setting was set in the camera. The shadows in the JPEG are completely black, while there's a hint of detail in the darkest areas of the Raw file. I was able to lighten the bottom part of the Raw image and bring out some of that shadow detail, something that would have been impossible with the JPEG.

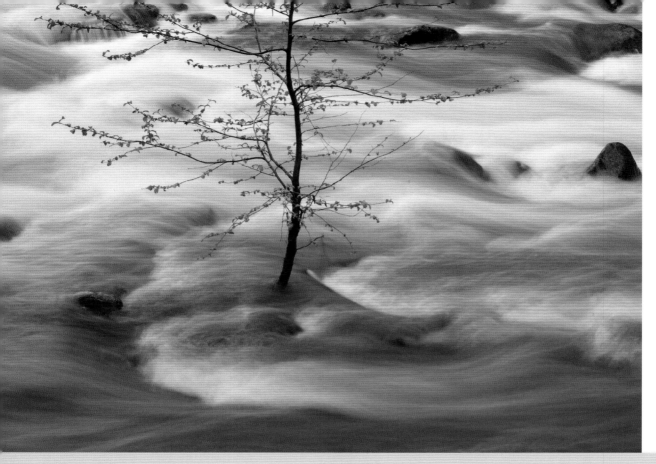

1. **A Stable Platform**
A tripod kept the tree and rocks sharp during the one-second exposure required for this image.

2. **Freezing Motion**
A shutter speed of 1/3000 sec. froze the motion of this hummingbird's wings.

3. **Manual Focus**
If autofocus isn't cooperating, switch to manual focus, as I did with these aspen leaves.

1

Controlling sharpness in the field

Do you want to show every leaf and blade of grass, or deliberately blur the image? The choice is yours—if you're in control. You should be able to render every detail when you need to, and create blurring when it suits you. Sharpness, or the lack of it, is a powerful tool.

You have to learn the rules before you can break them, so you need to learn how to make everything sharp before you can make controlled blurs. We'll start by looking at causes of inadvertent fuzziness and how to avoid them.

Camera Shake

Mix a hand-held camera with a slow shutter speed and you've got a recipe for fuzzy pictures. But there's an easy cure: a tripod. A tripod is as important in landscape photography as a camera or lens. People seem willing to spend thousands of dollars on the latest camera or zoom lens, but then buy the cheapest tripod possible. Get a good one! It should be sturdy, tall enough to reach your eye level, and have easy, intuitive controls. Like any piece of equipment, you must use it to become familiar with it.

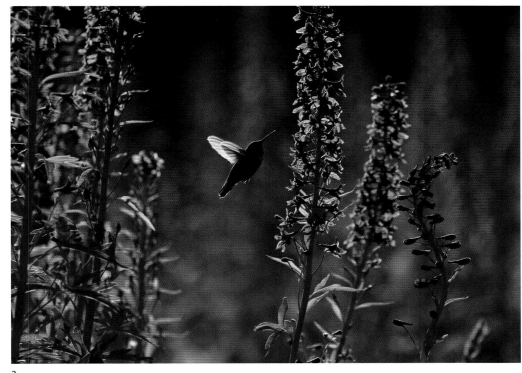

2

3

Subject Movement

Focus

You should also have a cable release or an electronic release. You can sometimes get away with using the self-timer, but when you set up the tripod for a flower photo, wait ten minutes for the wind to die down, and then it does—but only for one second!—you'll wish you had that cable release.

Landscapes aren't just made of rocks. You must often deal with flowing water, wind-blown flowers, or waving branches. Freezing motion requires either a fast shutter speed or the patience to wait for the subject to stop moving.

How fast does the shutter speed need to be? It depends on how quickly the subject is moving across the frame. A relatively long exposure can freeze something moving toward you or away from you, but the same object going across the image may need a much faster shutter speed. Experience is the best teacher, but a zoomed-in look at your LCD screen can help.

Sometimes an image is just out of focus! This can happen when the autofocus locks onto something other than your main subject. Don't be a slave to autofocus—switch to manual when necessary. On the other hand, one of the prime causes of blurry photos is forgetting to switch back to autofocus.

Depth of Field

Simply put, depth-of-field is how much of a photograph is in sharp focus from front to back. Professional photographers understand and use depth of field, while most amateurs don't. Professionals know that they can't leave this critical element to chance, or to the programmed whims of an automatic camera.

Landscape masters Porter, Weston, and Adams always tried to get everything in focus throughout their photographs, to the point of forming Group $f/64$ in 1932 as mentioned on page 11. Part of their original manifesto read, "The name of this Group is derived from a diaphragm number of the photographic lens.

It signifies to a large extent the qualities of clearness and definition of the photographic image which is an important element in the work of members of this Group."

Modern photography aesthetics accept a wide range of styles, including more impressionistic looks. But emulating Ansel Adams or Edward Weston is never a bad idea. In most landscapes images, everything should be in focus unless there's a specific reason for not doing so—like creating a soft, impressionistic look, or focusing attention on one element.

Factors Affecting Depth of Field

The Lens
Theoretically, a telephoto lens has the same depth of field as a wide-angle lens. This is true if you're talking about subject magnification rather than camera-to-subject distance. But we tend to think in terms of distance rather than magnification. When talking about camera-to-subject distance, wide-angle lenses do provide more depth of field. At $f/22$ you get from three feet (1 m) to infinity in focus with a 28 mm lens; with a 100 mm lens at the same f-stop you only get from twelve feet (4 m) to infinity.

Shallow Depth of Field

I was able to get most of this coneflower in focus at $f/4$, and this wide-open aperture blurred the background flowers into blobs of yellow.

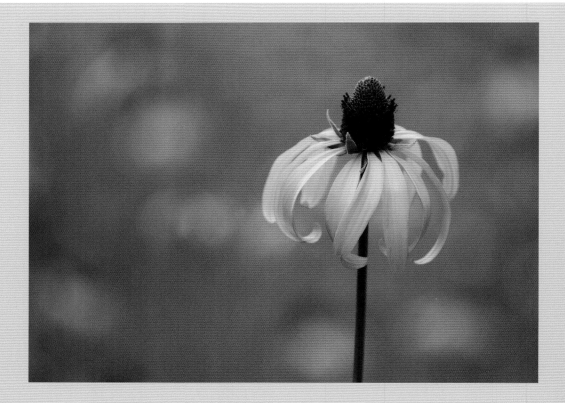

Sensor Size

Most digital SLRs have small, "APS-size" sensors. It's easier to get everything in focus with these cameras because you can use shorter lenses to get the same composition and perspective. With 35 mm film, or a "full-frame" digital sensor, you would need a 32 mm lens to get the same field of view you would get with a 20 mm lens on an APS-size sensor.

Aperture or f-stop

The smaller the aperture, the more depth of field. Is $f/22$ a small aperture or a large one? What about $f/4$? Here's an easy way to remember: the greater the f-stop number, the greater the depth of field; the smaller the f-stop number, the smaller the depth of field. So a large f-stop number, like $f/16$ or $f/22$, means a great depth of field; a small number, like $f/4$ or $f/5.6$, means a shallow depth of field.

If you're mathematically inclined, it might help to know that these numbers are fractions, or ratios. $f/8$ really means focal length in the formula f/D (D being pupil diameter). So, $f/8$ on a 200 mm lens is $200/8 = 25$, so a 25 mm pupil diameter (hole) is required for $f/8$. Similarly on a 20 mm lens, a 2.5 mm pupil diameter would be described as $f/8$. (The pupil diameter and the aperture might not be the same, as many lenses have additional magnifying elements.)

Shallow Depth of Field

Isolating a Subject

- Use a telephoto lens; the longer the better. It's difficult to get everything in focus with a telephoto, but it's easier to throw unwanted things out of focus.

- Use a small f-stop number (large aperture) like $f/4$ or $f/5.6$ (remember, small number, small depth of field).
- Put as much distance as possible between your subject and the background. The more distant the background, the more out of focus it will be.

If that seems easy, it is. But what if you need $f/16$ to get the whole subject in focus yet still want to blur the background? First, take a picture and look at your LCD screen: maybe the background looks okay even at $f/16$. If not, perhaps you don't really need to make the whole flower sharp. An alternative would be to focus just on the most critical parts and leave the aperture wide open (at $f/4$ or $f/5.6$).

Washes of Color

I deliberately put out-of-focus blossoms between the camera and the main subject to create washes of color. The focus point was vital—if only one thing is sharp, it has to be interesting enough to hold the viewer's attention.

Great Depth of Field

Getting it All in Focus

Unless you're deliberately trying to isolate one subject, you should get everything in focus. Don't be wishy-washy: either get it all sharp or make just one thing sharp.

How do you get everything in focus?

1) Choose a lens and compose the picture.

2) Focus somewhere between the foreground and background. You'll want to use manual focus for this. Where exactly should you focus? I've heard people say a third of the way between the closest object to the camera and the furthest object. But what's a third of the way between 3 feet and infinity? If you're focused somewhere between the foreground and background, but closer to the foreground, you're close. To be more precise, look through the viewfinder and try to make the nearest and furthest objects equally blurry. To be really precise, follow the steps under "Focusing for Maximum Depth of Field" below.

3) Use a large *f*-stop number (small aperture) like *f*/16 or *f*/22. With the camera locked on a tripod and a motionless scene you can just use your smallest aperture and hope for the best. But how do you know

if that was enough? Depth-of-field scales have become rare, and depth-of-field previews are hard to use, but all digital cameras have an excellent way to check sharpness: the LCD screen.

Take a picture, then go into playback mode and zoom in. Do the foreground and the background look as sharp as the middle? Make sure you're checking the very closest and furthest objects from the camera. I find it helps to not zoom in too far, otherwise everything looks blurry. Also, use the same magnification each time you check sharpness so you build up a frame of reference.

4) Set the shutter speed. In aperture-priority mode this happens automatically. In manual mode you have to set the shutter speed yourself (see page 34 for more on exposure). If the first image is too light or dark, adjust the shutter speed, but leave the aperture alone to keep everything in focus.

Using a small aperture (large *f*-stop number) in low light often requires a slow shutter speed. Use a tripod! If you need a fast shutter speed—say you're trying to freeze the motion of a waterfall—you may be able to get everything in focus at *f*/8 or *f*/11 instead of *f*/16 or *f*/22. Alternately, a higher ISO may allow you to use both a small aperture and fast shutter speed.

5) Press the shutter!

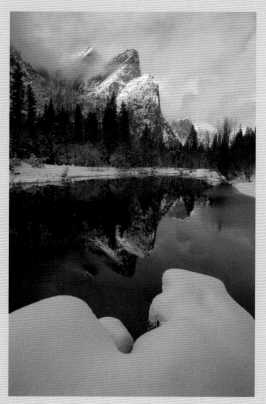

Depth of Field with Wide-Angle Lens

The snow at the bottom of the frame was only two feet from the camera, while the rock formation, Three Brothers, was at infinity. Careful focusing kept everything sharp at *f*/22 with a 24 mm lens on a full-frame sensor.

Focusing for Maximum Depth of Field

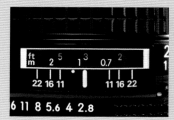

First focus on the object closest to the camera, and note the distance on your focusing ring. In this illustration, it's three feet away.

Next, focus on the furthest thing from the camera, and once again check that distance on your focusing ring. Here it's at infinity.

Then set your focus halfway between these two spots on your focusing ring.

Increasing the ISO

This stormy afternoon at Mono Lake required both a fast shutter speed to freeze the motion of the waves and great depth of field. Pushing the ISO to 400 introduced a small amount of noise, but allowed me to shoot at 1/125 sec and f/16.

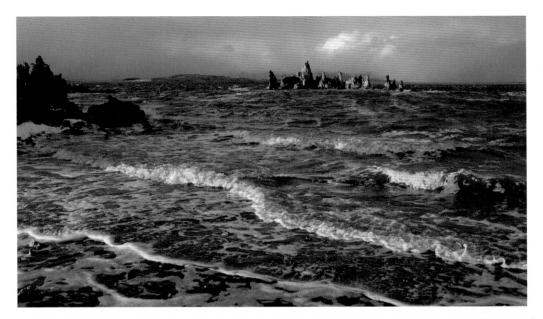

It can be difficult to get enough depth of field with telephoto lenses, especially with larger camera formats. I needed precise focusing and an aperture of f/32 to keep both the redbud and rocks sharp with a medium-format camera (6 × 4.5 cm) and a 150 mm lens.

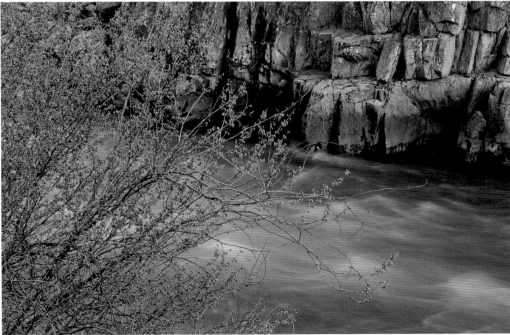

Expanding Depth of Field

Sometimes even your smallest aperture isn't enough to get everything in focus. Adams, Weston, and Porter got around this problem by changing the plane of focus in their view camera. But even without a view camera it is now possible to expand depth of field by combining multiple images in software. I explain how to do this on pages 140-143, but first you have to capture a series of images in the field that contain all the necessary information. The area of sharp focus should overlap between one image and the next, and every part of the scene must be covered—that is, every part of the frame should be sharp in at least one image.

I recommend using a medium to small aperture. $f/16$ is a good choice—it's small enough to have some depth, but not so small as to degrade the image (most lenses lose some sharpness at their very smallest apertures due to diffraction).

A tripod is essential to avoid camera movement and keep the images aligned. Use manual exposure to ensure consistency between frames. With JPEGs you should also use manual white balance. Any order will work, but it helps to be systematic. You could start by focusing on the foreground, making an exposure, then focusing a little further back, and so on. Use the camera's depth-of-field preview or a zoomed-in look at the LCD screen to make sure that the focus overlaps between frames.

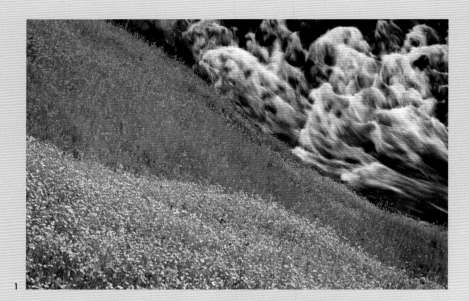

1

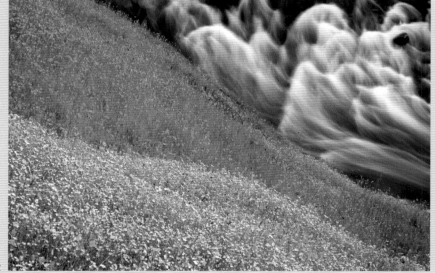

2

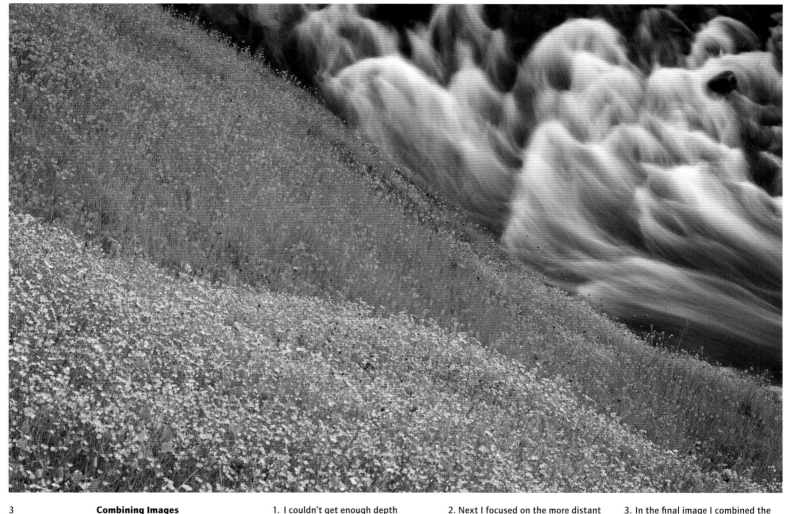

3 **Combining Images**
 for Depth of Field

1. I couldn't get enough depth of field for this scene, even at my smallest aperture, so I combined two images. First, I focused on the foreground and pushed the ISO to 400 to get a shutter speed of $1/6$ sec at $f/22$. This allowed me to freeze the motion of the flowers during a lull in the breezy winds.

2. Next I focused on the more distant blossoms and dropped the ISO down to 50. This lengthened the shutter speed to $1\frac{1}{2}$ seconds, long enough to give the water a good silky blur. The flowers remained sharp, despite the slow shutter speed, because their greater distance from the camera made their relative motion slower.

3. In the final image I combined the foreground of the first image with the background of the second. The flowers are sharp throughout, while the water retains its flowing look.

Filters

Filters can't make bad photographs into a good ones, but they can make good photographs better. I've never carried a lot of filters. Now, with a digital camera, I only carry a polarizing filter, or "polarizer." The other filters that used to fill my camera bag are now gathering dust because their effects can be easily duplicated in software.

Polarizing Filters

Cutting Reflections

This is probably the most useful all-around filter for landscapes. Most people know that a polarizer can darken a blue sky, making clouds stand out, but they often don't utilize the polarizer's other main strength: it's ability to cut reflections. The first waterfall image was made without a polarizer, the second with one. Notice how the filter has reduced the reflections on the wet rocks, enhancing their colors. But remember that sometimes you need reflections! You don't want to eliminate a mountain's reflection in a calm lake.

Rainbows

Rotated to maximum strength—the point where it cuts reflections and darkens a blue sky—a polarizing filter will make a rainbow completely disappear. But turn it 90 degrees from that point, to its minimum strength, and it will actually enhance rainbows, as in this photograph of Mono Lake.

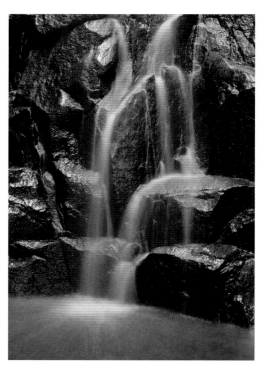
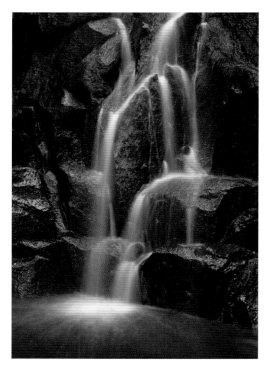
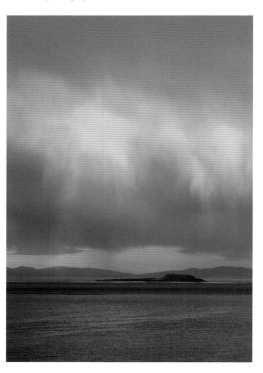

Graduated Neutral-Density Filters

Graduated neutral-density filters are designed to balance contrast between light and dark parts of a scene. They're half gray and half clear, with a gradual transition between the two sections. I used one on the second photo of Pothole Dome, putting the gray part of the filter over the top half of the image. Notice how the bottom part of the image has been lightened relative to the top.

Graduated neutral-density filters are expensive and difficult to use. I don't carry them anymore, since I can reproduce the same effect more easily, with more control, in Photoshop or Lightroom (see page 134).

Warming Filters

Color Temperature Difference

Photographs taken in the shade often have a blue color cast, as the light comes from the blue sky, rather than directly from the sun. This photograph of the Merced River shows the color temperature difference between the snowy trees in the shade and the sunlit rocks.

Warming Filter

Pale amber warming filters (called 81A, 81B, 81C, etc.) correct for that bluish cast and make the image appear more natural. The first flower photograph was taken without a warming filter, the second with an 81B filter. Notice how the greens look blue-green in the first image.

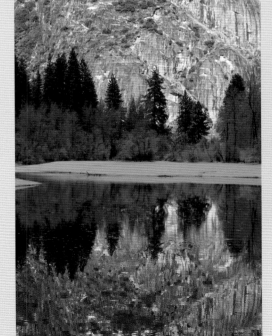

But warming filters aren't necessary with digital cameras, because you have better options for correcting color balance. I'll say more about this on page 33.

Filters for Black and White

For over a century photographers have used colored filters to alter tonal relationships in black-and-white images. A red filter, for example, makes red objects lighter, but darkens objects that are on the opposite side of the color spectrum, like cyans, greens, and blues. A green filter lightens green objects (or colors close to green, like yellow and cyan), and darkens reds, oranges, and magentas. A classic example is a red apple next to a green apple. In black and white, without a filter, both apples appear medium gray. With a red filter, the red apple becomes light, the green apple dark. With a green filter, the green apple becomes light, the red apple dark.

But in the digital age these filters are obsolete. Converting a color image to black and white in software offers far more sophisticated control. It's like being able to take a paintbrush and change the colors of the scene before applying a filter—to make green trees red, and then put on a red filter. I show how to do this on page 120. So even if you intend to create a black-and-white image, it's better to capture it in full color without filters (except perhaps a polarizer), and convert to black and white later.

In Raw mode you actually have no choice: Raw files are always in full color. If your camera has a menu setting for recording black-and-white images, it only applies to JPEGs. But even in JPEG mode, it's better to keep the images in color until processing. The one case where using the camera's black-and-white mode might be helpful is to better visualize how the scene will look without color. You could try capturing in both Raw and JPEG simultaneously to see the scene in black and white but keep all the color information. Bear in mind that each camera handles this black-and-white conversion differently: some, but not all, make the conversion with the look of a red filter.

1
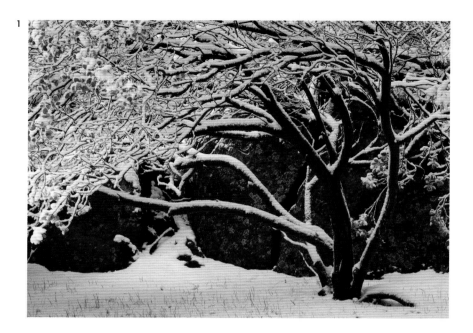

2

3

4

Separating Tones

1. This image of a manzanita bush was originally captured in color.

2. A "straight" black-and-white conversion with no filter. The trunk blends into the rock behind it: they're both the same shade of gray.

3. Applying the software equivalent of a green filter didn't help—there's still no separation between the trunk and rock. I tried substitutes for all the traditional filters, but none could separate the tones and make the manzanita stand out.

4. By changing the color of the trunk to magenta in software, and then applying the equivalent of a green filter, I was finally able to make the greenish-yellow rock lighter and the manzanita darker.

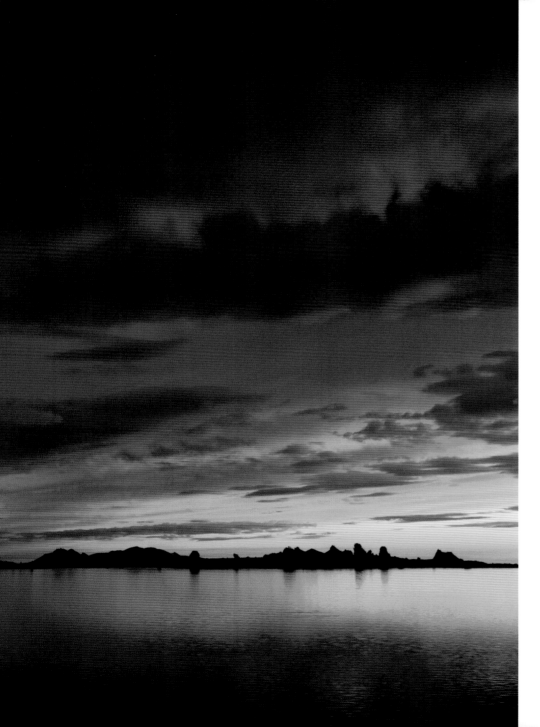

White Balance

For color images, getting the correct white balance is critical—but it doesn't have to be perfect in the camera, as even JPEGs can be adjusted later. Here are a few suggestions for how to deal with white balance:

For Raw images

Just leave the camera set to automatic white balance. This will usually get you close, and then you can fine-tune the color in software (see page 130). If you know the color balance will be tricky, include a white or gray card in one of the frames, then click on that card with an eyedropper tool in software. I always do this at dusk or with mixed lighting (man-made and natural light in the same photograph).

For JPEGs

First, test your camera's automatic white balance in a variety of lighting conditions: sun, shade, overcast, dusk, sunsets, and so on. If it seems to work well—if it's close most of the time—then just leave it set to automatic white balance. You can make minor corrections in your image-editing software.

If the automatic white balance doesn't work well— if it seems to be off much of the time—you're going to have to override it. Set the white balance manually for the conditions. Any scene with at least partial sun, or taken at sunrise or sunset, should be set to daylight white balance.

Sunset Color Temperature

A camera's automatic white balance can easily be confused by sunset colors, but that's easily fixed—just set the white balance to Daylight in the camera, or to around 5000K in software. Daylight, or 5000K, is what slide film is balanced for, and slides handle sunsets very well.

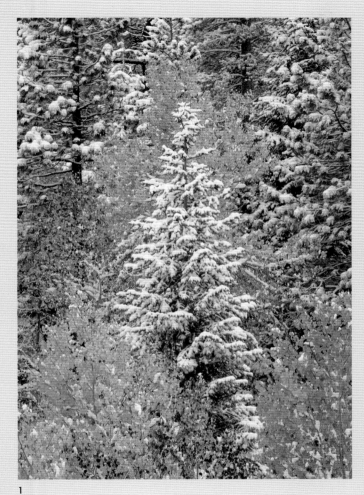

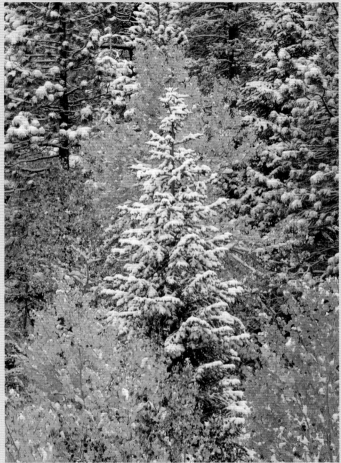

1

2

1 Camera's automatic white balance
2 White balance corrected in software

White Balance for Shade

In dusky shade the camera's automatic white balance chose a color temperature of 4800K for this Raw file—much too blue. The color balance was changed to 7000K using software, making the snow neutral and brightening the colors of the aspens.

Exposure and Histograms

Exposure used to be the single most difficult technical problem in photography, but digital cameras have made this thorny issue much easier. Does that mean you can now just turn on Program mode and turn off your brain? Sorry! Thought and care are still required. The basic problems of exposure have not changed. The only difference is that you can see right away whether you got it right.

Don't judge the exposure by how it looks on your LCD screen. These are notoriously unreliable. They're wonderful for checking compositions, or seeing the effects of a slow shutter speed with a moving subject, but not for judging exposure. There are two good ways to evaluate the exposure of a digital image: a histogram, and a calibrated monitor. Your camera's LCD is not even close to a calibrated monitor, but it does have a histogram.

Most cameras also have an overexposure warning, technically known as the "blinkies." When reviewing an image, overexposed areas will flash, or blink, warning you that these parts of the photograph are overexposed. Since highlights are the most visually important parts of an image—the spots your eyes are drawn to—and since it's difficult to rescue overexposed highlights in software, it's a good idea to pay attention to these warnings. If small, unimportant areas become washed out, that's okay, but critical parts of the scene shouldn't be flashing at you.

But the blinkies only tell you about highlights. A histogram tells you about the whole image if you know how to read it.

Right Edge

The most important part of the histogram is the right-hand edge, because that's where the highlights are. If you see pixels touching the right edge of the histogram, or a spike like this, that means some pixels are overexposed, and parts of the image are washed out.

Left Edge

Pixels pushed up against the left edge of the histogram indicate areas of pure black with no detail.

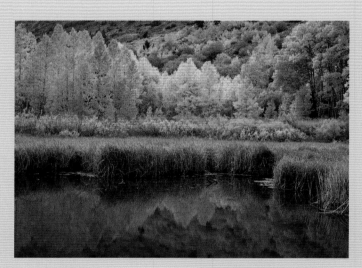

Perfect Exposure

Ideally you'd like to have detail in both the highlights and shadows: nothing washed out, nothing completely black, and a histogram that shows no pixels pushed up against either the right or left edge, as in this photo of Lundy Canyon from the Eastern Sierra.

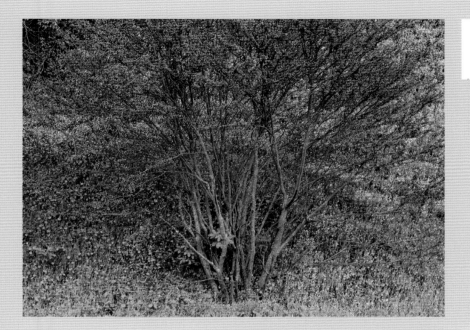

Shape Doesn't Matter

A histogram shows how dark and light pixels are distributed within your photograph. This image of a redbud is low in contrast, with lots of medium tones, so the histogram displays a mound of pixels in the middle. The image of gulls on a pier has no medium tones; it's dominated by the light gold water, with the contrasting dark areas of the gulls and pier. The histogram shows a big spike on the right side—that's the water. There's a smaller spike on the left—the gulls and pier. Both images are properly exposed. The shape of the histogram doesn't matter; these are just different photographs, and the histograms reflect that.

Keep Detail in the Highlights

The first histogram represents an image with black shadows, but detail in the highlights. The second histogram shows a photograph with detail in the shadows, but washed-out highlights. In most landscape photographs bright areas are more important, so it's better to see this first histogram than the second one.

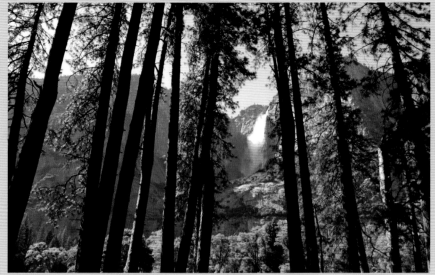

Overexposed High-Contrast Image

The overall exposure for this image of Yosemite Falls is good, but the key highlight, the waterfall, is washed out, as shown by the small spike at the right edge of the histogram.

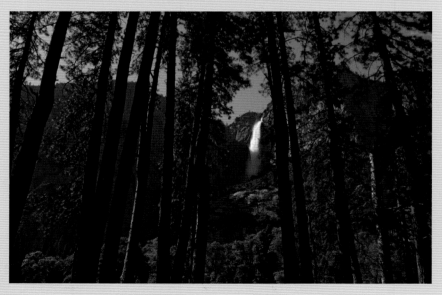

Properly Exposed High-Contrast Image

This is a better exposure for this scene, as the waterfall is properly exposed—nearly white, but with detail and texture. The sliver of pixels along the bottom near the right side of the histogram represent the waterfall. The left side of the histogram shows that some pixels have gone completely black, but that's preferable to overexposing the most important highlight.

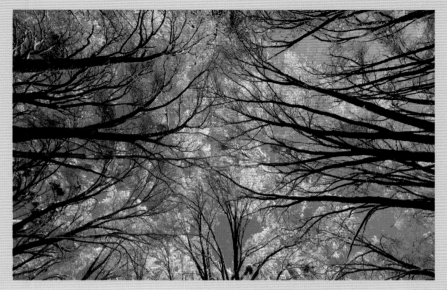

Which Are More Important, Highlights or Shadows?

Often a scene has too much contrast to retain detail in both highlights and shadows. Then you have to choose: Would you rather have detail in the highlights, and let some shadows go black? Or would you prefer to keep detail in the shadows, and allow the highlights to wash out?

The answer depends on the image. Which are more critical, the highlights or shadows? In most landscape photographs, the highlights are more important. Why? First, our eyes are drawn to bright areas, so viewers immediately notice if they're overexposed. Second, in real life we can always see detail in bright spots (except when looking at the sun itself, or the sun reflected in water or glass), but we can't always see detail in shadows. It seems unnatural to find washed out highlights in a photograph, yet it feels perfectly normal to see regions of pure black.

So if you can't have both, 99 percent of the time you should sacrifice the shadows and keep the highlights. In most photographs, the lightest pixels should be close to the right edge, but not touching it. Since digital images actually have more information in lighter tones, you want the image to be as light as possible without being overexposed.

If you really need detail in both highlights and shadows, it's now possible to combine several exposures together in Photoshop or HDR software, which will be discussed later in the book.

Highlights are Critical

Sunlit snow and dark trunks meant lots of contrast in this image of oak trees. The histogram shows perfectly exposed highlights: pixels near, but not touching, the right edge. Some shadows in the tree trunks have blocked up and become completely black, as shown by the left edge of the histogram, but that's better than seeing washed-out highlights, and actually the small areas of black add impact.

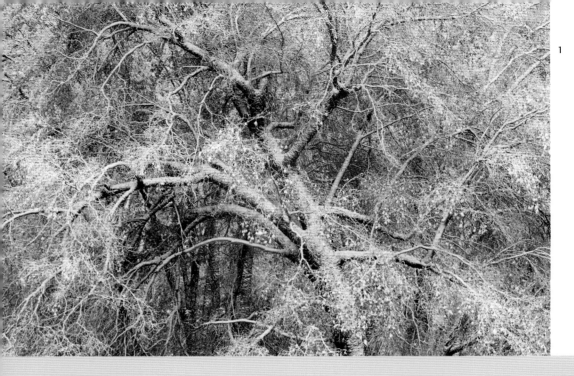

Exposure Compensation

With practice you can predict which images need exposure compensation and dial it in right away.

1. If the image is predominantly light, as with this snow-covered oak, you'll need plus compensation (start with +1.0).

2. A predominantly dark scene, like this image of a sunlit aspen surrounded by dark fir trees, requires minus compensation (try -1.0 to start, then adjust from there).

Exposure With Digital Cameras

Metering

Most cameras have three metering modes: center-weighted, spot, and a programmed mode called Evaluative (for Canon), Matrix (Nikon), or some other name. The programmed modes "evaluate" the light and dark areas of the image to achieve, in theory, more accurate exposures.

Exposures with center-weighted, Matrix, or Evaluative metering tend to fall in the middle, between the lightest and darkest parts of a scene, since these methods average the all tones together. This works fine when contrast is low, but with high-contrast images the highlights are usually so much brighter than the average exposure that they become washed out. Spot metering can avoid these problems by measuring only a small portion of the scene, but only if you know what you're doing—which means using the Zone System.

In conjunction with histograms, any of these metering modes can lead to perfect exposures with digital cameras. For landscape images, there are three viable approaches: aperture-priority automatic with exposure compensation, manual with center-weighted metering, and the Zone System with spot metering. The choice depends on the subject and your level of experience.

As well as the histogram, most cameras have the option to indicate clipped areas of the image on-screen. This is typically done with a blinking color overlay many photographers refer to as the "blinkies."

Aperture-Priority Automatic with Exposure Compensation

Since aperture-priority mode allows you to control depth of field, it's a better automatic-exposure choice for landscape photography than program or shutter-priority modes. Use either center-weighted, Evaluative, or Matrix metering, then start by choosing the aperture (f-stop). As explained earlier on page 22, use a small aperture ($f/16$ or $f/22$) to get everything in focus, and a large aperture ($f/2.8$ or $f/4$) to isolate your subject and throw the background out of focus. The camera will automatically set the shutter speed. Note that small apertures may result in slow shutter speeds, so use a tripod.

Then take a picture and look at the histogram. In most situations this will look fine. Great—you're done! But if the histogram is shoved too far left or right, use the exposure-compensation dial. If the first image is overexposed—you see pixels pushed up against the right side of the histogram, or you see the "blinkies"—you'll have to dial in "minus" compensation. Try 1.0 to start with. If the image looks underexposed—perhaps you see pixels pushed up against the left edge of the histogram, but there's plenty of room on the right side—you should dial in "plus" compensation. Try +1.0 at first, and keep making adjustments until you get it right. When you're done, be sure to set the exposure compensation back to zero!

2

What About Bracketing?

Many photographers think that bracketing will
solve all their exposure problems. But this scattershot
method can still completely miss the mark. I've found
many situations where the camera's meter indicated
an exposure two or three stops lighter than the correct
one. So with three bracketed shots, each one stop
apart, the darkest image would still be too light. If you
bracket, you must still check the histograms and make
sure that at least one image is exposed correctly.

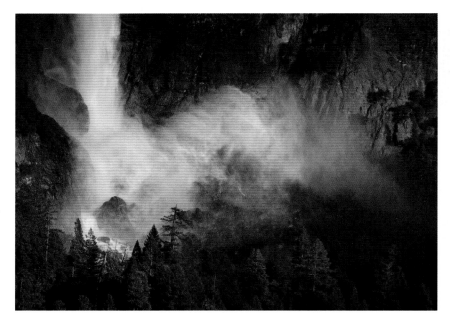

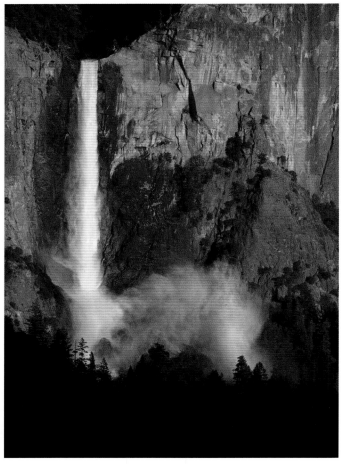

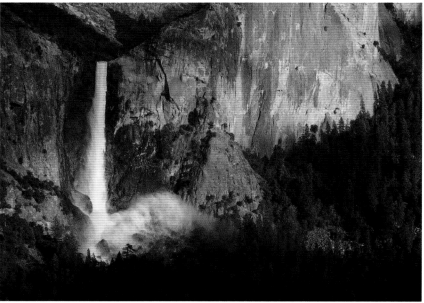

Consistency With Manual Exposures

I manually set an exposure of 1/125 sec at $f/5.6$ (with a polarizer at 100 ISO) for this sequence of Bridalveil Fall. I knew that as long as the light didn't change, and all the photographs included the same highlight—the waterfall—then the exposure would remain the same. This allowed me to concentrate on composition and timing without thinking about camera settings. Any automatic mode would have required continually adjusting the exposure compensation dial as I zoomed in and out. For the close-up of the base of the fall I might have needed plus compensation, as the frame is predominantly light, while the large dark area at the bottom of the vertical image might have led the camera's meter to overexpose the picture, requiring minus compensation.

Manual Exposure with Center-Weighted Metering

Set your camera to manual mode and use either center-weighted, Matrix, or Evaluative metering. As with aperture-priority automatic, you should set the f-stop first to control depth of field. Once again, use a small aperture ($f/16$ or $f/22$) to get everything in focus, a large aperture ($f/2.8$ or $f/4$) to isolate your subject and throw the background out of focus.

Next, set the shutter speed. Most cameras have a scale indicating over- or underexposure. Just rotate the shutter speed dial until the scale shows zero. If the shutter speed ends up being slow, use a tripod.

Then take a picture and look at the histogram. Again, in most cases the histogram will look fine. But if the histogram indicates over- or underexposure, or if you see the "blinkies," you'll have to adjust the shutter speed. Don't change the aperture—you already chose this based on depth of field.

If the first image is too light—you see pixels pushed up against the right side of the histogram, or the "blinkies"—use a faster shutter speed. If you started with 1/125 sec, for example, go to 1/250 sec (a faster shutter speed means less light reaching the sensor, a darker image, and, you hope, a better histogram). If the image looks too dark—perhaps you see pixels touching the left edge of the histogram, but there's plenty of room on the right side—use a slower shutter speed. If you started with 1/125 sec, go to 1/60 sec. Keep adjusting the shutter speed until you're satisfied.

Both of these approaches—aperture priority and manual—are similar. If so, is there any reason to use manual mode? Yes! First, when using aperture priority (or any automatic mode), most cameras only allow exposure compensation up to two stops. Sometimes this is not enough, and the only solution is to switch to manual.

Second, manual mode ensures consistent exposures for different compositions of the same scene. With automatic modes, the exposure changes as you move the camera because the meter reads different areas of light and dark. In a wider view, the image might be evenly balanced between sun and shade, while a tighter composition might be mostly shade, causing the camera to lighten the exposure to "compensate" for the dark scene. But if the light hasn't changed, the exposure shouldn't either! Manual mode can eliminate a lot of fiddling with the exposure-compensation dial.

Manual settings are also essential for stitching together panoramas or expanding depth of field by combining multiple images in software. In both cases it's vital to maintain consistent exposures between images.

The Zone System

In 1940, Ansel Adams, along with his fellow instructor at the Art Center School in Los Angeles, Fred Archer, developed the Zone System. Photographers had long known that they could alter the contrast of a negative by changing the development time: shorter development lowers contrast; longer development raises contrast. Adams and Archer were the first to quantify this and relate it to exposure. They created a precise procedure for evaluating the light and dark values of a scene, visualizing the finished photograph, exposing the negative, and developing that negative to hold the contrast the photographer visualized.

This system is still perfectly valid when using black-and-white film today, but how does it relate to digital photography? There's a fundamental rule in digital imaging: it's easy to increase contrast, but difficult or impossible to decrease it. So, if an image looks too flat, it's easy to add more punch later in software. But if the scene has too much contrast—if it exceeds the dynamic range of the camera—then part of the image will either become pure black or pure white.

If you need detail in both highlights and shadows in a high-contrast scene, you're not totally out of luck. Later, on page 50, we'll examine some methods of combining two or more separate exposures to expand the dynamic range. But for now let's assume that your contrast range is fixed. Is the Zone System still useful? Yes, as a way of setting your exposure quickly and accurately. The exposure methods I've described so far involve some trial and error. The Zone System will lead you to the perfect exposure more quickly. With practice you should get the right exposure on your first try at least 90 percent of the time.

To use the Zone System you have to have a spot meter and use the camera in manual mode. The spot meter can be hand-held or built into the camera, but either way, the smaller the spot, the better.

The Zones

Adams and Archer's original Zone System had eleven zones, zero through ten, but with digital cameras we are mostly concerned with zones three through seven. Looking at the accompanying chart, start in the middle at Zone 5. This represents a mid-tone in the scene. Anything one stop darker would render as Zone 4, two stops darker Zone 3, and so on. Anything one stop lighter is Zone 6, two stops lighter Zone 7, etc. Anything at Zone 2—three stops below middle—is too dark to show detail, while Zone 3, although dark, has detail. Anything at Zone 8—three stops above middle—is too light to show good detail, while Zone 7, although light, has detail.

For color photographs you must consider color, not just detail. A light color will lose saturation beyond Zone 6. Although it will still have detail at Zone 7, the color will be pale. And a dark color can't go below Zone 4 without becoming muddy.

"I have found that the Zone System is invaluable in color photography, primarily in relation to exposure, but of course its application poses very subtle considerations."
—Ansel Adams

Zones and Histograms

This diagram shows approximately how each zone relates to a histogram. Pixels pushed up against either the right or left edge indicate that parts of the image are beyond the range of the histogram. The spike at the right-hand edge of this histogram indicates pixels that are overexposed— Zone 8 or higher. Overexposed pixels like this are the main thing to look out for and avoid when judging exposure with a histogram. Anything at the far left edge of the histogram is Zone 2 or lower—black.

Zone 0
Pure black

Zone 1
Nearly black

Zone 2
A hint of detail

Zone 3
Dark, with good detail but muddy color

Zone 4
Dark tone or color

Zone 5
Middle tone, medium color

Zone 6
Light tone or pastel color

Zone 7
Light, with texture but faded color

Zone 8
A hint of detail, but essentially washed out

Zone 9
Nearly white

Zone 10
Paper white

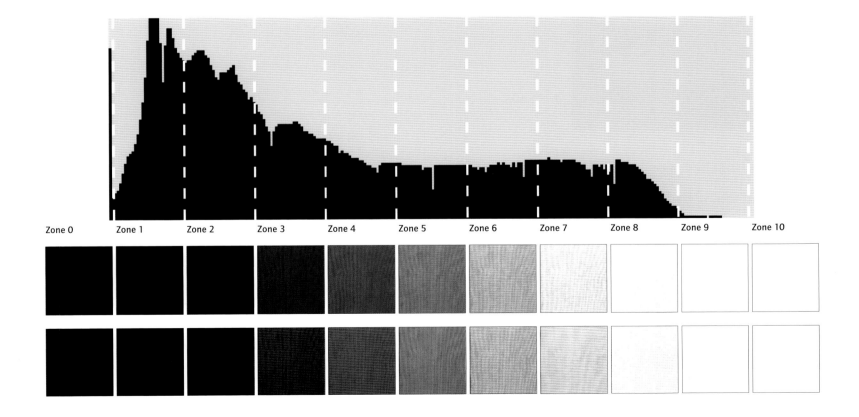

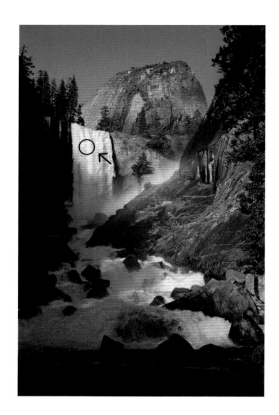

White Subject

The sunlit waterfall is clearly the most important highlight in this photograph. A spot meter reading off the white water indicated 1/125 sec at ƒ/11. Anything white or nearly white, like this waterfall, is a perfect candidate for Zone 7, so I opened the aperture two stops to ƒ/5.6, placing the water on Zone 7—light, but not washed out. (An in-camera spot meter should indicate +2, or two stops of overexposure, for Zone 7, as shown here.) Note that because I wanted to freeze the motion of the waterfall, and depth of field was not a concern, I left shutter speed high and changed the aperture instead.

Light Color

The most important highlights here are the lighter tones of the tree. The very brightest spots were too small to meter, but the circled area looked like a perfect Zone 6. The meter indicated 1/15 sec at ƒ/16, so I slowed the shutter speed to 1/8 sec to place the tree at Zone 6. (An in-camera spot meter should indicate +1, or one stop of overexposure, for Zone 6.) Here the subject was still, the camera was on a tripod, and I needed to keep everything in focus, so I kept the aperture at ƒ/16 for depth of field and changed the shutter speed.

The Zone System for Digital Cameras

The simplest approach to the Zone System concentrates on highlights and ignores shadows. Start by picking the most important highlight—not a tiny spot, nor something that lacks detail. Pick the brightest significant part of the scene that needs to have detail and texture.

Then decide what zone that highlight should be. If that sounds hard, it's not, because there are only two choices. Zone 5 isn't a highlight, it's a midtone. Zone 8 is washed out—too light for an important highlight. So that leaves Zone 6 or Zone 7. Use Zone 7 for objects that are white or nearly white, like white water, snow, light sand, or very light rock. Use Zone 6 for any other highlight, including tans,

yellows, light greens, or something that you would describe as a light or pastel color.

Next, take a spot meter reading from the highlight you've picked. Make sure the whole spot is filled with a consistent tone; you don't want a mixture of light and dark areas. A very small, narrow-angle spot meter is invaluable. If you're using your camera's built-in meter, try zooming in or changing to a longer lens. When using a hand-held meter make sure you compensate for filters. Add one-and-a-half to two stops of light for a polarizer, or hold the filter up against the meter and take readings right through it.

To make the highlight Zone 6, increase the exposure by one stop from your meter reading. To make it

Zone 7, increase the exposure by two stops. If you don't do this—if you just use the meter's recommended settings—the highlight will render as a middle tone, or Zone 5. So you need to lighten the image to make that highlight Zone 6 or Zone 7. For example, if the meter indicates 1/125 sec at ƒ/16, lower the shutter speed to 1/60 sec to make that highlight Zone 6, or 1/30 sec to make it Zone 7.

You actually don't need to make these calculations with an in-camera spot meter. While pointing the meter at the highlight, just turn either the shutter speed or aperture dial until the exposure scale indicates two stops of overexposure for Zone 7, or one stop of overexposure for Zone 6.

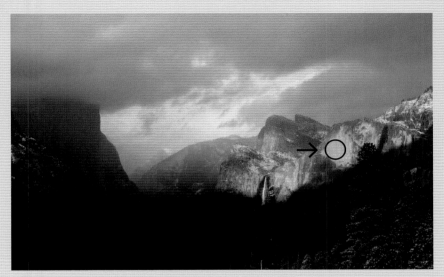

Sunset Color

The golden cliffs are not the brightest things in this photograph, but they are clearly the focal point. Sunrise or sunset color on mountains should almost always be placed at Zone 6. After making an exposure I checked the histogram to make sure that the white clouds weren't overexposed.

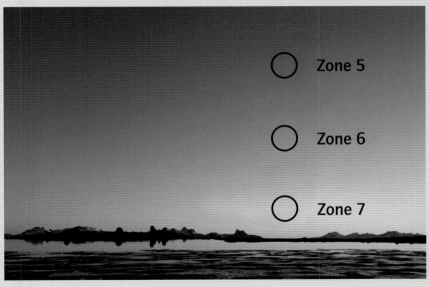

○ Zone 5

○ Zone 6

○ Zone 7

Small Highlight

If the highlights are too small to meter, see if you can move in closer. Here the critical highlights were the white flowers. Even with a one-degree spot meter I couldn't fill the spot's circle with just one blossom from the camera position, but it was easy to move in closer and meter off just one petal, then place that white subject on Zone 7.

Sky

It's difficult to meter skies because they vary so much. Near the horizon, a dusk sky like this should usually be placed on Zone 7; higher up it becomes Zone 6, Zone 5, or lower.

Mt. Williamson, Sierra Nevada, from Manzanar, California, 1945 by Ansel Adams

These mountains, lit from behind, form almost abstract shapes, much like Minor White's famous Grand Tentons (1959) image. There is a strong emotional and even spiritual quality in evidence in this shot.

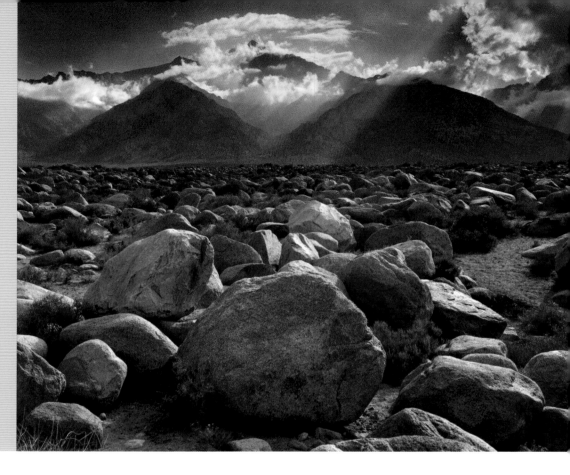

Expanding and Contracting the Contrast Range

Minor White began teaching with Ansel Adams at the California School of Fine Arts in San Francisco in 1946. When Adams explained the theory of the Zone System to him he thought, "Why didn't I think of that?—It's so easy! And so that afternoon I started explaining the Zone System to people."

He went on to teach the Zone System to generations of photographers in San Francisco, at the Rochester Institute of Technology, and MIT. His students included Paul Caponigro and Jerry Uelsmann. He combined the practical techniques of the Zone System with meditation and hypnosis to help his students "see."

The heart of the traditional Zone System is the ability to expand or contract the contrast range of the negative—to increase contrast and add impact to flat, low-contrast images, or reduce contrast to hold detail in both highlights and shadows in high-contrast scenes.

With black-and-white film, the Zone System mantra is, "Expose for the shadows, develop for the highlights." In other words, after determining the correct exposure for the most important shadows, you develop the negative

Effect of Expansions

Normal development	1 2 3 4 5 6 7 8						
N + 1 development	1 2 3 4 5 6 7						
N + 3 development	1 2 3 4 5						

Effect of Contractions

Normal development	1 2 3 4 5 6 7 8
N – 1 development	1 2 3 4 5 6 7 8 9
N – 3 development	1 2 3 4 5 6 7 8 9 10 11

Increasing contrast with levels or curves

Zones	1	2	3	4	5	6	7
Low contrast image				4	5	6	7
Slight contrast increase			4	5	6	7	
Greater Contrast increase	4	5	6	7			

Combining multiple images to reduce contrast

Three exposures, one stop apart, capture seven zones of detail

First exposure

Second exposure

The three frames are compressed with software into the usable range of zones 3 through 7.

1 2 3 4 5 6 7
1 2 3 4 5 6 7

An Adaptation of Minor White's Diagram for Expansion and Contraction in the Zone System

Expansion and Contraction for Digital Cameras

to control how light the brightest highlights are. Reduced (minus) development will bring highlights that would otherwise be overexposed down into usable territory like Zone 7. Increased (plus) development will push a dull highlight that would normally be at Zone 5 or 6 into the more brilliant range of Zone 7 or 8. Shadows are relatively unaffected by changes in development.

The first diagram (above, left) was adapted from one created by Minor White as an aid for teaching the Zone System. The diagram shows the effects of contraction—reducing contrast through less-than-normal

development—and expansion—increasing contrast through greater-than-normal development. Contraction brings areas that would normally be Zone 9, 10, or 11 down to Zones 7 and 8. Expansion pushes objects that would normally fall at 5, 6, or 7 up to Zone 7 or 8.

Digital cameras require the opposite approach: exposing for the highlights and developing for the shadows. "Developing" in this case means either increasing contrast with curves or levels, or decreasing contrast by combining exposures with Photoshop or HDR software. The second diagram adjusts White's concepts for digital cameras.

Using the Zone System to Combine Multiple Images

First, make sure the camera is on a sturdy tripod to avoid camera movement between frames.

Then, start by spot-metering the brightest highlight. Place this at Zone 7 (overexpose by two stops from the indicated meter reading). Take the picture and check the histogram. The brightest pixels should be near, but not touching, the right edge of the histogram. If not, adjust either the shutter speed or aperture until the histogram looks right.

Then check the left edge of the histogram. If no pixels are pushed up against the left edge, that means you have detail in the shadows, and you don't need to do anything else. But we'll assume that this is a high-contrast scene, and that some pixels are touching the left edge. You could now spot meter the darkest shadows to determine how much darker they are than the highlights. But it's simpler to just make another exposure one stop lighter than the first one, and check the histogram again. If you still see blocked shadows, make another exposure one stop lighter, and another, and so on, until you see space between the darkest pixels and the left edge of the histogram. You've then captured detail in both highlights and shadows, plus a full range of tones in between.

You could use 1⅓ stop intervals, or 1½ stops. Two stops is probably too far apart; the ideal interval between exposures for an HDR merge is usually between 1 and 1½ stops.

Auto-bracketing is usually too scattershot to be a serious tool, but when combining exposures it can actually be useful to avoid subject movement. Fast-moving clouds, for example, can change position substantially between exposures when bracketing manually, and this slight misalignment can cause headaches when trying to combine these images later with HDR software. But with auto-bracketing you can take five images in less than a second, minimizing the movement between frames. Just make sure that at least one image has highlight detail and one has shadow detail.

1
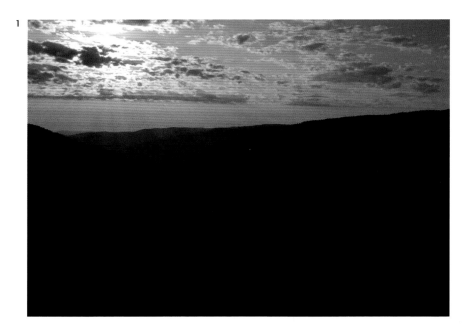

2
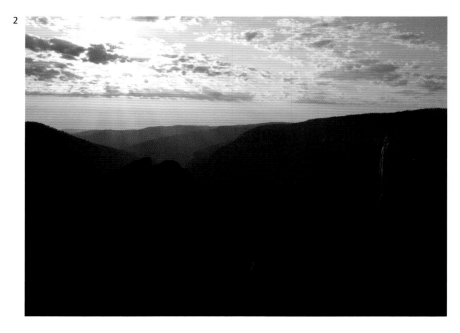

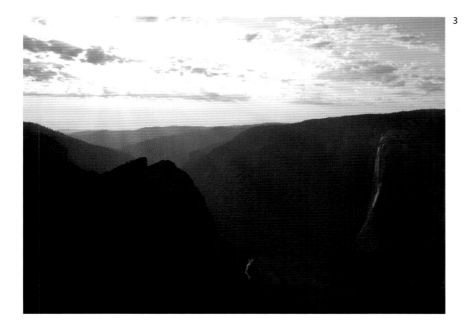

3

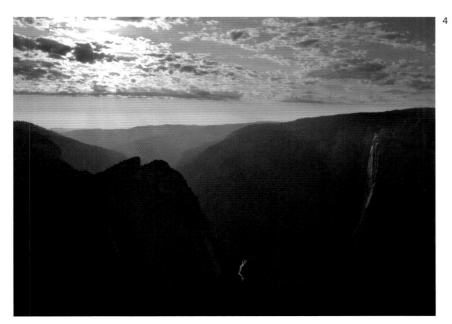

4

Photoshop Blend

The three original files (1-3) from this very high-contrast scene were manually combined in Photoshop using layer masks (see page 142). Each exposure was one stop apart. I allowed the bright clouds near the sun to become washed out—the brightest spots are probably Zone 10 in the final image (4)—to retain a sense of brilliance. Overexposed highlights usually look unnatural, but there are exceptions: the sun itself, reflections of the sun in water or glass, and bright clouds next to the sun.

1

2

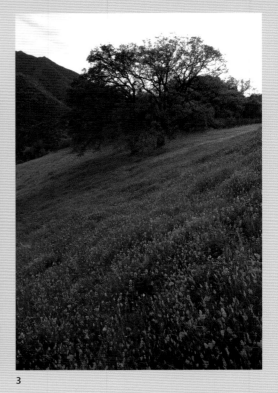

3

Photomatix Exposure Blend

I would never consider photographing this scene with color film—either the sky would be washed out, or the flowers would become dark and muddy. Here, with a digital camera locked firmly on a tripod, I made four exposures (1-4), each one stop apart, making sure the darkest image had detail in the bright clouds, and the lightest had good color in the foreground. Then I combined the four frames (5) using the Exposure Blending mode in Photomatix HDR software (see page 138).

In the darkest original (1), the brightest clouds are at Zone 7, and the flowers are six or seven stops lower—about Zone 0 or Zone 1. Some objects, like the tree trunks, are even darker. In the final image (5) the tree trunks were brought up to Zones 2 and 3 and the flowers to about Zone 4½, while the sky remained Zone 7. This extreme tonal compression is actually beyond the capabilities of the traditional Zone System. Aside from the fact that this image is in color, the highly reduced development needed

to retain detail in both the clouds and the foreground here would have flattened the local contrast, and the flowers would have looked dull look and unnatural. Here, the tonal compression is only taking place in the top third of the image. The bottom two-thirds of the final image is made entirely from the lightest original exposure, and I actually increased the contrast in this area when adding the finishing touches to this photograph.

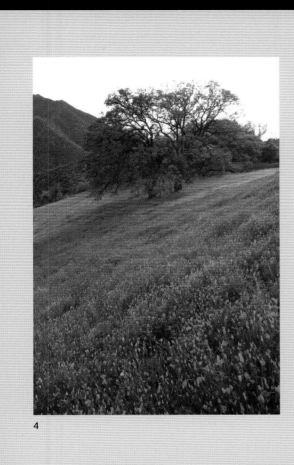

4

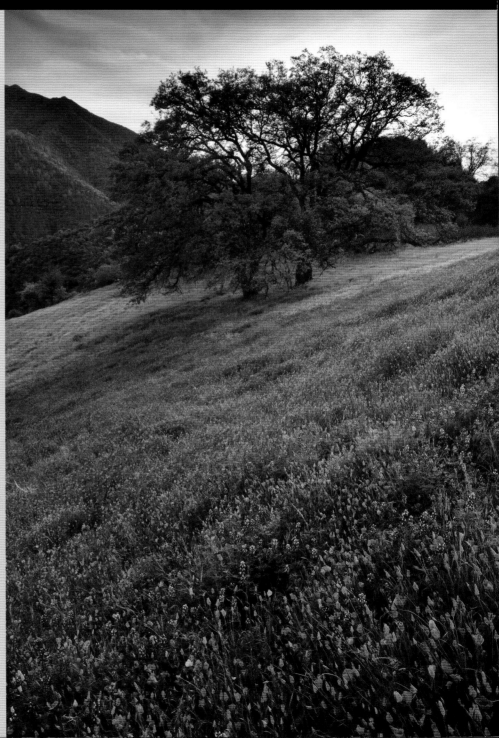

5

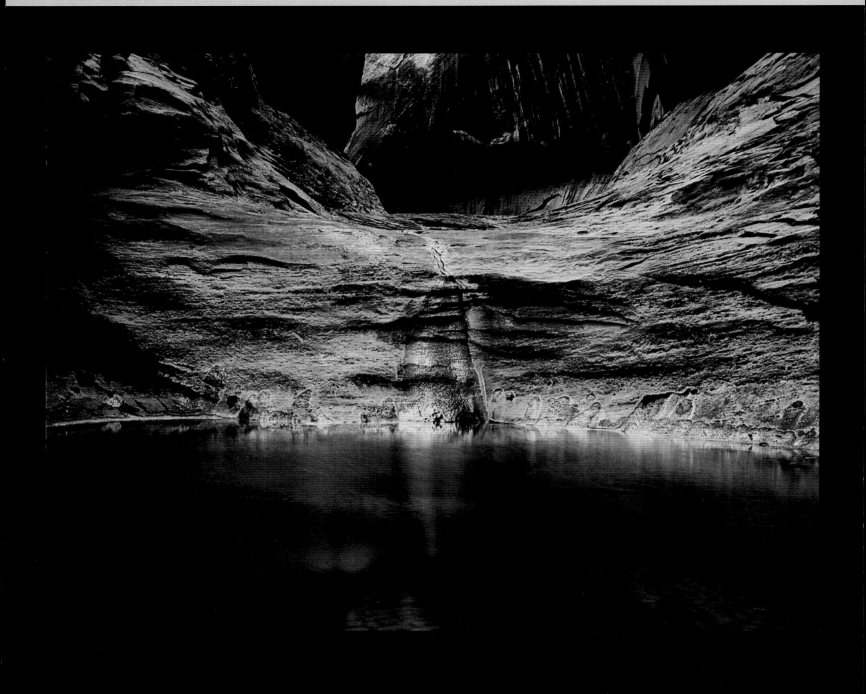

**Pool in Mystery Canyon,
Lake Powell, Utah,
by Eliot Porter**

Eliot Porter taught generations of
color photographers how to see the
landscape. He took the principal
limitation of his transparency film,
its high contrast, and turned it into
an advantage by focusing on intimate
scenes and emphasizing subtle colors
and patterns.

Porter was one of the first people
to consciously use photography to
promote conservation. This image,
Pool in Mystery Canyon, was originally
published by the Sierra Club in *The
Canyon No One Knew*, about Glen
Canyon, in 1963. Construction of the
dam that would fill the canyon began
in 1956, and finished in 1966. The
poignancy of this book, coupling
Porter's beautiful images with the
knowledge that all the scenes he
depicted would soon be drowned
by the rising waters of Lake Powell,
helped spur the conservation
movement into more vigorous action
to prevent such tragedies in the
future. In all, Porter published five
books with the Sierra Club and helped
put conservation into the mainstream
of political conversation.

*"The essential quality of a photograph is the emotional
impact that it carries."*
—Eliot Porter, 1987

Technique, while important, is only a first step.
Mastering exposure and depth of field will help convey
your idea, but you have to have an idea to convey in
the first place. As Ansel Adams said, "There's nothing
worse than a sharp image of a fuzzy concept."

Light

Edward Weston said, "The most important element
with which the photographer must deal is light.
Camera, lens, film, developer, and printing paper have
but one purpose: to capture and present light. Yet for
all its place of importance in the photographic scheme,
light is too often unknown, unstudied, and abused by
photographers today."

It may seem obvious that landscape photography
requires an appreciation of light, yet how many of us
have really studied it? Weston once advised a friend
to "go out with his camera and study light at first hand:
To see what it does to familiar and unfamiliar objects—
a tree, a face, a cloud, or a cloudless sky. To look at the
same scene at every hour of the day—not glance—but
look with understanding, until he learned to see objects
in terms of their light quality." His son Brett put it more
succinctly: "If you've no sense of light, you may as well
forget about it."

Composition

For many photographers, no aspect of photography is more difficult than composition. Perhaps for that reason, people have tried to create rules for composing photographs. But the landscape masters of the past were unanimous in their disdain for such formulas. "To consult the rules of composition before making a picture is a little like consulting the law of gravitation before going for a walk," said Weston.

While rules (maybe guidelines would be a better word) can be helpful in some situations, the world is too complex for any rule to apply in all situations, but there is one principal that always applies: simplicity. The best compositions contain only the essentials of the scene or subject, and nothing extra. Or, to quote Weston again, "To compose a subject well means no more than to see and present it in the strongest manner possible."

Good compositions almost always have something else in common: a strong, abstract design. Too often photographers become trapped into thinking in terms of subjects rather than designs. When photographing a tree, for example, many photographers approach the scene with a pre-formed mental image of what a tree is supposed to look like, instead of seeing the unique qualities of the particular tree they're photographing. As Ansel Adams said, "The photographer should not allow himself to be trapped by something that excites him only as subject; if he does not see the image decisively in his mind's eye, the result is likely to be disappointing."

Mood

Ultimately, the best photographs are not just interesting, or even beautiful—they capture a mood or feeling. They evoke a reaction in the viewer. Adams felt that the photographer had to respond to a subject before the viewer could: "I have made thousands of photographs of the natural scene, but only those visualizations that were most intensely felt at the moment of exposure have survived the inevitable winnowing of time."

Adams' unique ability to capture the grandeur and mood of the American landscape cemented his place in photographic history, and in the hearts of millions of viewers. His best images convey the monumental quality of mountains or deserts, but also capture the feeling of a particular moment when the light, clouds, and weather were just so.

To infuse your own photographs with mood, you must pay as much attention to light and weather as Adams did, and use every possible visual tool—line, shape, pattern, tone, color, movement, exposure, and depth of field—to emphasize the feeling you're trying to convey.

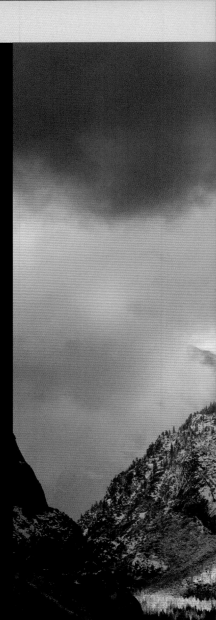

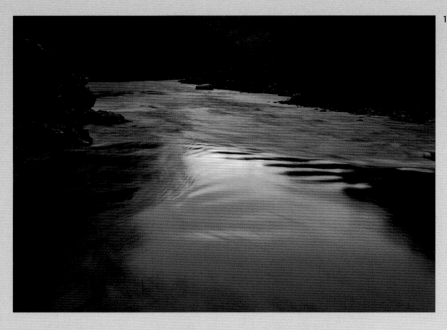

1

Light

"It cannot be too strongly emphasized that reflected light is the photographer's subject matter. Whether you photograph shoes, ships, or sealing wax, it is the light reflected from your subject that forms your image."
—Edward Weston

We don't photograph objects. We photograph the light reflected from objects. A great subject with poor light makes a poor photograph. An ordinary subject— one that most people wouldn't notice—can make a great photograph with the right light. Landscape photographers must become fluent in the language of light.

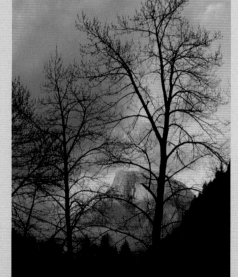

2

Directing the Eye

1 Bright Spots

Look at this photograph from the Grand Canyon. What draws your eye? If you said the center of the image, you're not alone. Bright spots attract attention, while our eyes—and brains—tend to ignore dark areas.

2 Warm Colors

Warm colors like red, orange, yellow, and magenta also grab attention. In this image, although Half Dome is no brighter than the blue sky, it draws the eye because of its warm color.

3 Visual Conflict

When the brightest spot in the photo is not the main subject—not what you want people to look at—you have a problem. The sunlit area in the upper-left portion of this image (3A) draws attention away from the main subject, the waterfall. The result is a visual conflict between the waterfall and the sunlit cliff.

Faced with such a conflict, you come back when the light is better, or try a different composition. In this case (3B) I used a longer lens and juxtaposed the bottom of the waterfall with the sunlit tree. Now the two main subjects stand out clearly against darker surroundings and don't compete with other bright spots.

4 Dark Spots

The exception to this rule—that bright spots attract attention—is when most of a photograph is light. Then any contrasting dark area attracts the eye. These tufa towers at Mono Lake stand out against brighter surroundings.

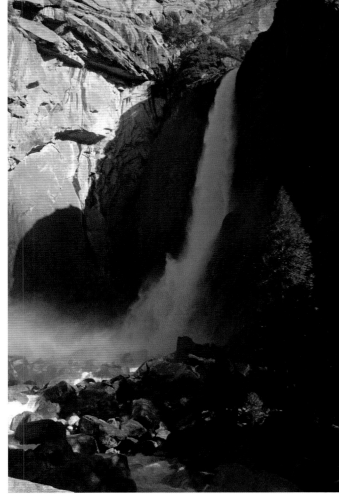

3A

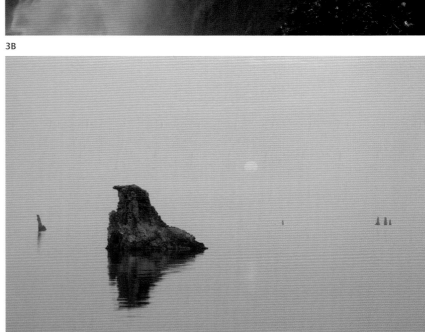

3B

4

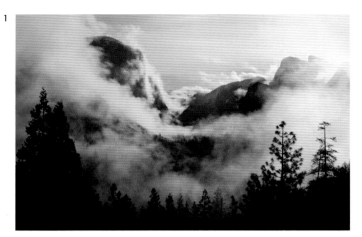

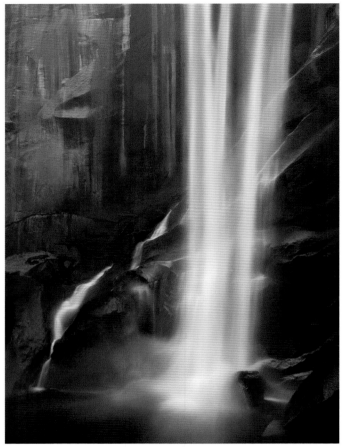

1 & 2. **Contrast**

A photograph can have light-and-dark contrast, color contrast, or both, but with little contrast it will look flat and uninteresting. This image from Tunnel View in Yosemite (1) has strong light-and-dark contrast, but little color, while the wildflowers (2) have vivid color contrasts, but no bright highlights or dark shadows.

3. **Seeing in Black and White**

Some photographers see the world in black and white, while others are drawn to color. Few do both well. Eliot Porter understood this: "When Ansel Adams photographs something, he sees it as a black-and-white image right away, and so he photographs it that way. I see it as a color image right away."

Adams is known for creating prints with a rich, full range of tones, from deep black to brilliant white. This contrast helps convey the drama that his images are famous for. But his images aren't harsh. The areas of pure black or white are usually quite small, with a full spectrum of grays in between. As Adams said,

"Marvelous effects are possible within a close and subtle range of values."

Making good black-and-white photographs requires visualizing the relationships between lighter and darker tones. The most effective images often use a clear juxtaposition of light against dark or dark against

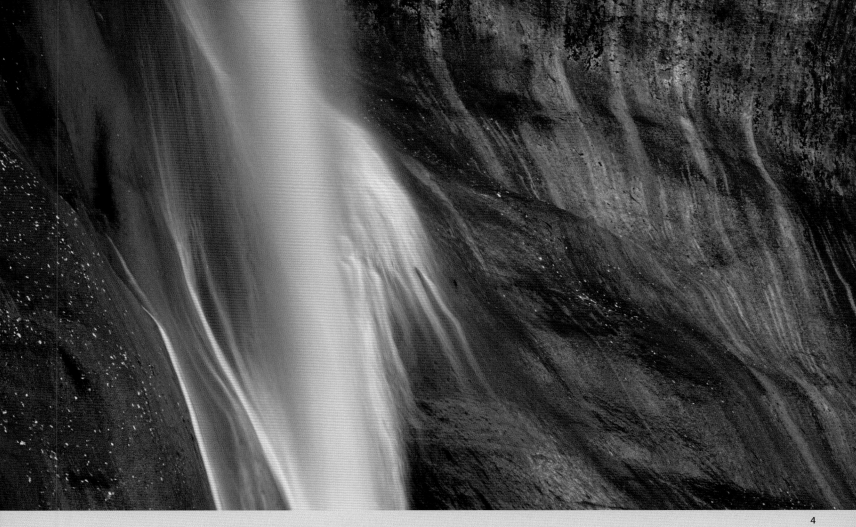

4

4. Seeing in Color

light, as in this image of Bridalveil Fall (3). But notice that there's little pure black or pure white in this photograph. Most of the tones range from dark to middle gray, with some light grays in the waterfall.

Photographers who "see" in color often find colorful subjects, then build compositions around them. They make color the subject of the photograph. Subtle colors often work as well as rich, saturated ones. This image of Calf Creek Falls in Utah lacks vivid reds or yellows, but its rich and varied palette adds contrast and texture, and the photograph would

clearly be less effective in black and white.

While compositions can be designed around color, a random arrangement of hues won't work—you have to find a way to create order. Here the parallel lines in the rock and waterfall help to organize the color palette into a coherent whole.

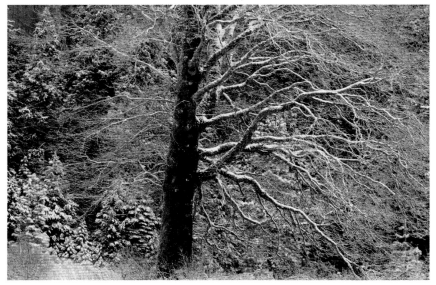

The Four Basic Types of Light

Soft Light

*"I began to see the effect of available light on my
subjects, either from a clear blue or from an overcast
sky, and I began to recognize that direct sunlight
was often a disadvantage, producing spotty and
distracting patterns"*
—Eliot Porter, 1987

Porter was one of the first people to recognize what
many photographers have realized since: that soft light
is often the best complement to colorful subjects. When
there's no direct sunlight in the scene, the light is soft
and diffused, striking the subject more or less evenly
from all directions. Since the light itself won't provide
contrast, the subject must have its own. This is great
light for flowers, autumn leaves, or anything colorful.

Forests often present a chaotic array of trunks,
branches, and leaves. Shade or overcast conditions can
simplify these scenes, but only if bright patches of sky
are kept out of the frame. As Ansel Adams pointed out,
"One problem with forest scenes is that random blank
areas of sky seen through the trees can confuse the
spatial and tonal continuum of the composition. In
reality such interruptions are logical and accepted,
but in a photograph they can be extremely distracting.
The sky is usually much brighter than foliage, and these
bits of blue sky can be considerably overexposed and
blankly white." Telephoto lenses can help to narrow
the focus of the composition and crop out the sky.

Soft Light and Color

While sunlight can overwhelm color,
soft light seems to make colors glow,
as in this image of redbud and oak
trees (top).

Subtle Color

Colors don't need to be intense to
be effective. Soft light can bring out
the subtle, nuanced colors in subjects
like this snow-covered oak tree.

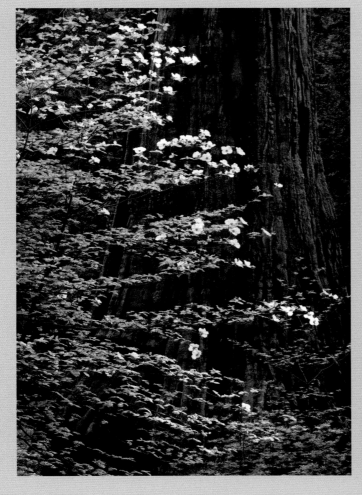

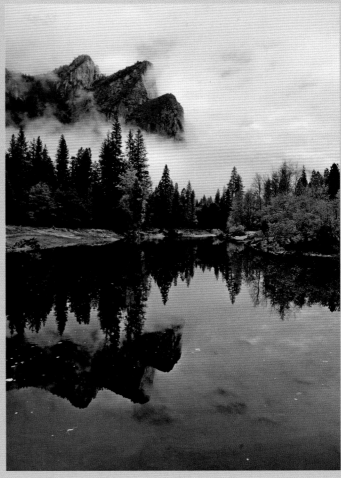

Simplification

Forest scenes are often chaotic, and splotchy sunlight filtering through the trees just adds to the confusion. Soft, late-day shade simplified this busy scene of a dogwood and giant sequoia.

Big Subjects

Soft light usually works best with medium or small subjects. It's difficult to photograph big, sweeping landscapes on an overcast day, because these scenes often need the punch provided by sun and shade, and bright, washed-out skies can be distracting. This photo of the Three Brothers is a rare exception. It works because there's contrast, including color contrast, and the sky is not completely blank.

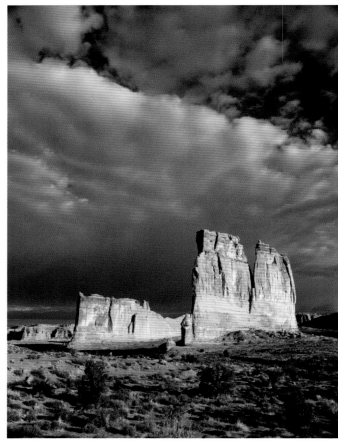

Frontlight

Frontlit Color

Putting the sun at your back creates even lighting—much like soft light—as shadows fall behind objects. This uniform illumination can be too flat for many scenes, but it works well for colorful subjects, like these poppies and goldfields. The shadows here are small, and touches of black help set off the colors.

Quartering Light

Direct frontlight is often too flat, but putting the sun at a slight angle—over the shoulder instead of directly behind you—can introduce shadows and create contrast and texture, as in this scene of the Courthouse Towers in Arches National Park, Utah. Note the shadows raking diagonally across the foreground and outlining the left sides of the rock formations.

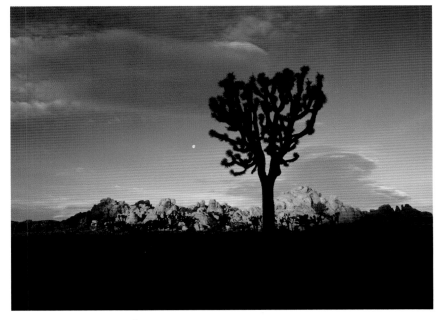

Frontlit Silhouette

We usually associate silhouettes with backlight, but one of my favorite types of light is the frontlit silhouette. This situation can occur anytime the sun is at your back but an object in the foreground is shaded. In this scene from Joshua Tree National Park, the morning sun was striking the clouds and rock formations, but hadn't yet reached the foreground Joshua tree.

Sidelight

Texture and Form

Sidelight, with the sun raking across the scene from the left or right, can be exquisite, especially when the sun is low in the sky. It can accentuate the texture, roundness, or three-dimensional form of an object. In the image of Yosemite Falls, sidelight brings out the texture of water and rock, while it highlights both the texture and form of the sand dunes in Death Valley.

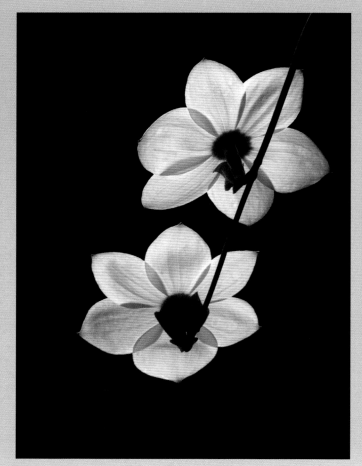

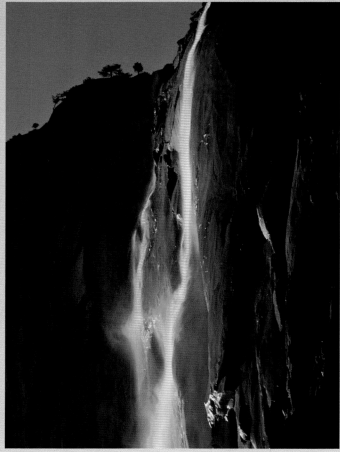

Backlight

Many people avoid backlight. Perhaps they once owned an Instamatic camera and took to heart the words in the little instruction pamphlet: "Always photograph with the sun at your back."

Please ignore that advice and look into the sun. Backlight is too interesting to avoid. Yes, exposures can be difficult, and lens flare problematic, but when it works it's beautiful.

Translucence

Translucent subjects seem to glow when lit from behind, especially when placed before a dark backdrop. For these dogwood blossoms I found some shaded trees to use as a background, and used a 200mm lens to narrow the angle of view and avoid including bright patches of sunlight.

This photograph of Horsetail Fall in Yosemite (right) uses the same principle—a translucent, backlit subject against a dark background. For only about one week every year this fall is lit by the setting sun while the cliff behind it is in the shade, creating that perfect backdrop.

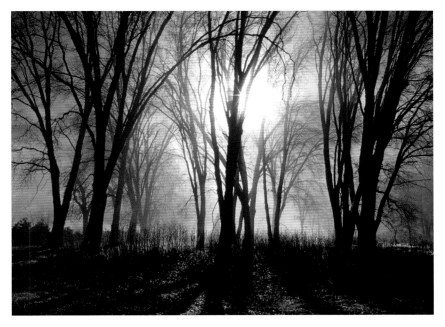

Silhouettes

Backlight can also create silhouettes. This is almost the opposite concept: instead of putting something translucent against a dark background, you set something opaque against a light background. Since the silhouetted subject is usually black, or at least dark, it must have interesting lines or shapes, like the spreading forms of these oak trees.

Lens Flare

Pointing the camera toward the sun can create lens flare—bright spots, streaks, hexagons, or an overall washed-out look. If the sun is outside the frame, just stick your hand out and shade the front of the lens to make these artifacts disappear. Of course, be sure to keep your hand out of the picture! It's difficult to hold the camera with one hand and shade the lens with the other, so use a tripod.

It's possible to keep the sun in the frame, but you have to hide it behind something, like a tree, rock, building, or mountain. Try to catch just the edge of the sun poking out from behind the object to add a bright focal point, but keep most of the sun hidden to avoid flare. A small aperture ($f/16$ or higher) can create rays around the sun.

In this image of Half Dome and the Merced River I positioned the sun behind a tree to avoid flare, and used a small aperture ($f/22$) to create the rays radiating out from the bright point of light. This photograph has both silhouettes (Half Dome and the trees) and translucence (the mist and yellow leaves).

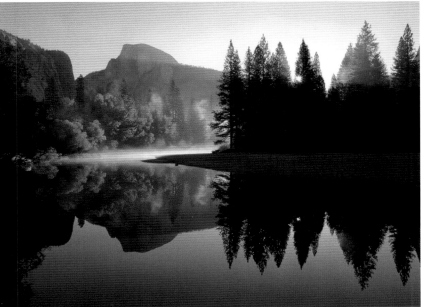

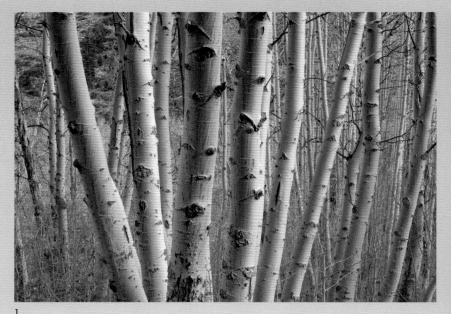

1

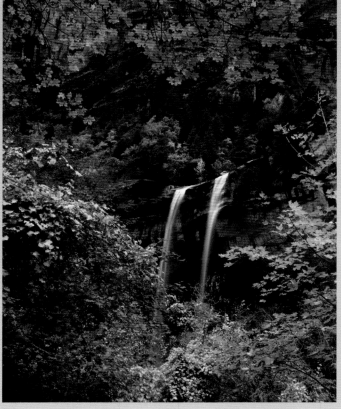

2

Beyond the Basics: Subtleties of Light

"The possibilities of natural light are so infinitely great they can never be exhausted. In a lifetime you could hardly exhaust all of the light-possibilities for a single subject, and the world is over-crowded with subject matter as yet untouched by the camera."
—Edward Weston

Soft Light with Direction

Soft light isn't uniform, or perfectly even—it's always stronger from one side. I photographed these aspen trunks (1) after the sun had passed below a ridge to the west—to the right as you look at this image. Full sunlight would have been too harsh for this scene, but soft sidelight kept the contrast low while still emphasizing the roundness and smooth texture of the trunks.

Under an overcast sky, more light strikes the top of an object than the bottom. In this photograph from

Emerald Pools in Zion National Park (2), I pointed the camera up slightly so that the trees were softly backlit. The translucent leaves glow with the light coming mostly from behind, but the contrast under overcast skies didn't overwhelm the scene.

Use directional soft light the same way you would use its harsher sunlit cousins: soft frontlight for color contrasts, soft sidelight to show texture and form, and soft backlight for translucent objects.

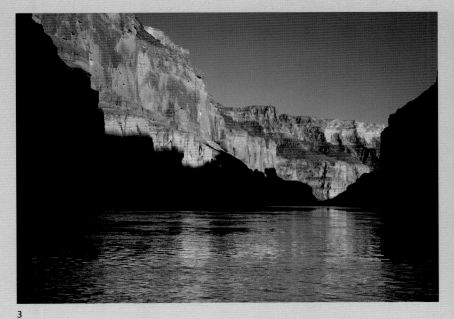

3

4

Reflections

"In rills and puddles, water also reflects the sky, giving some marvelous effects in surroundings of quite a different color."
—Eliot Porter

The best reflections show sunlit objects reflected in shaded water. Sunlight glaring on the water's surface kills reflections. Look for mountains, hills, or trees that catch late sunlight after the water below has slipped into shadow (or the opposite in the morning).

Smooth, mirror-like water is great, but not essential. Ripples, reflecting a kaleidoscope of hues, are often more interesting. A fast shutter speed freezes this wave pattern, while a long exposure can blur the water's surface into a beautiful sheen.

The first from the Grand Canyon (3) shows shaded water reflecting sunlight cliffs and sky. In this case the textured water is more effective than a smooth mirror. The second photograph, from the east side of the Sierra Nevada (4), depicts sunlit aspen trees reflected in a creek. Here a slow shutter speed smoothed the water's ripples.

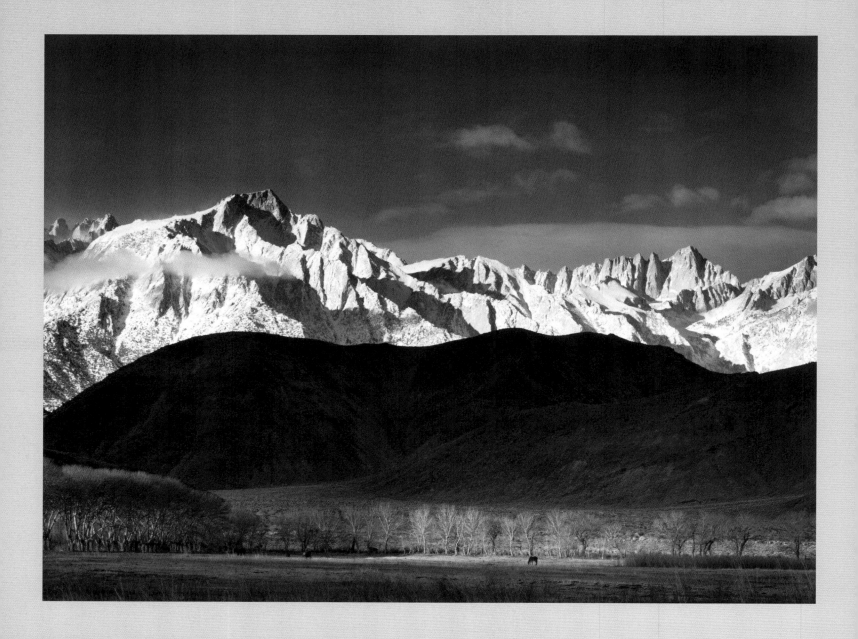

Chiaroscuro

Chiaroscuro is an art term used to describe dramatic contrasts between light and dark; Rembrandt was the most famous practitioner. In landscape photography, broken sun and clouds can create chiaroscuro.

Sunbeams highlight some landforms, while others are thrown into shadow, forming contrast even with the sun behind you. Of course you want the light to highlight the most interesting points. This takes timing, patience, and a little luck. "Waiting" and "photography" are synonyms in my dictionary.

Winter Sunrise, Sierra Nevada, From Lone Pine, by Ansel Adams

Ansel Adams was intimately familiar with the most subtle aspects of natural light, and used this knowledge to give his photographs emotional impact. With his wife Virginia he set up his camera on a frigid morning near Lone Pine, on the eastern side of the Sierra Nevada, and waited for light, clouds, and a horse to cooperate. "A horse grazing in the frosty pasture stood facing away from me with exasperating, stolid persistence. I made several exposures of moments of light and shadow, but the horse was uncooperative, resembling a distant stump." Finally, as the last shaft of light approached, the horse turned to show its profile, and Adams made his exposure. "Within a minute the entire area was flooded with sunlight and the natural chiaroscuro was gone."

In this first image from Yosemite Valley I was lucky enough to find an almost perfectly balanced pattern of sun and shade, with light striking the focal point, Bridalveil Fall. The second photograph shows another fortuitous combination of weather and light, with the sun breaking upon the Grand Tetons underneath dappled clouds.

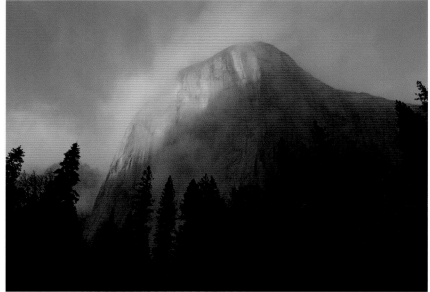

Color Temperature

The technical aspects of color temperature and white balance were covered on page 32. Some photographers become obsessed with capturing perfectly neutral white balance, but with any image the goal is not to meet some artificial standard—the goal is to create a good photograph. Color temperature can be a creative tool. An overall tint—like blue or magenta—can add to the mood, and differences in color temperature can be aesthetically pleasing—they create a warm-cool color contrast. I didn't correct for the blue tint of the snow covering these alder trees; I left the snow blue so that it would contrast with the warm, golden reflections in the river.

The most vivid contrasts in color temperature occur around sunrise or sunset. Sunlit objects become orange, red, or pink, while the sky and shaded areas remain blue, as you see in this El Capitan photograph. Frontlight, sidelight, and backlight are all more interesting early and late in the day; the low angle of the sun creates more dramatic shadows and contrasts, and the most drab subject can become colorful.

Bounce Light

While Yosemite photographers look for storms and interesting weather, their Utah cousins hope for clear skies. In the Southwestern United States, sunlight bounces off red canyon walls and casts a beautiful amber glow on objects in the shade. Deep in Buckskin Gulch, along the Arizona-Utah border, I found sunlight reflecting off rock and sand to illuminate this bend in the canyon.

Desert photographers don't have a monopoly on bounce light. In cities, light reflects off glass buildings, adding a surreal glow to the streets below. The sun can rebound off snow or sand to illuminate the underside of a tree. Early or late in the day, any valley or canyon can reflect sunlight off its walls into the shade below.

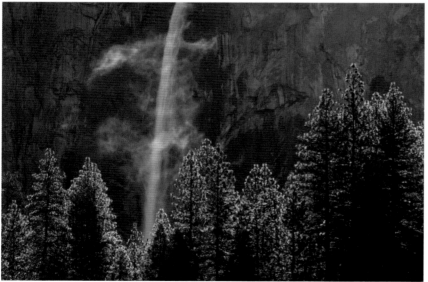

Composition

"The art of photography is knowing how much to exclude. You can't photograph the whole world."
—Eliot Porter

Painters start with a blank canvas and add their vision to it. Photographers start with the entire universe, pick one small piece of it, put a frame around it, and invite people to look at what they found. Photography is an act of reduction. The more you eliminate, the better the photograph will be. The fewer the elements, the stronger their impact. Less is more.

The Rule of Thirds and the Golden Mean

The rule of thirds says that if you divide a photograph into thirds, both vertically and horizontally, those lines, and the places where they intersect, are strong points to put your main subject or a point of interest.

This rule is actually a simplification of the golden mean, golden ratio, or golden rectangle—ancient aesthetic concepts that espouse the beauty of a ratio of approximately 1.62. In practice, this is closer to $2/5$ than $1/3$—that is, using the golden mean you would place important objects $2/5$ of the distance from the left, right, top, or bottom of the frame.

No rule can cover every situation. I break these rules more than I use them, but they can be useful when I'm not sure where to place something. They serve as a reminder to keep the main subject out of the center. It's usually more interesting, more dynamic, to put the focal point off-center.

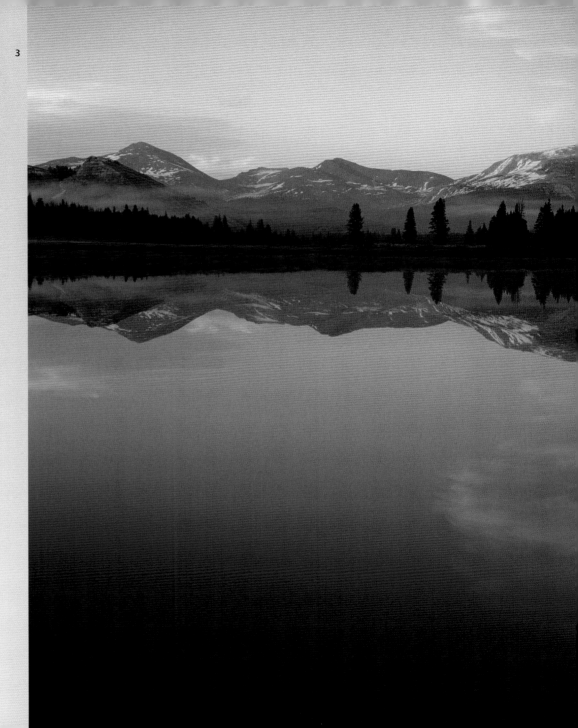

1 & 2. The lone pine tree adheres to the golden mean—it's about $2/5$ of the way from the right edge of the photo. Bridalveil Fall also fits this rule, as it lies close to $2/5$ of the distance from the left border. While these images happen to fall close to the "ideal" of the golden mean, adhering exactly to any artificial standard is less important than finding the right balance and proportions for each situation.

3. The rule of thirds and golden mean can also be used for horizons; it's often best to place them $1/3$ to $2/5$ of the way from either the top or bottom of the photograph. I placed this horizon from Tuolumne Meadows, in the Yosemite high country, closer to the top to emphasize the reflection.

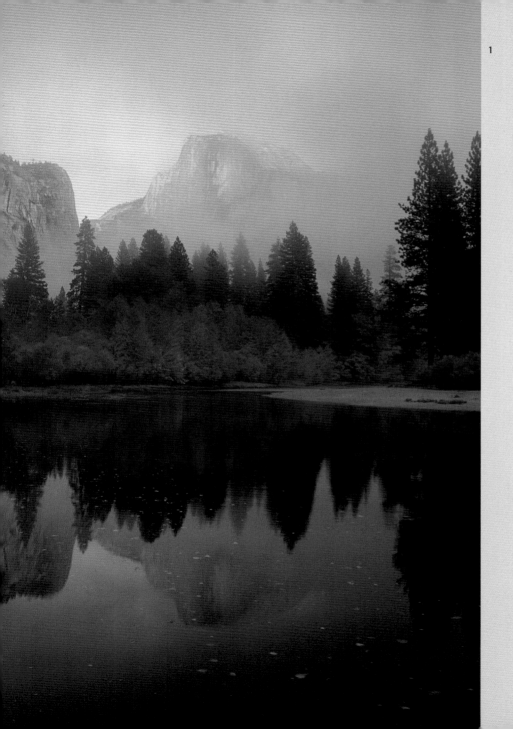

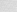

2

3

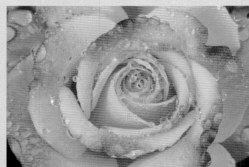

When to Break the Rules

Often! As Edward Weston said, *"Pictures came first. Rules followed. No one ever became an artist by learning rules or keeping them."*

4
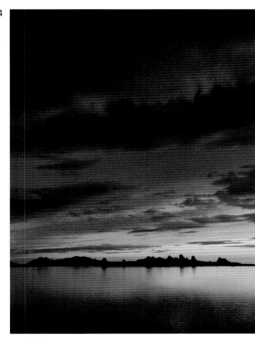

5

6

1. Think of the rule of thirds and golden mean as a guidelines, reminders that a centered subject often looks static. But there are plenty of exceptions. With reflections, a centered horizon can be effective because it creates symmetry and emphasizes the feeling of calm, as in this image of Half Dome.

2 & 3. Sometimes the center is just the logical place to put something. This photograph of Utah's Calf Creek Falls would look off-balance if the waterfall wasn't centered, and the placement of the rose emphasizes it's symmetry.

4 & 5. Horizons can be placed near the bottom of the frame to emphasize the sky, as in this photograph from Gaylor Lakes, or near the top to emphasize the foreground, as with these wildflowers from Tuolumne Meadows.

6. Some photographs don't have a focal point—they're just patterns, like this field of lupine flowers, so the rule of thirds and golden mean don't apply.

The Only Real Rule: Simplify

"For photographic composition I think in terms of creating configurations out of chaos, rather than following any conventional rules of composition."
—Ansel Adams

The best compositions are simple. The photographer's point stands out clearly without distractions or clutter.

The single most common photographic mistake is including too much in the frame. Imagine someone walking through Yosemite Valley who decides to photograph Half Dome. Without thinking, he snaps a picture. Later he notices that, in addition to Half Dome, the photograph includes sky, trees, a meadow, plus a large bus on the roadway, and Half Dome has become lost in the chaos.

Don't be like him! Take a moment to think. What caught your eye in the first place? Make the photograph about that, and nothing else. If a composition isn't working, move in closer or use a longer lens. Doing either will automatically crop out unnecessary material and simplify the design. If you're trying to combine two elements, but they don't seem to mesh, then concentrate on just one of them.

Less is More

The best compositions convey your message clearly and directly. Nothing competes with these tiger lilies—they dominate the frame.

1

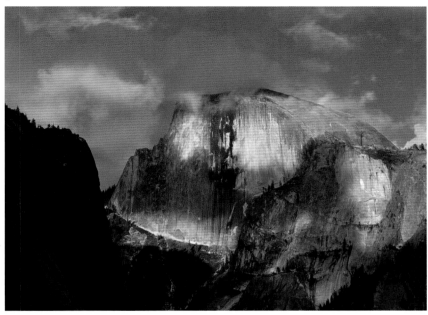

3

Finding the Essence

To find the essence of your subject, ask yourself what caught your eye in the first place. What compelled you to make the photograph?

These three photographs of Half Dome are all different, but each one includes only the essential elements. In the first image, the light and clouds around Half Dome were interesting enough by themselves—I didn't need anything else. So I used a telephoto lens to fill the frame with just the rock and clouds. In the second version

I wanted to juxtapose two objects, Half Dome and the backlit dogwood leaves. Here I used a wide-angle lens, which turned Half Dome into a small silhouette, but its distinctive shape is still recognizable, and the composition remains simple—most of the frame is filled with just the leaves and granite monument. In the third image I was attracted to the large, colorful cloud above Half Dome, so I put the rock at the bottom of the frame, pointed the camera up, and filled the image with only the two most important items.

2

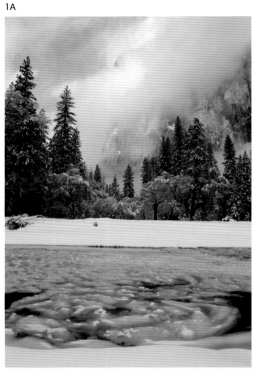

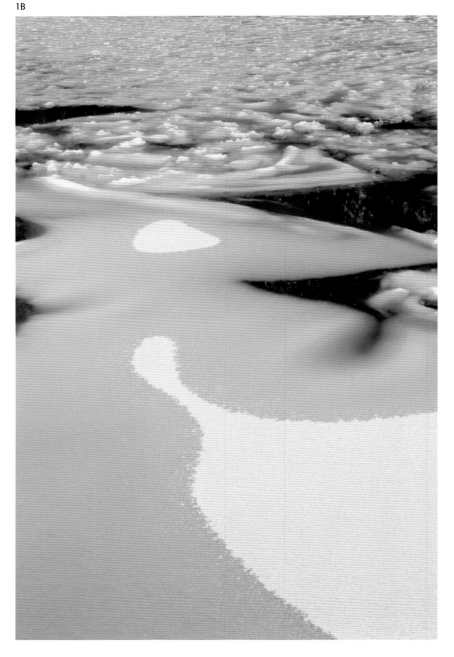

1. Narrowing the Focus

In this first photo (1A) I was attracted to both El Capitan, and to the pattern of ice in the river. But it just didn't work. There were too many other things that I had to include, like the trees and snow on the opposite bank of the river, plus the horizontal lines in the bottom half of the frame didn't mesh with the vertical lines of El Capitan. So I decided to forget to just concentrate on the ice. This second version is much simpler and stronger (1B).

2. Eliminating Distractions

This first image of the small waterfall isn't bad (2A), but I felt that the dark rocks were distracting. I decided that what most caught my eye was the streaks of falling water and the golden reflection above, and used a longer lens and filled the frame with these most essential components (2B).

3. Adding Impact

This first photograph is a nice, straightforward rendition of Vernal Fall (3A). It shows what the waterfall looked like, but didn't capture the noise and power of the water. So I found a part of the fall that, to me, conveyed that feeling better (3B).

2A

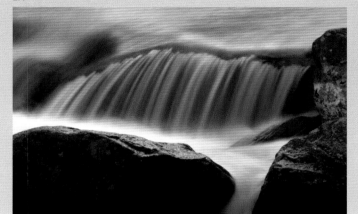

2B

3A

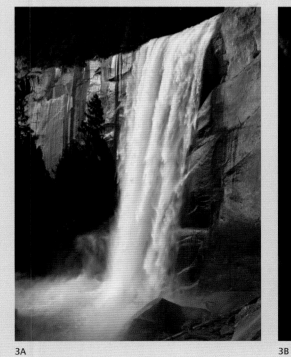

3B

The Power of Lines

Lines

Do you even know what you're looking at here? Does it matter? The real subject of the photo is the abstract design—the descending series of squares. At its essence, every photograph consists of lines, shapes, tones, and colors on a flat surface. The more you look at your own photographs that way—as abstract designs—the better your images will be. Take it from Edward Weston: "How little subject matter counts in the ultimate reaction!"

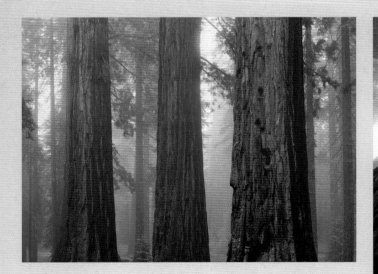

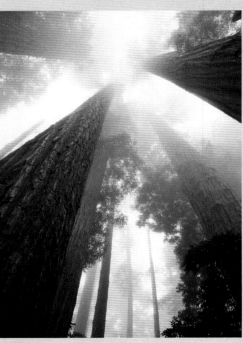

Vertical Lines

Lines can convey feeling. A succession of vertical lines looks stately and monumental, like Greek columns—appropriate for the immense sequoia trees in this first photo. In the second image the vertical lines converge, helping convey a sense of height.

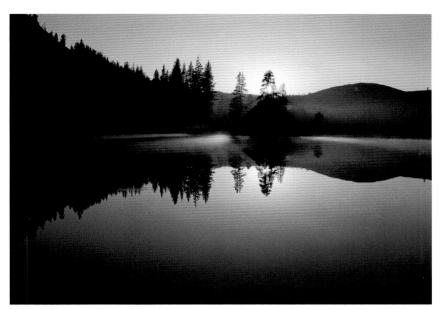

Horizontal lines

Horizontal lines convey tranquility and calm. The strong horizon line in this photo from the Yosemite high country adds to the peaceful mood.

 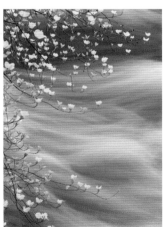 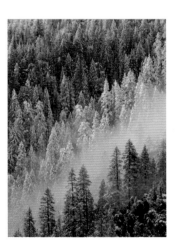

Curved Lines

S-curves, as shown in the first image from the Grand Canyon, can be a powerful way to lead the viewer's eye through a photograph. Curves can also create a sense of flowing movement, as in this second photograph of dogwood blossoms.

Diagonal lines

Diagonal lines create a feeling of movement and energy. These two photographs have very different subjects, but similar compositions, and both rely on strong diagonals.

Patterns and Repetition

Corn Lily Leaf Pattern

One leaf by itself is just a leaf.
Two similar leaves form a pattern.
Repetition creates rhythm, unity,
and strong compositions. If you find
a pattern, try to fill the frame with
it and make the viewer think the
pattern continues indefinitely.

Focal Point

It often helps to have a focal point;
a spot where the viewer's eye can rest
before roaming around the pattern,
like the yellow cottonwood leaf left
of center in this image.

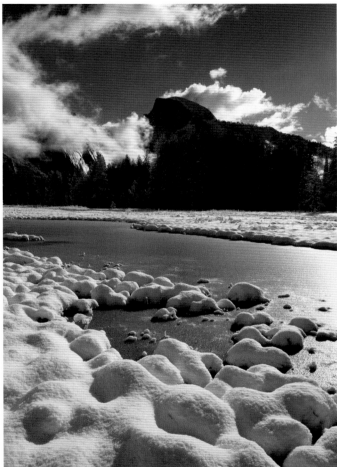

Patterns in the Grand Landscape

It's easier to see strong designs in small subjects, but it's just as important to find them in big, sweeping landscapes. Notice the diagonal lines and repetitive vertical cliffs in this Grand Canyon image.

Connecting the Foreground and Background

If the photograph has a foreground and background, there must be lines, shapes, or colors that tie the two together; if not the photograph will look disjointed. The mounds of snow in this image echo the rounded shape of distant Half Dome.

Changing Perspective

Too often photographers act as if their tripods had grown roots. They see a possible subject and stop in their tracks, never considering what might happen if they moved the camera to the left or right, up or down, forward or back. The first view of the subject is not necessarily the best one. Move around!

Ansel Adams said, "With practice, we can rapidly assess visual relationships and choose an appropriate camera position for any subject." The key word there is practice. Adams often turned this into a mental exercise while engaged in everyday activities. Simply sitting in a chair, holding a conversation, he might imagine taking a photograph of the person he was talking to, and how the visual relationships might change if he altered his point of view. It's a great exercise—try it sometime.

Camera Position

Consider how a change in camera position might have affected this image from White Sands, New Mexico. Lowering the camera would have merged the top of the spiky leaves with the dune's shadow. Stepping to the right would have merged the yucca's stalk with the curved ridge of the dune, while positioning the camera further left would have created too much separation between them. Moving closer with a wide-angle lens would have made the background dune smaller in relation to the foreground. Stepping back with a longer lens would have forced me to crop out some of the clouds. In short, there was only one appropriate position for the camera.

1

1. **Viewpoint**

Most photographs are made with the camera at eye level looking straight out toward the horizon. Breaking this habit can lead to more dynamic photographs. Adams built platforms on top of all his vehicles to give him a higher perspective. Try to look up or down and find higher or lower vantage points. Pointing the camera toward the sky created an unusual perspective on these aspen trees.

2. **Telephoto Lenses**

Telephoto lenses compress space—objects appear larger and closer together than they really are. You can use this to flatten images and create abstract patterns. Here the foreground ice was about 20 feet (6 m) closer to the camera than the background ice, but a 200 mm lens flattened the perspective into a surreal design.

3. **Wide-Angle Lenses**

Wide-angle lenses expand space. Objects look further apart and more distant than normal. You can take advantage of this by exaggerating the size difference between foreground and background to create an illusion of depth. Get close to something in the foreground, as I did with the rock strata in this photo from Zion, otherwise everything will look small and insignificant. It also helps to include converging lines, like those in the foreground rocks, to create a sense of perspective.

2 3

Capturing a Mood

The best images do more than show what something looked like—they capture a mood or feeling, and evoke a response from the viewer. Brett Weston said, *"Unless a landscape is invested with a sense of mystery, it is no better than a postcard."*

To convey mood, photographers must use all the tools discussed so far: exposure, depth of field, light, and composition. But there are a few more items that merit consideration, including tone, color, weather, and motion.

Tone

1. **Dark tones** suggest somber moods, as in this image of Bridalveil Fall.

2. **High contrast** helps convey drama in this image from Tunnel View in Yosemite.

3. **Light tones**, as in this photo of a misty ponderosa pine, create a mood that's, well... lighter—bright, even happy.

4. **Low contrast** creates a softer, more delicate feeling in another view of Bridalveil Fall.

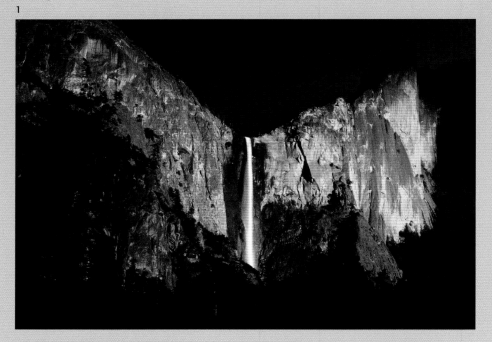

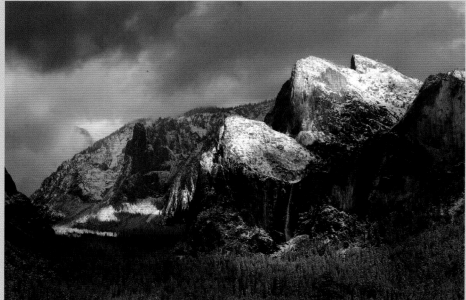

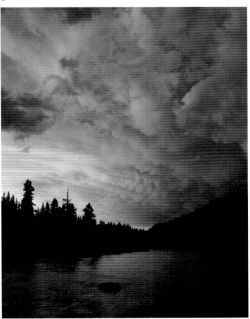

Color

Studies have shown that color can have a powerful effect on a person's mood. Interior designers create peaceful, serene rooms with blues and greens. Advertisers use red to grab your attention. Black can convey power, sexuality, elegance, or mystery.

5. **Red and black** convey mystery and power, and add drama to this image of storm clouds over Tenaya Lake in Yosemite.

6. **Blue** represents peace, tranquility, and calm, helping to enhance the mood of this photo from Mono Lake.

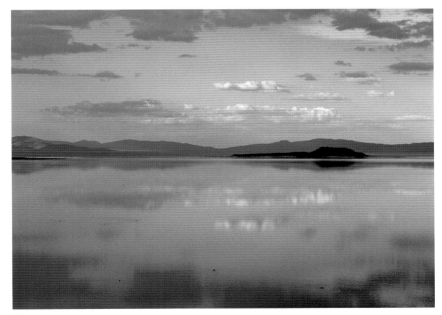

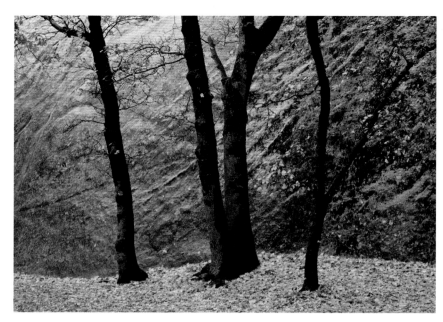

Rain, Snow, Fog, and Wind

Any kind of weather can add interest to a photograph. Rain enriched the colors of leaves, bark, and moss in the image of oaks and granite. Snow provided the perfect complement to another oak tree in the second photograph. Fog added a magical quality to the third image, while wind created an unusual opportunity in the fourth photo: a flurry of falling leaves.

Clearing Storms

Many spectacular landscape photographs owe their drama to a clearing storm. A storm's aftermath can leave snow-covered trees, raindrops on flowers and leaves, fog, mist, and the sun breaking through clouds.

As the storm is breaking, try to determine where the sun is, and what it could illuminate if it does break through the clouds. Then you have a better chance of being in the right place at the right time.

I used my local knowledge to make this first photograph of Yosemite's El Capitan. In winter the sun strikes the west side of this rock at sunset, so I knew that if the sun peaked underneath the clouds there was a chance for dramatic light. The second image shows the eastern side of the same rock as the morning sun broke through remnants of a spring rainstorm.

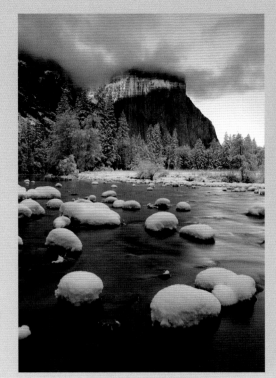 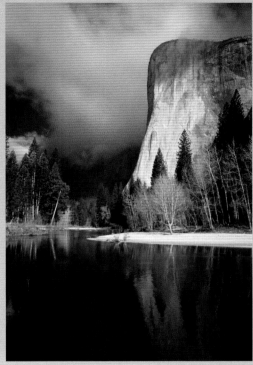

Weather and Atmosphere

We tend to think of landscapes as static, because the basic components, like rocks, trees, and bodies of water, change slowly. But the best landscape photographs often capture a particular instant, a unique, unrepeatable moment when the light, weather, and subject were just so.

This isn't just luck. Photographers can learn to anticipate such moments. They stalk their subjects, looking for those special combinations of light and weather. Many good images are made close to the photographer's home, or a place he or she visits frequently. Familiarity helps them find the best viewpoints, learn the patterns of weather and seasons, and anticipate when conditions will be right.

Ansel Adams made repeated visits to the Japanese internment camp at Manzanar during World War II. While there he scouted locations with photographic potential, and when conditions were right made some of his most famous images, including *Mount Williamson, Sierra Nevada*, and *Winter Sunrise from Lone Pine* (page 68).

Adams also lived in Yosemite Valley for ten years, and maintained a part-time residence there for the rest of his life. It's no coincidence that many of his best photographs were made there, like *Clearing Winter Storm* (page 102). There's a persistent myth that he camped at Tunnel View for days to make this image, but why would he camp when he lived only a few miles away? He did, however, return to this spot again and again when the weather looked promising.

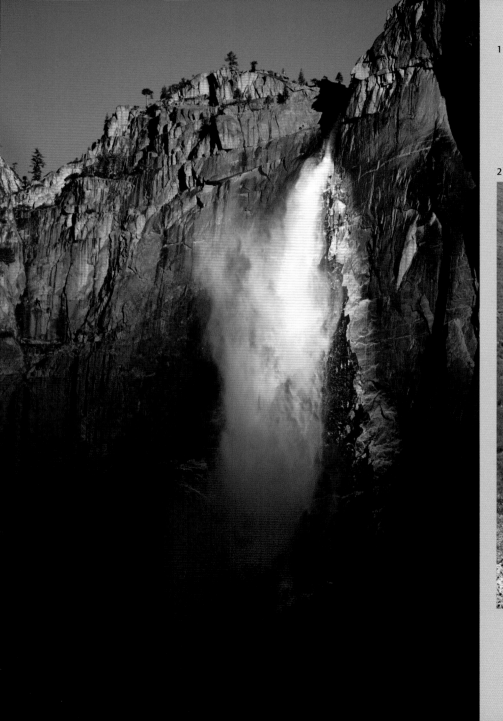

1

2

Seasons

Every place has seasons, even if they're not the traditional winter, spring, summer, and fall rotation. Each season—indeed, each week—offers unique possibilities. Not only that, but every year is different. Is it a wet spring or a dry one? Each can be equally beautiful. Is it a cold winter or a warm one? Both provide great opportunities for photographs.

1. Light changes from winter to summer. In winter, Upper Yosemite Fall receives beautiful early morning light, but in spring, when the fall is roaring, the sun doesn't reach it until 10 a.m. Therefore the best photos need a rare combination of winter light and unusually high water flow.

Unusual Opportunities

2 & 3. A wet winter led to an exceptional wildflower year in southern California, painting the hills with color. In the second image (3), an early snowstorm etched autumn aspens with snow.

Moon Cycles

Ansel Adams said he was "moonstruck," because of the inordinate number of moons in his photographs. Or maybe he just knew that the moon can add drama to any image.

Most people know the basic lunar cycle: 28 days from new moon to new moon. The ends of the cycle—new and full—are the most photogenic, as the moon hovers near the horizon at sunrise and sunset.

Moonstruck photographers should know that the moon rises (and sets) an average of 50 minutes later each day. So if it was in perfect position at sunset yesterday, it won't be today. The moon also rises and sets further to the north or south each day (except near the equator). This movement is too complex to describe in detail here, but remember that the full moon is always opposite the sun. You can find out local details using the internet. During summer in the northern hemisphere, the full moon rises from the east-southeast, takes a low path through the sky, and sets to the west-southwest—like the winter sun. In winter the full moon rises from the east-northeast, takes a high path through the sky, and sets to the west-northwest—like the summer sun.

New Moon

1. The new moon is always close to the sun, so its crescent hovers near the horizon at sunrise or sunset. One or two days before the new moon that crescent will appear to the east around sunrise. A day or two after the new moon it can be seen to the west at sunset. This sunrise image of Mono Lake was made two days before the new moon.

2. The full moon can always be seen opposite the sun. It rises from the east at sunset and sets to the west at sunrise. The best images can usually be made before or after the actual full moon date. A day or two before the full moon, it rises to the east just before sunset, when there's still light on the landscape. One or two days after the full moon it hangs above the horizon to the west after sunrise. On the actual full moon date you may see the moon only when it's truly dark, making it difficult to capture detail in both the moon and landscape.

3. This image from Middle Gaylor Lake in Yosemite was made at dawn the day after the full moon. I saw the three-quarter moon rising above Half Dome at sunset three days before the full moon.

Conveying Motion

As the earth rotates, the sun, moon, and stars move through the sky. The wind blows, clouds grow, rain falls, water flows, animals run, birds fly, people walk, and cars drive. The world is in constant motion. Capturing that motion can add a powerful dimension to landscape photographs. But how do you convey movement in a still photograph? There are basically two ways: use a fast shutter speed to freeze motion, or a slow shutter speed to blur it.

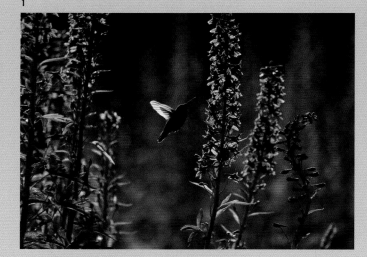

1

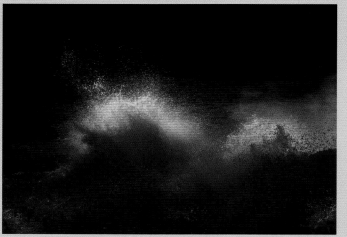

2

3

Freezing Motion

1. The Decisive Moment

Most photographs are static, so a fast shutter speed doesn't automatically convey movement. You must show something hanging in the air, or off balance. The viewer has to know that the subject couldn't stay suspended in that position.

Capturing such moments requires skill, timing, anticipation, and a little luck. You almost never catch the action the first time you see it, but if you're observant, you'll notice that events often repeat. I saw this hummingbird periodically visiting this group of flowers, so I sat and waited for it to return. It was shot at 1/3000 sec. Normally this wouldn't be quick enough to freeze its wings, but I happened to catch the wings at the top of their arc when they were relatively still.

2 & 3. Shutter Speeds

How fast should your shutter speed be to stop motion? It depends on how quickly the subject moves across the frame. A relatively slow shutter speed might freeze an object moving toward or away from the camera, but the same object moving across the frame would need a faster shutter speed.

To freeze motion you may need to set a lower f-stop (wider aperture) to get the necessary shutter speed. Of course this means less depth of field. If you can't afford to lose depth of field, or the light is too low to get the right shutter speed even at $f/4$ or $f/5.6$, try increasing the ISO setting.

This distant view of Old Faithful geyser (2) required only 1/125 sec to freeze its spray, but the tighter view of Yosemite's Silver Apron (3) required a shutter speed of 1/1000 sec.

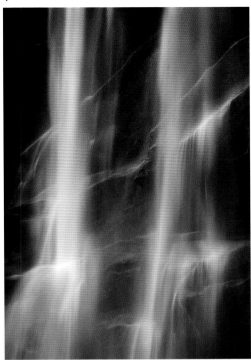

Blurring Motion

We're taught that photographs should be sharp. Terms like *blurry* and *out of focus* are not usually meant as compliments. Yet deliberate blurring can make powerful photographs. In real life we never see actual motion blurs; we view the world like it's a movie, a series of images in rapid sequence. So blurred motion creates an unusual look that can add a flowing, mystical, slightly surreal quality to a photograph. It also allows a period of time to be compressed and viewed all at once.

6

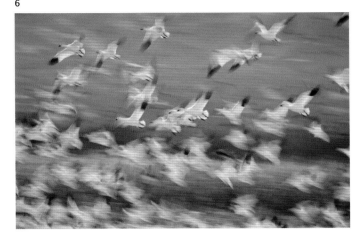

4 & 5. Still Camera, Moving Subject

This technique lends itself to many landscape subjects. It's now become standard to let flowing, cascading water blur. But this method can work with anything that moves—waves, stars, falling rain or snow, wind-blown flowers and branches, even moving cars.

The longer the shutter speed, the better these images usually look. Although there are no absolutes, in most cases you need a shutter speed of ½ sec or slower to give cascading water that silky, flowing look. You usually have to make these images in low light; even at your highest f-stop number (smallest aperture) and lowest ISO you can't shoot at ½ sec in midday sun without a neutral-density filter.

It usually helps to have something in the frame that's sharp to contrast with the moving, blurred subject. Of course that requires using a tripod, otherwise everything will be blurred from camera shake. In this close-up of Vernal Fall, a shutter speed of ½ sec allowed the water to blur, while a tripod ensured crisp detail in the rocks.

In the next photograph of reflections in the Merced River, everything is blurred. Yet it still works because the waves have their own structure, an organic pattern that holds the image together. The shutter speed was again ½ sec.

6. Panning

When panning, you're trying to capture a relatively sharp image of the subject while blurring the background. It's challenging: the subject must be moving in a steady and predictable way so that you can follow it smoothly with the camera. It helps if the background has some texture to create streaks behind the subject. Moderately slow shutter speeds like ⅛, 1/15, or 1/30 sec often work best. Slower speeds will give you a better blur, but it's hard to keep the subject sharp. This image of snow geese was made at 1/15 sec using a tripod with a panning head.

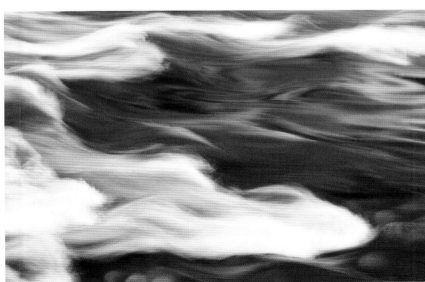

Retaining Texture

While very slow shutter speeds
(½ sec or slower) usually work
best for these images, sometimes
a moderately slow shutter speed
can retain more texture and detail.
Don't be afraid to experiment!
I used 1/8 sec for this image of
Unicorn Peak and the Tuolumne
River in Yosemite, as this showed
more texture in the water while
still suggesting movement.

Wind

My initial idea was to let the water
blur while capturing a sharp image
of the redbud. Persistent winds made
this impossible, so I decided to let
the redbud blur also. I waited for
the biggest gusts and used a shutter
speed of 2 seconds to capture
maximum motion.

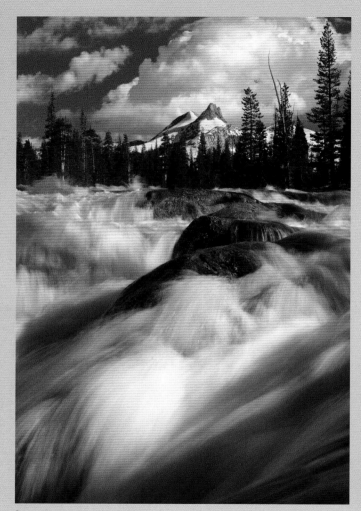

1

2

Nighttime Exposures

At night, light levels allow for very long exposures. The shutter was left open for eight minutes in this moonlit scene from the Grand Canyon, allowing the clouds to blur into streaks. The sky above Half Dome was exposed for 10 minutes, capturing parallel streaks of rotating stars and radiating lines of falling meteors from the Leonid meteor shower.

Visualization

It's often hard to imagine how blurred images will look, so digital cameras provide a huge advantage. Keep checking your LCD screen to see how the movement is rendered by the camera, and change your shutter speed or refine your composition if necessary. Although I could tell that these leaves were moving in a slow circle, I couldn't see the center of that circle with my naked eye. But as I photographed, that circular pattern appeared on my LCD screen, and I kept refining my composition until I got this image.

Expressive Images

Ideally, every single element in the photograph—
the subject, light, color, composition, weather, motion,
exposure, and depth of field—should contribute to
the photograph's message and mood.

Redwoods in Fog

Repeating vertical lines add a stately, monumental quality to these trees. The fog lends a touch of mystery. The tones are a mixture of light and dark; you can easily imagine how a darker or lighter exposure could alter the feeling. The colors are muted, which is appropriate for this subject—bright colors would destroy the mood. Everything is in focus; the trees need to be sharp to give them weight.

Oaks and Mist

Light and weather add an optimistic mood to this photograph. The contrast is high, but most of the tones are light. Sunbeams, mist, and a splash of yellow color all contribute to the bright, hopeful feeling.

The leaning shapes of the oak trees echo each other and give the photograph structure and repetition. Radiating and diagonal lines give this image energy.

Thunderstorm Over Mono Lake

Theatrical light and clouds add a dramatic mood in this photo. The long horizontal line of the horizon would ordinarily add a calm feeling to the image, but the turbulent shapes of the clouds create tension. Contrast is high, adding to the drama. The rainbow provides a clear focal point, but the rest of the image is essentially black and white. I used a 200 mm lens to zoom in on the most interesting and expressive part of this scene.

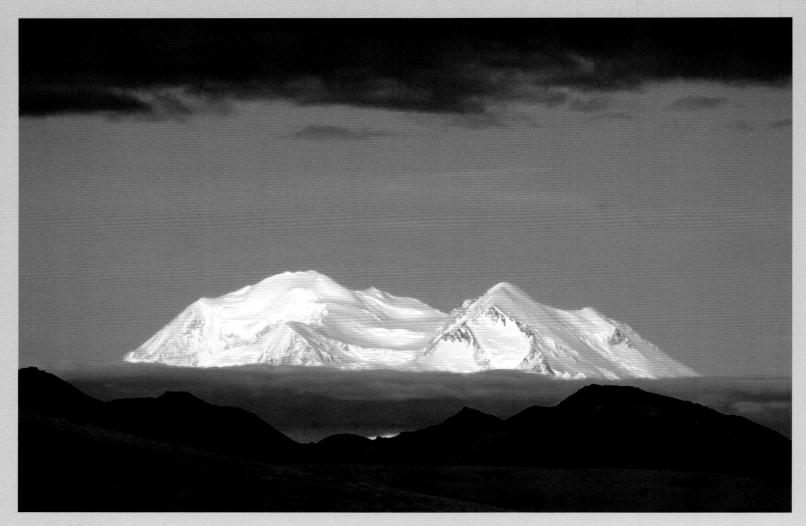

Mount McKinley

Dark tones at the top and bottom
of this image create a frame, as
if you were looking through
a window toward the mountain.
The juxtaposition of tones and lines—
the bright triangles of the mountain
thrusting up through the dark
horizontal lines of the clouds—
creates a feeling of grandeur.

A 300 mm lens filled the frame with
the most essential elements, and
added an unusual and somewhat
disorienting perspective by bringing
the foreground hills into visual
proximity with the snowy peak.

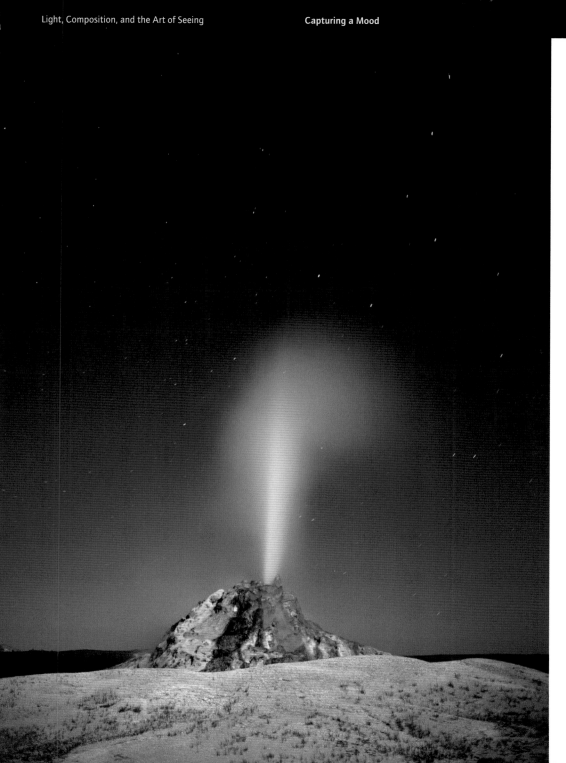

White Dome Geyser

A two-minute exposure by moonlight softened the water and added an ethereal, mystical quality to this photograph. The color palette—white, light blue, deep blue, black, and a touch of brown—also contributes to the peaceful yet mysterious mood. I pointed the camera up and used a wide-angle lens to include more stars and add to the expansive feeling. The overall composition couldn't be simpler.

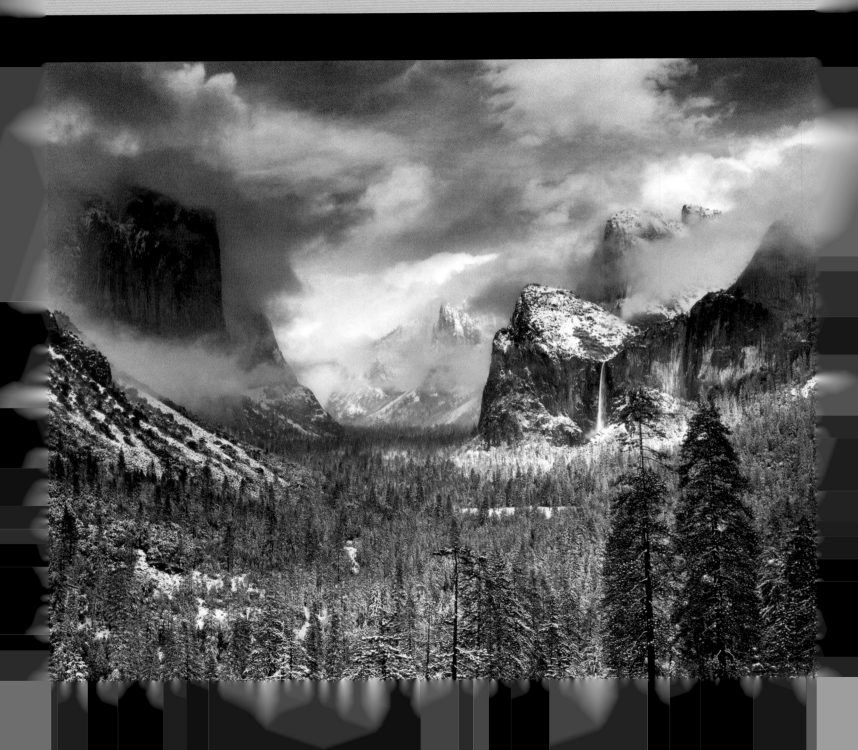

**Clearing Winter Storm,
Yosemite National Park, 1940,
by Ansel Adams**

This photograph reveals Ansel Adams'
darkroom mastery. A straight version,
with no dodging and burning, is
lifeless by comparison. But Adams
saw hidden possibilities: "Although
the scene was of low general contrast,
my visualization of the final print was
quite vigorous. The subject had a very
dramatic potential."

The process of realizing that potential
began by increasing the contrast
of the negative with a longer
development time (Normal-plus-one).
Precise dodging and burning did
the rest. Adams used a metronome
to time his movements, dodging
(lightening) the two foreground
trees for two seconds, and burning
(darkening) the edges, top, sky, and
center for times ranging from one
to ten seconds. Adams' darkroom
skill created a masterpiece of light
and mood out of this seemingly
ordinary negative.

*"I think of the negative as the 'score,' and the print
as a 'performance' of that score, which conveys the
emotional and aesthetic ideas of the photographer
at the time of making the exposure."*
— Ansel Adams, 1983

To convey his "emotional and aesthetic ideas," Adams
became a master of black-and-white darkroom printing.
The kind of control he learned through painstaking
trial and error, using elaborate darkroom equipment,
is now available to anyone with a computer and the
appropriate software. In fact Adams might envy the
power that black-and-white photographers have today
to convert colors to shades of gray or precisely dodge
and burn their images.

But while black-and-white photographers have reason
to celebrate new digital tools, color photographers
might be excused for setting off fireworks. Black-
and-white darkroom printing had matured into a
sophisticated, beautiful process long before Photoshop
was invented, but analog color printing remained
complex and difficult. Perhaps the most beautiful
darkroom color printing process is dye transfer. It
involves making three matrices, one for each color
dye (the inks printed onto the page, cyan, magenta,
and yellow), then transferring each dye to the final
print. Each layer must be kept in perfect registration,
so the process takes years to master.

In 1940, Eliot Porter struggled to learn a precursor
to dye transfer called the washoff-relief process.
"The properties of the materials used," he said, "did
not always seem to conform to expected standards,
and thus it required a great deal of experimentation
to obtain even moderately acceptable results." The
complicated masking technique forced a tradeoff
between subdued colors or posterization. Eventually,
Porter became one of the great practitioners of the
"easier" dye transfer process.

It's telling that one of the modern masters of dye
transfer printing, landscape photographer Charles
Cramer, virtually abandoned this process at the
dawn of the digital age. In the late 1990s Cramer
experimented with digital printing from his

drum-scanned 4x5 transparencies. Several years later
he described his darkroom: "Everything was just as
I left it, covered with a layer of dust. It was like one
of those Anasazi ruins, with corn cobs lying around as
if the occupants had just fled." Cramer found that he
could make better color prints with the new digital
tools than with the painstaking dye-transfer process.

Modern digital printers, coupled with the sophisticated
controls offered by Photoshop and other applications,
can make prints as beautiful as any from the wet
darkroom. Learning to use these tools is one thing.
Learning the taste and judgment to make good prints
is another. While the methods have changed, the
aesthetics of a printing haven't. Here the landscape
masters of the past—particularly Ansel Adams, the
great darkroom technician—have much to teach us.

Adams said, "Print quality... is basically a matter of
sensitivity to values." This means finding the right
amount of contrast—enough to give the image life,
but not so much that it becomes harsh. It also means
knowing when a photograph needs a touch of pure
black for drama, or when subtler tones would convey
the right mood.

For color prints, the amount of saturation is also
key. Not enough and the photograph will look flat.
Too much and it becomes garish. The right color
balance is also vital. This doesn't mean locating
some theoretically neutral point, but rather
finding harmony between warm and cool hues.

Adams said, "The difference between a very good
print and a fine print is quite subtle and difficult,
if not impossible, to describe in words. There is
a feeling of satisfaction in the presence of a fine
print—and uneasiness with a print that falls short
of optimum quality."

Editing

Unrestrained by film and processing budgets, digital photographers can produce hundreds or even thousands of images in a day. How do you pick the best ones?

Start with an initial, quick look. First impressions are valuable. If an image strikes you right away as good, it probably is.

But while first impressions can be helpful, the key to good editing is objectivity, and objectivity increases with time and distance. I find it difficult to edit my work the evening after a shoot, but three days later it's easy. I've lost some attachment to my photographic offspring, and can look at them more objectively. So in the initial edit I only throw out the obvious dogs—images that are clearly overexposed, out of focus, or otherwise unusable. After a few days it's easier to pick the real winners.

Don't confuse effort with quality. Just because you spent months waiting for the perfect light doesn't mean the photograph is good. Try to look at the result, not the process.

It's common to collect sequences of similar images. There might be slight differences in composition, exposure, or focus. Perhaps they're all identical except that the subject was moving—you were trying to capture a waterfall when the spray was just so, or when the wind calmed and a field of flowers stood still. For checking sharpness it's invaluable to have software that allows you to zoom in and compare images side-by-side. A series of slightly different compositions is more difficult to edit. Again, first impressions help. Which photograph jumps out at you?

While time may allow more detachment from your photographs, another person is always more objective. But it has to be the right person. It's nice to have people in your life who love everything you do, but such people are worthless as editors. The ideal candidate has sophisticated visual taste (is not easily impressed by pretty sunset pictures), is completely honest, and can articulate what he or she likes or doesn't like about a photograph.

But don't hand over complete control to someone else. If, after living with an image for a while, you still like it—even if no one else seems to—stick with it.

1

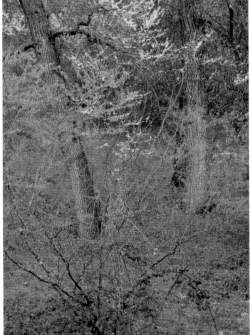

2

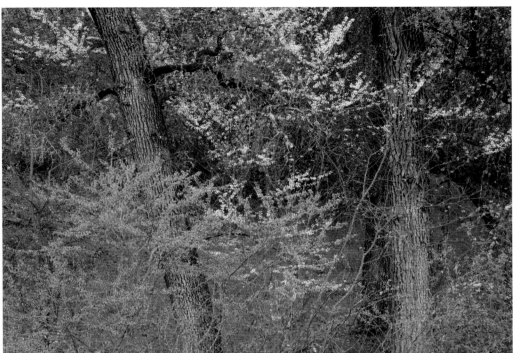

3

4

Variations in Composition

Here are four similar photographs I made of pink and white redbud outside Yosemite National Park. Which one jumps out at you? Here it's best not to over-analyze—just go with your first impression.

I chose 3; it just seemed like the most satisfying composition. I like the spaciousness of 1, but the branch in the upper-left corner is distracting. 2 has too much space at the bottom, and no logical place to crop it. 3 and 4 are similar, but to my eye 3 has better rhythm and balance.

Raw Workflow

The straightforward processing required for this image—cropping, removing dust spots, adjusting contrast, and some minor burning—didn't require Photoshop, so I was able to do everything in Lightroom.

Photoshop Workflow

This photograph required Photoshop's sophisticated selection tools to lighten the foreground flowers without affecting the background water. I made only minimal adjustments in Lightroom before bringing the image into Photoshop.

Workflow

Ansel Adams, Eliot Porter, and Edward Weston each had their own post-processing workflow—a sequence of steps for developing, editing, and filing negatives, then more complex procedures for printing the best ones.

The tools may have changed, but a good, consistent workflow is still vital—perhaps even more so with the thousands of images that digital photographers often generate. A good workflow should be streamlined but powerful. You want to wring out maximum beauty with minimal effort. It also needs to be flexible so you can make changes later without having to start over. Every step should be editable without having to throw away other changes.

Today there are two main, viable options that fit those criteria: Raw workflows (for example using Lightroom), and Photoshop workflows.

Raw Workflow

This method uses Lightroom, Aperture, Adobe Camera Raw, Nikon Capture, Capture One, or any software that works directly with Raw images to do most of the work, with occasional forays into Photoshop to perform more complex tasks. All these Raw processors are non-destructive, which means that the original file is never modified, and all changes to the image's appearance are written as instructions in the file's metadata.

This workflow is viable only if the software can do most routine tasks. For me this includes dodging, burning, and curves, as every image needs some dodging or burning, and curves are the only way to have complete control over image contrast.

Even though I call this a Raw workflow, many of these programs work well with JPEGs also.

Photoshop Workflow

This method often starts with another program (anything from Lightroom to iPhoto) for editing, sorting, and making some basic adjustments, but uses Photoshop for most of the heavy lifting. Photoshop is the most powerful and sophisticated image-editing program available, and you may prefer to take advantage of it's power right away. This workflow is also a better choice if your other software can't do routine tasks like dodging and burning, or lacks curves. If you know you're going to take an image into Photoshop, it's better to make only minimal adjustments in other software, as this leaves you with more flexibility later. All you really need to do is get the white balance close, and make sure you're bringing as much highlight and shadow detail as possible into Photoshop. Some sharpening may also be needed for Raw images, or JPEGs with minimal sharpening applied in the camera.

Since Photoshop was not designed to be a non-destructive editor, you have to make it behave like one. This means using adjustment layers to keep all changes editable.

Simple Adjustments

Most Raw processors could easily handle the simple adjustments needed for this image—mostly converting to black and white and adding contrast.

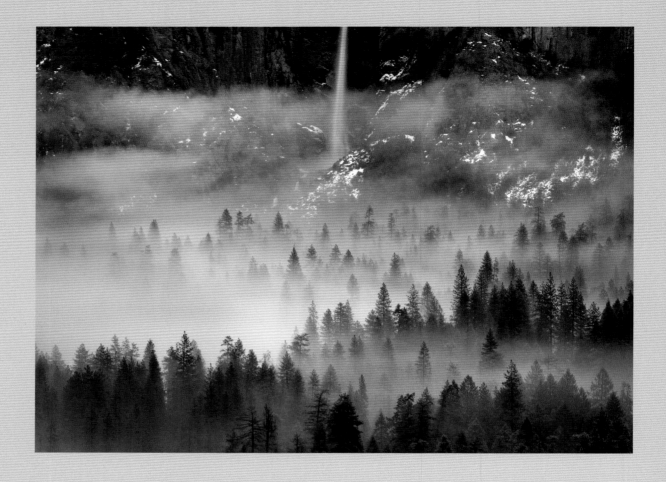

Choosing a Workflow

The advantage of the Raw workflow is that you can use one tool for everything—editing, sorting, keywording, and processing—without having to switch between programs. Non-destructive editing (which maintains all the original data) is also inherently superior, even though Photoshop can be forced to behave in a non-destructive fashion. Raw processors can also be easier to learn than Photoshop.

The Photoshop workflow takes advantage of Photoshop's tremendous power. Many tasks can't be done in other programs, including perspective cropping, serious retouching, making complex selections, and combining two or more images.

There is no reason why you need to use one workflow for every image. I use both; processing most images in Lightroom, but moving some photographs into Photoshop for jobs that Lightroom can't handle.

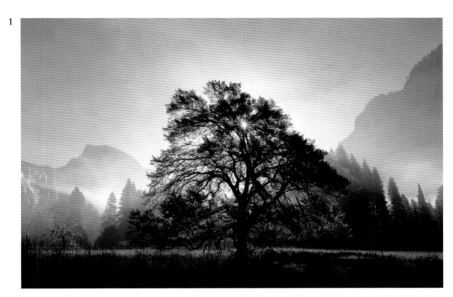

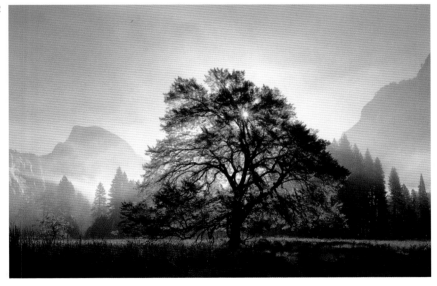

Perspective Cropping

1. Pointing a wide-angle lens upward caused the trees at the edges to lean in.

2. Photoshop's perspective cropping straightened the trees.

Combining Images for Depth of field

I blended five original images to expand the depth of field in this photograph, something that required Photoshop's power. Before bringing the Raw files into Photoshop I made minimal adjustments in Lightroom, making sure all the images had the same white balance, sharpening, contrast, etc.

As his materials and technique improved, Ansel Adams changed his darkroom interpretations. Moonrise, Hernandez on page 6 is a great example: he lowered the value of the sky over the years until it became nearly black. He wrote: "As months and years pass the photographer refines his sensibilities and may change the value relationships within an image according to his evolving awareness."

Over time I've changed the color balance and softened the contrast in this photograph of Bridalveil Fall. A master file should always be flexible—you should be able to modify any aspect of it without starting over.

The Master File

With either workflow the goal is to produce a master file—a file that contains all your adjustments and can be copied or exported for any use, including large prints, small prints, web, and email. There are four important principles to keep in mind with any master file:

Calibrate the Monitor

Without a properly calibrated monitor you may as well be blind. You're just guessing about the colors and tones, and how a print might look. You need a colorimeter—one of those puck-like devices that rests on the screen—and its accompanying software.

Keep the Master File Editable

This happens automatically with non-destructive applications like Lightroom or Aperture. If you use Photoshop, make all your adjustments on layers, and never flatten those layers in the master file. If you need to merge the layers to print, make a copy of the master file first.

Don't Resample the Master File

You can't resample the original file in non-destructive programs, so again this is not a concern with that workflow. With Photoshop, you should never resample the master file—that is, never increase or decrease the number of pixels. Resampling downward—decreasing the number of pixels—throws away information and valuable detail. Resampling upward—increasing the number of pixels—won't destroy information, but makes the file larger without adding detail. To produce a large print, make a copy of the master file before increasing the number of pixels.

Sharpen Conservatively

Every Raw file needs some sharpening, as do JPEGs made with low sharpening settings (see page 18). Files from some cameras need a lot of sharpening, some very little, so you have to experiment to find the optimum settings for your own model. Sharpening in non-destructive programs like Aperture or Lightroom is always editable, so if you overdo it you can make an adjustment later.

Be conservative about adding sharpening in Adobe Camera Raw, Nikon Capture, or any other application before bringing an image into Photoshop. You don't want to box yourself into a corner and have to start over. You can always sharpen a file after bringing it into Photoshop, but to retain flexibility you never want to sharpen the original background layer of a master file—you should always sharpen on a separate layer, or turn the background layer into a Smart Object. Some popular plugins like PhotoKit Sharpener add sharpening on a layer automatically.

This slight sharpening of the original Raw or JPEG image should not be confused with print sharpening. Most images need a bit more sharpening before printing, but this should be one of the last steps, after setting the print size and resolution, and should only be done on a copy of the master file, never on the master file itself.

RGB Working Spaces

The large half-oval shape represents all the colors visible to the human eye. The smallest triangle shows the colors included in sRGB, the largest delineates ProPhoto RGB, while the middle triangle represents Adobe RGB. sRGB is obviously a very small color space, but Adobe RGB isn't much bigger. ProPhoto RGB, on the other hand, includes almost all the colors in the visible spectrum.

RGB Working Spaces

When opening images in Photoshop you can choose a working space. The most common options are sRGB, Adobe RGB, and ProPhoto RGB.

What is an RGB working space? Colors in digital images are described by amounts of red, green, and blue. The working space defines which red, which green, and which blue. In practice this means that some color spaces include a wider range, or gamut, of colors than others. The accompanying diagram compares sRGB, Adobe RGB, and ProPhoto RGB. Adobe RGB encompasses a slightly wider range of colors than sRGB, but both are quite small. ProPhoto RGB includes almost all the colors the human eye can see.

The differences only become apparent with highly saturated colors. With a smaller color space, like sRGB or Adobe RGB, a brilliant red could be changed to the nearest equivalent within parameters of the color space, becoming a more faded red, or perhaps shifting to red-orange. These differences can't be shown in a book like this, but will be apparent with the best inkjet printers, all of which can reproduce colors beyond the gamut of sRGB or Adobe RGB. For that reason, I routinely use ProPhoto RGB. There is a potential pitfall, however: The 256 levels of an 8-bit file must be stretched further to cover the wide color gamut of ProPhoto RGB, creating more potential for banding or posterization. So in theory it would be better to use 16-bits with ProPhoto RGB; in practice, it's rarely an issue.

8 Bits versus 16 Bits

8 bits means 256 levels in each color channel—red, green, and blue—while 16 bits gives you 32,768 levels per channel. In theory, 16 bits is better. Thousands of steps should be able to render subtle gradations in tone or color better than a mere 256. In practice, it's hard to tell the difference, though if you are making heavy adjustments in processing then the extra "bit-depth" will become apparent.

Problems with 8-bit files are most likely to show up as banding or posterization—abrupt shifts from one tone or color to the next where there should be smooth transitions. This can happen at dusk, where light skies near the horizon should gradually become darker above, but sometimes break into distinct bands. Banding may also appear when making a big change, as when lightening a severely underexposed image.

Lightroom, Adobe Camera Raw, and most other programs that work directly with Raw files use 16 bits per channel. From there, you can bring an image into Photoshop with either 8 bits or 16 bits. The tradeoff is that 16-bit files are twice as large as 8-bit files and take longer to open, run filters, and save. Since I rarely see differences, I routinely use 8 bits per channel. Only if I encounter a problem, like banding, will I go back and try re-importing the file with 16 bits. If the photograph is grossly underexposed I'll correct that in Raw software before opening the file in Photoshop.

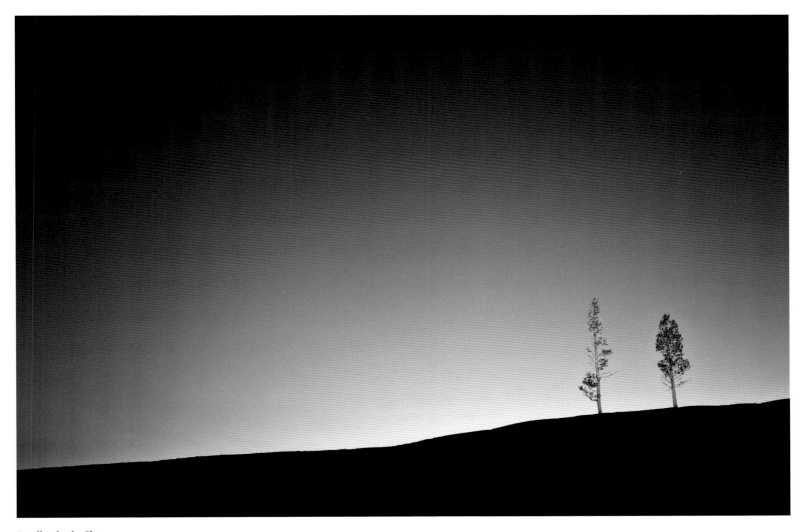

Banding in the Sky

This light-painted image shows slight banding or posterization in a dusk sky. I made minimal adjustments in Lightroom, then took the photograph into Photoshop with both 8 bits per channel and 16 bits per channel. Both show the same banding. This may be because the camera itself only used 10 bits per channel, or it may be a profiling issue. Either way, increasing the bit depth didn't solve the problem. While 16 bits is better in theory, differences can rarely be seen in practice.

Processing Order

Whatever workflow you choose, make it consistent.
Do the same steps in the same order each time so
that you don't forget anything vital. While an unusual
image might require a different sequence, most can
be approached in similar fashion. Here's an order
that makes sense to me for Photoshop. With a
non-destructive editing application like Lightroom
the sequence can be more flexible—just don't forget
something.

Crop
This is an important aesthetic choice that influences all
the other decisions about an image, so I do this first.

Reduce Noise
If necessary, this should be done early. In Photoshop
things get more complicated if you wait until after
retouching. To retain flexibility, run noise-reduction
filters on a copy of the background layer or turn the
background layer into a Smart Object.

Retouch
Whether removing dust spots or a distracting
telephone pole, I like to complete this odious chore
early. In Photoshop it also makes sense to manipulate
pixel layers before adding adjustment layers.

Convert to Black and White (optional)
It's better to convert to black and white before
adjusting tonality.

Make Overall Tonal Adjustments
This means setting the overall brightness and contrast.
Ignore small areas at this stage; make the image look
good as a whole, knowing that small regions can be
modified later. Since tonality affects color, leave
decisions about saturation until later.

Make Overall Color Corrections (Color Images Only)
This includes overall color balance and saturation.
Again, you're concerned with the overall image at
this point, not specific areas.

Make Local Adjustments
Dodging, burning, and other local corrections should
come after you've set the overall appearance.

3

Adjust Contrast Before Color

1. Before adding a curve for contrast, the colors in this ice pattern appeared faded.

2. Increasing the contrast also boosted saturation. Since tonality affects color, it's usually best to adjust brightness and contrast first.

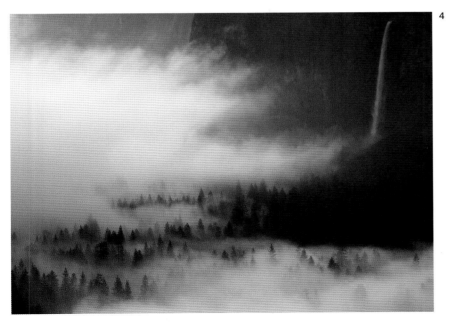

4

Make Overall Adjustments First

Bridalveil Fall is a focal point of this image (3 & 4), but a small part of the composition. I set the overall tonality for the clouds and trees (3), then lightened (dodged) the waterfall for the final picture (4).

Cropping

When you compose a photograph, you put a frame around part of the world and invite people to look at it. The exact borders are critical. Check all the edges for distracting elements—bright spots, dark spots, or objects that are cut in half. The easiest way to remove such distractions is to crop them out. If that's not possible—if cropping them would eliminate other important elements—then you might try cloning out the offending object.

Eliminating Distractions

Any dark or light spot along the edge of a photo can become a distraction. The small dark spot in the lower-right corner of this Nevada Fall close-up (top) was easily cropped out to create the final image (below).

Cropped Area: ○ Delete ● Hide ☑ Shield Color: [] Opacity: 100% ▾ ☐ Perspective

Editable Cropping in Photoshop

Like every other adjustment, cropping should be editable. Later, if you decide you cropped too much, you need to be able to recover the lost areas without starting over. This happens automatically with non-destructive programs like Lightroom and Aperture, but it requires some finesse in Photoshop.

First, change the Background layer to a regular layer. This will allow you to hide the cropped area instead of deleting it, so that you can change your mind later. Go to *Layer > New > Layer From Background*, or just double-click on the layer name (where it says Background). Give this new layer a name.

Then select the Crop tool. Click the Clear button (in the Options bar at the top) to make sure that the Width, Height, and Resolution boxes are empty. If they're not, Photoshop will resample the image. After making an initial selection with the crop tool, choose Hide instead of Delete in the Options bar. Drag the edges of the

marquee to make your final crop and press Enter to finish. To see the whole image again at any time in the future, select *Image > Reveal All*.

Retouching

Photographers were manipulating images long before Photoshop. Local teenagers painted white rocks to spell out "LP" on the hills in Ansel Adams' Winter Sunrise from Lone Pine (see page 68). Adams spotted these letters out of his negative. He said, "I have been criticized by some for doing this, but I am not enough of a purist to perpetuate the scar and thereby destroy—for me, at least—the extraordinary beauty and perfection of the scene."

Ethics aside, retouching is far easier in the digital age, but it still requires skill and a flexible approach.

Editable Retouching in Photoshop

1. In cloning out the lens flare from this image I kept the retouching editable by cloning onto a blank layer. First I clicked on the New Layer icon at the bottom of the Layers Palette. This created a blank, or transparent, layer.

2. Next I chose the Clone Stamp tool and set the mode to Normal, the Opacity to 100%, checked "Use All Layers," and selected the "Ignore Adjustment Layers" button.

3. After cloning out the lens flare I turned off the background layer to show the "patches" where pixels were copied from the background layer onto the transparent layer. With the Eraser tool I could easily remove one patch while leaving the other retouching intact.

4. The final image with the lens flare removed.

1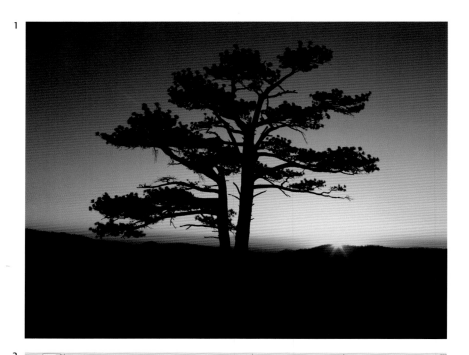

2

3

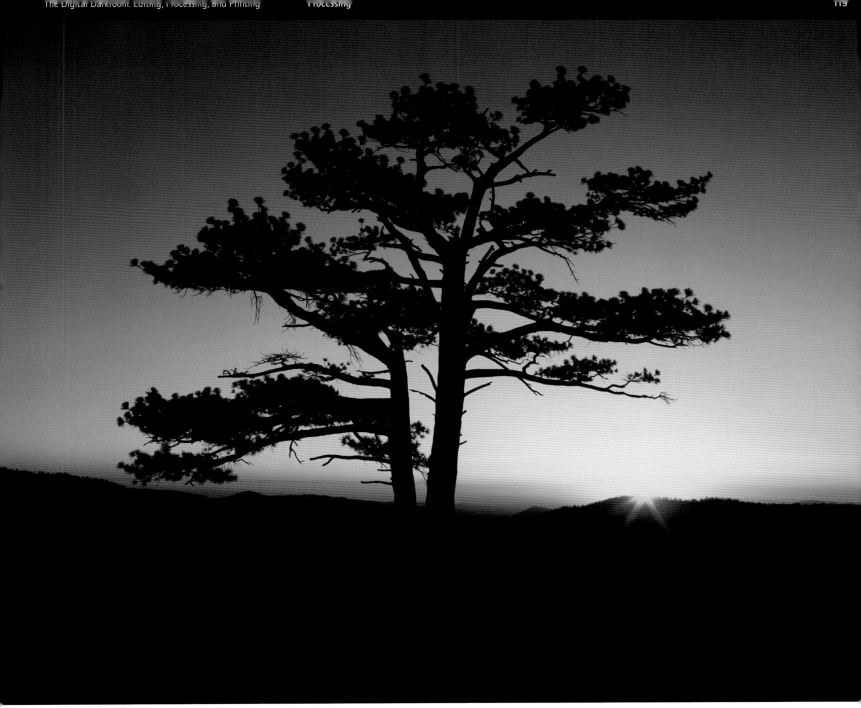

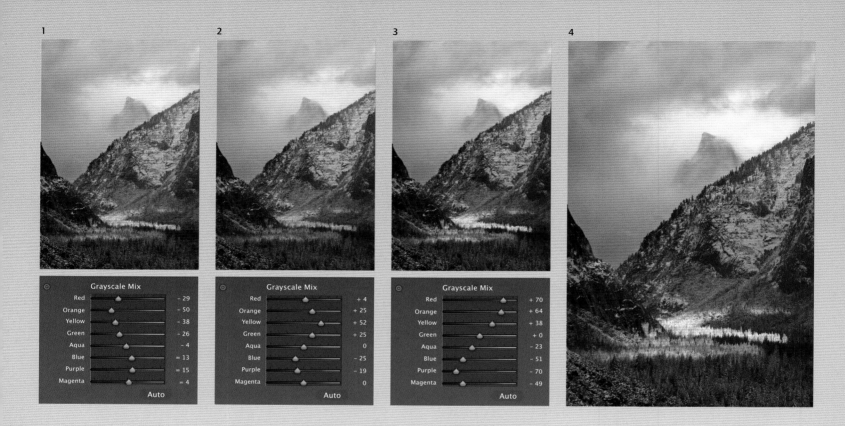

1 **2** **3** **4**

Grayscale Mix (panel 1)

Red	– 29
Orange	– 50
Yellow	– 38
Green	– 26
Aqua	– 4
Blue	– 13
Purple	– 15
Magenta	– 4

Auto

Grayscale Mix (panel 2)

Red	+ 4
Orange	+ 25
Yellow	+ 52
Green	+ 25
Aqua	0
Blue	– 25
Purple	– 19
Magenta	0

Auto

Grayscale Mix (panel 3)

Red	+ 70
Orange	+ 64
Yellow	+ 38
Green	+ 0
Aqua	– 23
Blue	– 51
Purple	– 70
Magenta	– 49

Auto

Converting to Black and White

As I mentioned in Chapter 1, you have far more control over black-and-white images if you capture them in color, then convert them to black and white in software. Photoshop, Lightroom, and Camera Raw now all have similar controls: In Photoshop, make a Black-and-White Adjustment Layer; in Lightroom or Camera Raw, modify the Grayscale Mix.

These tools allow you to adjust the relative brightness of individual colors: to make the reds lighter or the blues darker, for example. It's like being able to choose which colored filter to use after the fact, but even more powerful. You can separate colors that would be too close together for any conventional filter.

Choosing a Digital Filter

1. The original image Half Dome shows warmer colors in the sunlit areas, cooler shades in the shadows.

2. Adding the digital equivalent of a blue filter produced a flat rendition, as it lightened the blue shadows and darkened the golden sunlit areas.

3. Settings comparable to a yellow filter lightened the warmer sunlit areas, darkened the shadows, and generated more snap.

4. The equivalent of a red filter created the strongest contrast.

1

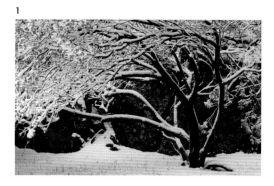

2A

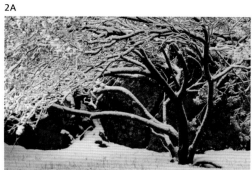

2B

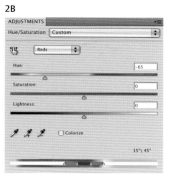

3

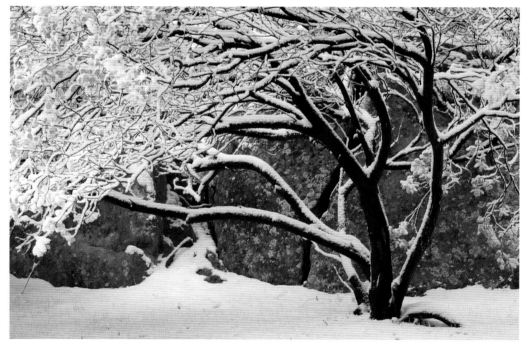

Separating Similar Colors

1. In this example from Chapter 1 (page 31) the challenge was to separate the orange trunk and the yellow-green rock into distinct shades of gray.

2. In Photoshop I made a Hue/ Saturation Adjustment Layer and changed the color of the trunk to magenta.

3. A Black-and-White Adjustment Layer lightened the yellows and greens while darkening reds and magentas.

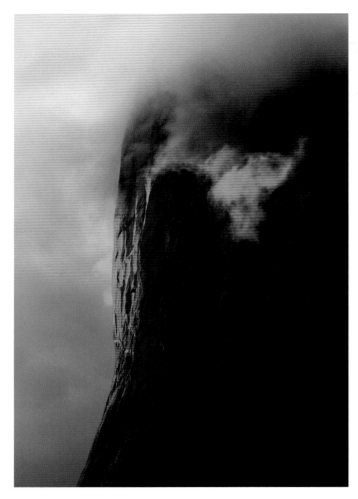

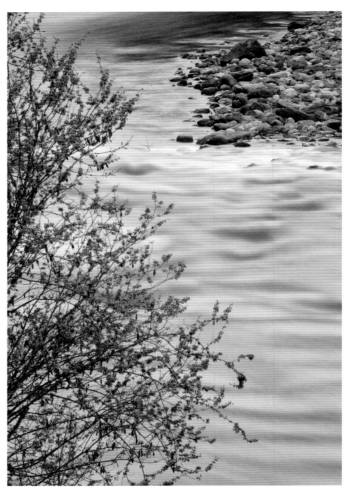

Sunset White Balance

For outdoor images taken with natural light, the color temperature should not be lower than around 5000K, 4800K at the lowest. Midday sunlight is about 5000K, and shade is higher (bluer). While the light at sunrise or sunset is warmer, you don't want to correct for this—you want it to be warm. So sunrises, sunsets, and anything lit by direct sunlight should have a color temperature setting of around 5000K. Higher numbers are for shade, overcast conditions, and dusk, while lower numbers are for images taken under tungsten lights. The color temperature of this El Capitan photo was set to 5200K in Adobe Camera Raw.

Dusk Color Temperature

When exposing images in difficult lighting conditions, such as dusk or mixed (natural and artificial) light, I sometimes put a white card into one image, then remove it for the rest of the shoot. Then I can use the Eyedropper tool in Lightroom or Camera Raw to click on that white card, set the white balance, and apply that same setting to all the other images. I knew finding the right color temperature could be difficult when I made this photograph of a redbud along the Merced River at dusk, so first I took a photo of a white card, then used the Eyedropper tool in Lightroom. The corrected color temperature, at 14,080K, was well beyond the range you might imagine.

1

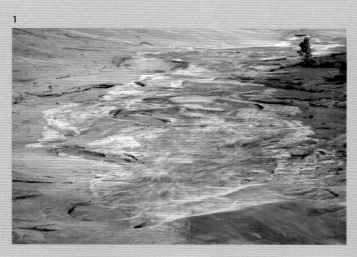

2

Color Temperature Correction

The camera's automatic white balance missed the mark more than usual, leaving this photo of Tenaya Creek too blue (1). The Color Temperature slider in Lightroom quickly cured this problem, allowing me to drag the mouse until the color looked good (2).

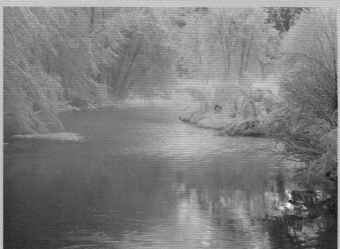

Adjusting White Balance

This is usually a simple matter with Raw images. Most Raw processors have a color temperature slider. Just move the slider left or right to make the photograph cooler (more blue) or warmer (more yellow). Even if I plan to take an image into Photoshop I'll adjust the white balance in Lightroom or Camera Raw first, as this is more straightforward than doing it in Photoshop.

Retaining Color Contrast

The best color balance is not necessarily neutral; sometimes a warmer or cooler tint looks better. I left the shadows blue in this wintry scene along Yosemite's Merced River to keep the contrast between the shaded snow and warm reflections of sunlit cliffs.

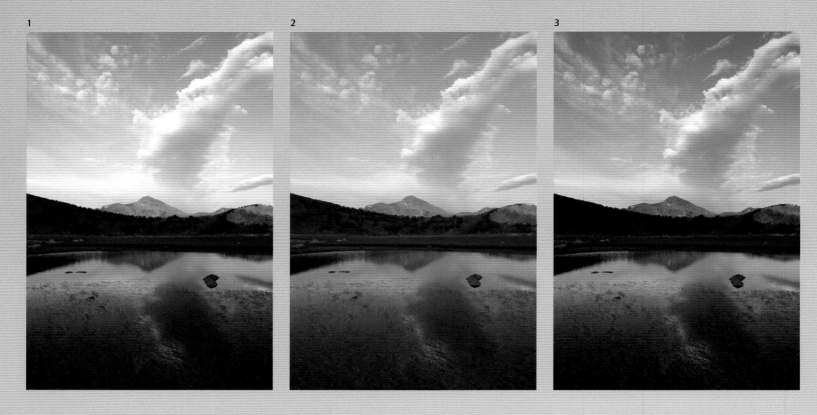

1 2 3

Black Points, White Points, and Contrast

"Life is not all highlights; there must be halftones and shadows as well."
—Edward Weston

Initial Contrast

Ansel Adams said, "As the final step in evaluating the negative... it is best to use a soft grade of paper to make a proof or first print. The print may be visually flat, but the purpose is to reveal all the information available in the negative, especially the texture and detail in the extreme values."

The same principle applies to digital images. The default settings on most Raw processors add contrast, so I always reset these defaults so that the curve is straight and contrast settings are at zero. This makes many images initially look flat, but that's easily fixed, and it's important to see the actual highlight and shadow detail in the Raw file.

If the photograph still has too much contrast—if the histogram shows washed-out highlights or black shadows—try to recover detail in those areas before proceeding further. Many applications have tools for restoring highlight and shadow detail, including Recovery in Adobe Camera Raw and Lightroom, and Highlight/Shadows in Photoshop.

Revealing Highlight Detail

1. The default settings in Lightroom added enough contrast to wash out detail in the brightest clouds.

2. Removing this extra contrast revealed texture in the clouds. The image looks flat, but as long as there's information in the darkest and lightest areas there's something to work with.

3. The final processed image is darker, with more contrast, but has detail in both highlights and shadows.

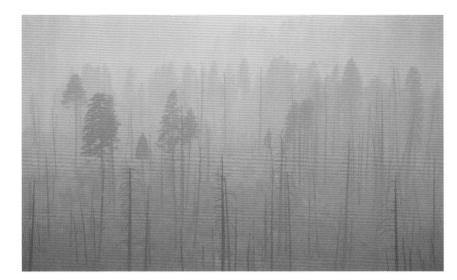

1

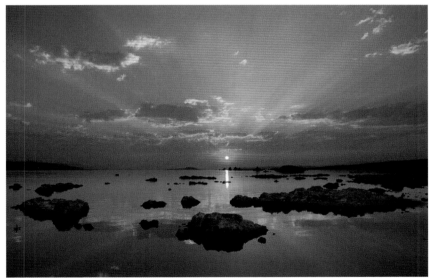

2

Black Points and White Points

Placing the black and white points is one of the most important aesthetic choices a photographer makes. An image with deep blacks and bright whites will have more punch, more snap, than one without them. But some photographs need a softer touch. Here's Ansel Adams' view: "A note of pure white or solid black can serve as a 'key' to other values, and an image that needs these key values will feel weak without them. But there is no reason why they must be included in all images, any more than a composition for the piano must include the full range of the eighty-eight notes of the keyboard. Marvelous effects are possible within a close and subtle range of values."

Observe that he said, "A note of pure white or solid black..." Large patches of solid black or blank white rarely look good. Small areas are all that are needed for most images, and some don't need any. Black-and-white photographs seem to tolerate small sections of pure white better than color images. For some reason, even small spots of blank, washed-out white seem unnatural in color, while they look fine in black and white. Perhaps it's the extra level of abstraction inherent in the monochrome palette?

1. Low Contrast

Not every image needs a full range of tones. The soft, ethereal quality of this smoky scene would have been ruined by deep blacks or bright whites.

2. High Contrast

This dramatic scene needs the impact provided by small areas of pure black and white.

Levels and Curves

There are two main tools for adjusting overall image contrast: levels and curves. Curves are far more powerful. In fact, curves are the most powerful processing tool in the digital photographer's arsenal. Master them and you're on your way to mastering the digital darkroom.

With either levels or curves in Photoshop, make sure you use adjustment layers to keep your changes editable.

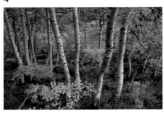
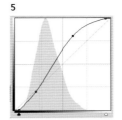

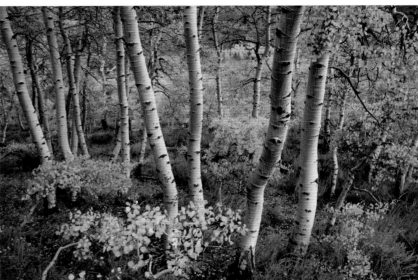

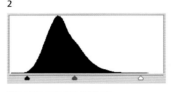
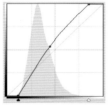

Comparing Levels and Curves

1. The original Raw file of these autumn aspens shows white balance adjusted but no contrast added.

2. With levels there are three controls—a black point, a white point, and a midtone slider. Pushing the black point to the right increases blacks; everything in the histogram to the left of the black point becomes pure black. Pushing the white point to the left increases whites; everything in the histogram to the right of the white point becomes pure white. The middle slider sets the midtone value—the overall brightness of the image. Here I increased the contrast by moving the black point to the right and the white point to the left. This clipped both highlights and shadows—made some small shadow areas pure black, and some small highlights pure white. I also moved the midtone slider to the left, lightening the image overall.

3. For comparison, I made the same adjustments with curves instead of levels. With curves, moving the bottom-left point to the right (keeping it along the bottom) is the equivalent of moving the black point to the right with levels. Moving the top-right point to the left (keeping it along the top) is the same as moving the white point to the left with levels. Moving the midpoint of the curve up or down is like moving the middle slider with levels left or right. Here I moved the black and white points to increase contrast, and lightened the midtones—just as I did with levels.

4. This image now has more contrast, but at the expense of some highlight and shadow detail.

5 & 6. With curves you have more than three points of control, giving you far more power. The steeper the line of the curve, the more contrast. Here I increased the midtone contrast (note the steep line in the middle of the curve) without clipping either highlights or shadows—the black and white points were kept outside the brightest and darkest points of the histogram. The photograph has more overall contrast, without sacrificing detail in the extreme values.

1A 1B 2A

2B

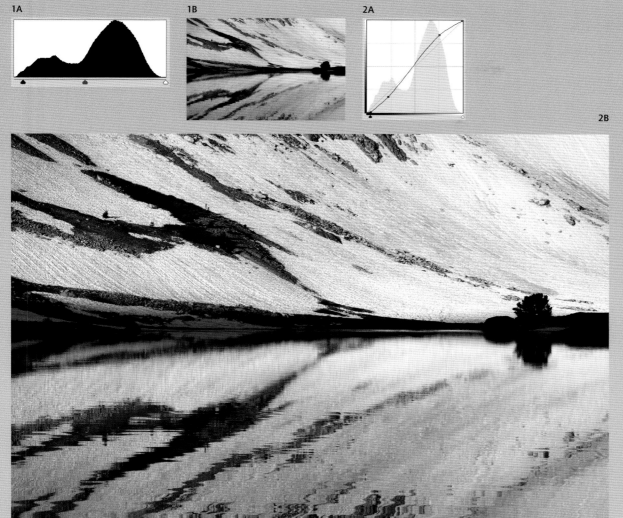

S-Curves

1A & B. This image fills the whole histogram, so there is no room to move the black point or white point without clipping either highlights or shadows, limiting the amount of contrast that can be added with levels. Using Levels, I pushed the black point to the right, turning some shadows pure black, and moved the midpoint slider to the left, lightening the midtones. Changing the white point would have washed out important highlights.

2A & B. Curves are more flexible. Here I pushed the black point to the right just enough to create small areas of pure black, left the white point alone to avoid clipping highlights, then placed two more points to make an S-curve. The S-curve increased the midtone contrast and lightened the snow without losing highlight detail. The result is a brighter, livelier image.

I use some kind of S-Curve on at least 95 percent of my photographs. An S-curve can increase the overall contrast without sacrificing highlight or shadow detail.

1. Low-Contrast Image

1A. Before curve
1B. After curve
With a low-contrast image—where the pixels don't fill the whole histogram—you can make sizable moves with the black and white points without clipping highlights or shadows. Here I moved both the black and white points, but kept them outside the image pixels to avoid clipping. A slight S-curve increased the midtone contrast.

2. High-Contrast Image

2A. Before curve
2B. After curve
This image already had plenty of black (note the spike on the left side of the histogram), while the highlights were almost touching the right edge of the histogram, so I couldn't move the black or white points without losing important highlight or shadow detail. A gentle S-curve enhanced midtone contrast and lightened the image overall.

3. Darkening S-Curve

3A. Before curve
3B. After curve
To darken an image, while also increasing contrast, place points at about the ¼ and ¾ points of the curve. Pull the ¼ point down, but leave the ¾ point near its original location. Note that the middle of the curve now passes below its original, straight-line position, showing that the midtones have been darkened.

4. Lightening S-curve

4A. Before curve
4B. After curve
To lighten an image while also increasing contrast, again place points at about the ¼ and ¾ points of the curve. This time leave the ¼ point near its its original spot but push the ¾ point up. The middle of the curve now passes above its original position, indicating brighter midtones.

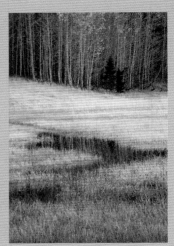

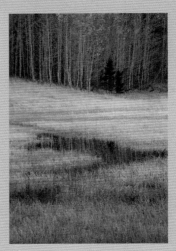

1A

1B

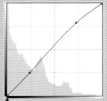

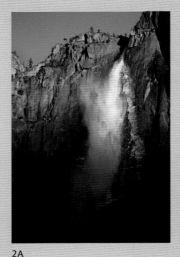

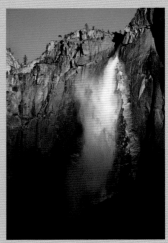

2A

2B

3A

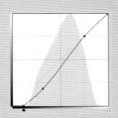

3B

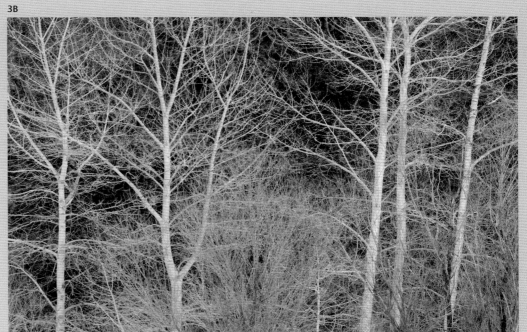

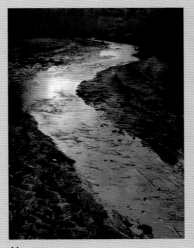

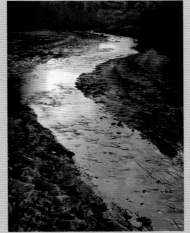

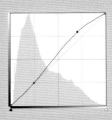

4A

4B

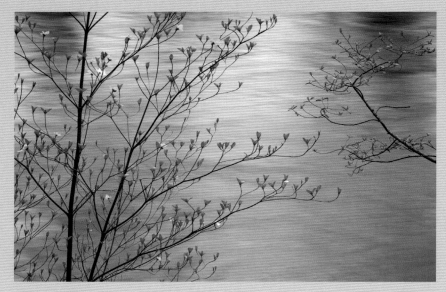

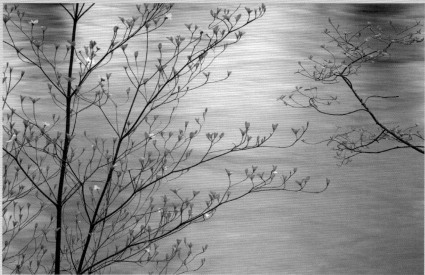

Adjusting Color

Color Balance

After setting the white point, black point, and overall brightness and contrast, some fine-tuning of the color balance may be necessary. If you're using the Raw workflow, you can simply tweak the white balance slider. In Photoshop, make another Curves Adjustment Layer, then select one of the individual channels—either red, green, or blue. It helps to remember the opposites: red and cyan are opposites, as are green and magenta, blue and yellow. So if you want more magenta, subtract green. If you want less magenta, add green, and so on.

Vibrance and Saturation

Saturation is the most abused tool in digital imaging. Some people feel that if a little saturation is good, more is better. But while extra color intensity can give a photograph life, too much will strangle it. There's a fine line between a luminous print and a garish one.

Photographic color has long been controversial. Eliot Porter wrote, "I have been criticized for the distorted and artificial colors in my photographs... however, the colors in my photographs are always present in the scene itself, although I sometimes emphasize or reduce them in the printing process. To do this is no more than to do what the black-and-white photographer does with neutral tonal values during the steps of negative development and printing."

Most Raw files are rather flat, and can benefit from a slight increase in overall saturation or vibrance. Here a moderate boost in saturation added intensity to the reflection in the final image (below).

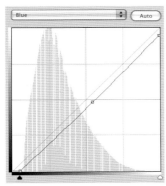

Color Balance Curve

This is a typical curve for correcting color balance in Photoshop. The photograph, taken in the shade, was too blue, so I selected the blue channel, added a point in the middle of the curve, and dragged highlights, shadows, and midtones down to reduce the blue. Small moves make a big difference. I usually make a slightly greater shift in the midtones than the highlights or shadows. When adjusting an individual color channel, rather than the composite RGB curve, it's okay to change the output levels—to put the black and white points along the sides of the grid. But it's not okay to have a crossover—to move shadows in one direction and highlights in another—unless you want to produce strange effects. Individual channels are not the place for an S-curve.

Dodging and Burning

Nature rarely provides perfect illumination. Dodging and burning allows photographers to shape the light into something more ideal.

When people look at photographs, they usually focus their attention on bright spots while ignoring dark areas. Dodging and burning are ways of controlling the viewer's eye. Does the image have a distracting highlight? Then darken it. Is an important focal point too dark? Make it brighter.

Flexible Dodging and Burning in Photoshop

The lower-right corner of this image (1) is too bright—it pulls your eye away from the colorful leaves. Photoshop's Dodge and Burn tools aren't flexible enough—the changes aren't easily editable. Instead, create a Curves Adjustment Layer (3) and pull the midpoint of the curve up and left to lighten (dodge), or down and right to darken (burn). Press Command-I (Mac) or Control-I (Windows) to invert the layer mask. Now select the Brush tool and choose a large, soft-edged brush. Make sure the foreground color is white, and the opacity set to 100%. Click and drag to paint over the portion of the image you want to change. Here I pulled the curve down and painted over the lower-right portion of this photo to darken it (2).

1

2

3

4

Increasing Contrast

You can use a similar procedure to increase contrast. The trees near the bottom of this photo (1) are barely visible; they need more contrast to help them stand out. I made a new Curves Adjustment Layer (3) with an S-curve for contrast, inverted the layer mask, then painted with white over the lower-center and right portions of this photo (2).

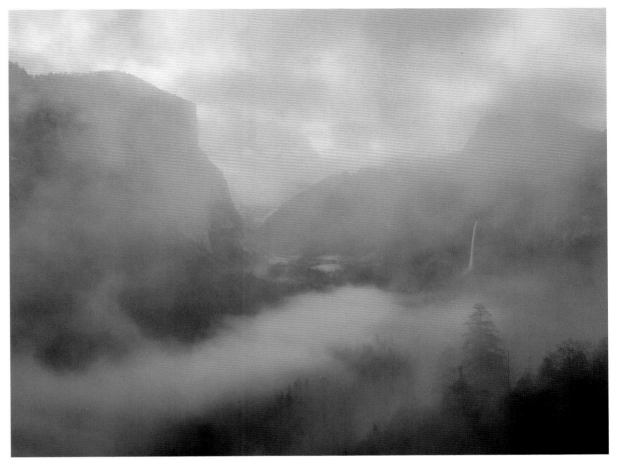

1

2

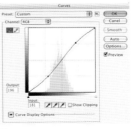

3

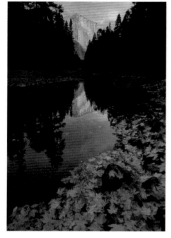

1

2

El Capitan Dodging and Burning

The first version of this El Capitan photo (1) was adjusted for overall brightness, contrast, and color, but has not been dodged or burned. The leaves in the foreground are too dark—they need to draw the viewer's eye more—while El Capitan and its reflection look washed out. In the finished image, El Capitan and its reflection have been darkened, enriching their colors, while the leaves and river bank were lightened to make them more prominent. The diagrams show the dodging (2) and burning (3) masks—the area of El Capitan and its reflection that was darkened, and the section of leaves and river bank that was lightened.

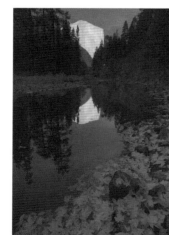

3

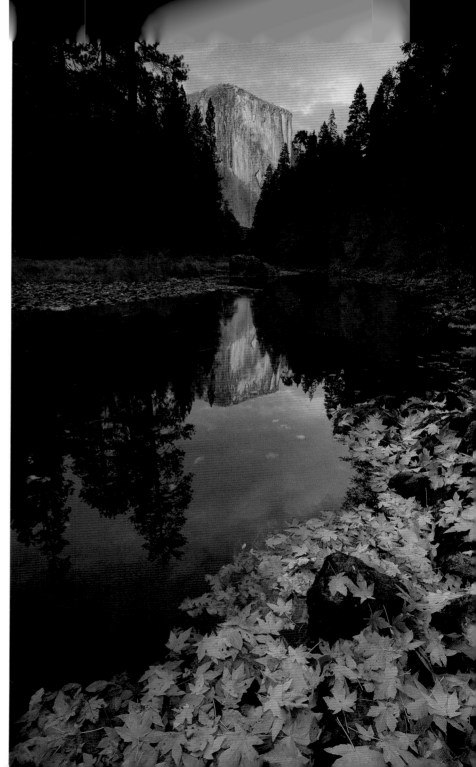

1

2

Digital Graduated Filter

A slight variation of these dodging
and burning techniques can imitate
the effect of a graduated neutral-
density filter, but with more control.
Some programs, like Lighroom and
Adobe Camera Raw, have built-in
graduated filter tools. In Photoshop,
start by making a Curves Adjustment
Layer. In this example, since I wanted
to lighten the foreground, I placed a
point in the middle of the curve and
dragged it up and to the left. Next,
I selected the Gradient Tool and chose
the Linear Gradient and the "Black,
White" preset. Then I clicked and
dragged from top to bottom through
the middle of the image—not the
whole photograph, just the transition
area from light to dark (2), the
graduated part of the "filter."
Dragging a short distance creates an
abrupt transition—a hard-edged filter
(3). Dragging a long distance creates
a gradual transition—a soft-edged
filter. (If you don't get it right the first
time, just click and drag again. If you
go the wrong way, just drag again in
the opposite direction.)

3

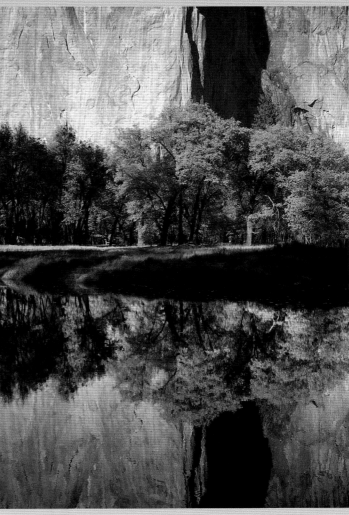

4

1

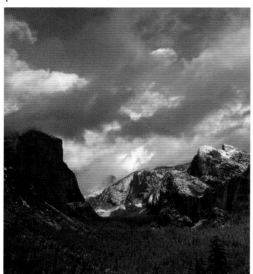

Precision Dodging and Burning

1. Yosemite Valley before dodging and burning.

2. I added a Curves Adjustment Layer with a slight S-curve, inverted the layer mask (Command-I for Mac, Control-I for Windows), and painted with white over the sky to add contrast to the clouds.

3. Another Curves Adjustment Layer lightened Bridalveil Fall.

4. A third Curves Adjustment Layer brightened El Capitan.

5. I lightened and added contrast to the trees in the middle.

6. A fifth curve brightened and increased contrast in the entire foreground except a few bright sunlit areas underneath Half Dome.

7. The final image.

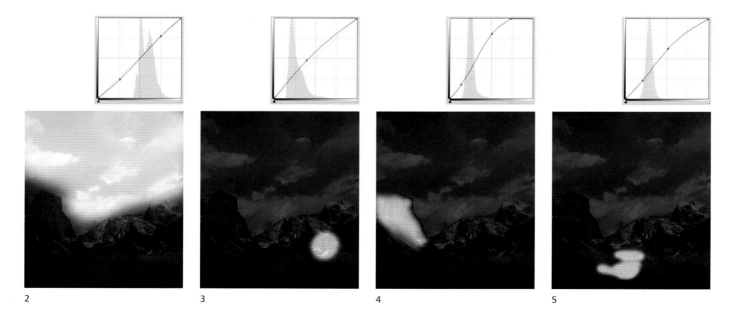

2 3 4 5

6

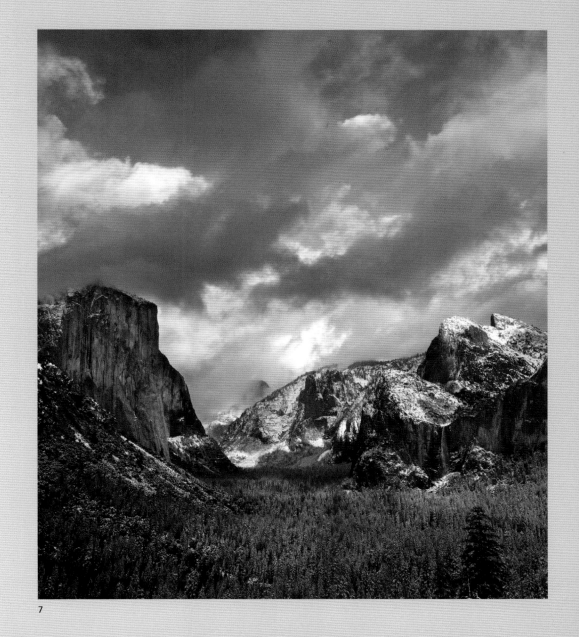

7

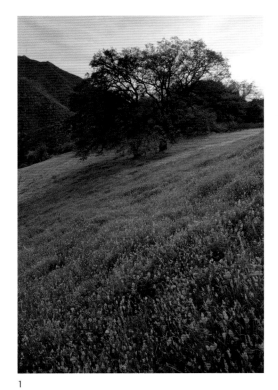

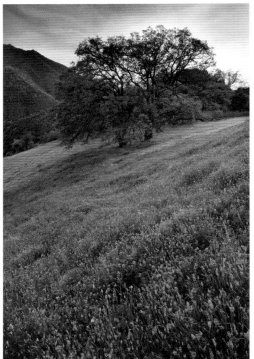

1

2

Sierra Foothill Flowers

1. HDR
2. Exposure Blend

With reduced development Ansel Adams was able to capture highlight and shadow detail in high-contrast scenes, but this could lead to flat, mushy areas in the midtones. The same problem confronts digital photographers using HDR software. Too much tonal compression can reduce local contrast and produce a lifeless image.

Expanding the Contrast Range

Digital photographers have unprecedented control over the contrast in their images. By combining exposures, it's possible to capture detail throughout any scene, no matter how great its dynamic range. The software tools for merging these exposures get better every year, yet it's still a challenge to make these images look natural and carry the right emotional impact.

HDR Versus Exposure Blending

HDR, or High Dynamic Range imaging, uses software algorithms to combine different exposures to capture detail in highlights and shadows. It's usually a two-step process. First, the varied exposures are combined into a 32-bit HDR image. Since the dynamic range of this image exceeds that of computer monitors or printers, a second step, called tone mapping, is required to compress the tones into a usable range. The most popular HDR software today is Photomatix, but there are many others, including an HDR mode in Photoshop.

HDR can be used to create surreal effects, but here we're concerned with creating natural-looking images of high-contrast scenes—the digital equivalent of Zone System contraction.

Exposure blending uses different pieces of two or more images to display a wider range of contrast than would be possible with one image. This could be as simple as using the sky from one image and the foreground from another, or could involve merging pieces of many images. There are automated methods, such as the Exposure Blending option in Photomatix and the Auto-Blend Layers tool in Photoshop, or you can manually combine images in Photoshop using layers and layer masks.

The best method depends on the image. I find that exposure blending usually produces more natural-looking results than HDR, but there are exceptions, so I often try both techniques. For automated

Tunnel View

1. Photoshop
2. HDR

The first image was assembled manually in Photoshop from five separate exposures; the second blended the same original images using Photomatix HDR with the "Detail Enhancer" method of tone mapping. With both versions I converted the images to black and white, adjusted contrast, and added some dodging and burning. In this case HDR retained more local contrast, especially in the clouds, resulting in a more dynamic photograph.

exposure blending Photomatix is consistently excellent, but I can usually do a little better by merging the images manually in Photoshop. But this takes more time, skill, and experience.

HDR seems to work best when bright and dark areas are distributed evenly across the scene. Exposure blending is usually a better choice when part of an image is distinctly brighter than another, as when combining a bright sky with a dark foreground. It's possible to use both: you can start with an HDR merge, then blend that image with one of the original exposures in Photoshop, as I did with the photographs on page 13.

Local Contrast

In Chapter 1, on pages 50-51, I showed the four original exposures used to make both these composites. Here the first versions (1) were blended using Photomatix software in its HDR "Tone Compressor" mode. It succeeded in retaining detail in the both highlights and shadows, but the midtones—especially the flowers—appear flat and lifeless. The second images (2) were created with Photomatix's "Exposure Blending" mode. This is not true HDR, but an automated way of blending pieces of the original images—like using using layer masks in Photoshop, only requiring less skill. This method retained all the local contrast in the bottom two-thirds of the both images because the blending only occurred near the tops. The result is a crisper, livelier photograph. Blending images with layer masks in Photoshop could yield even better results.

1
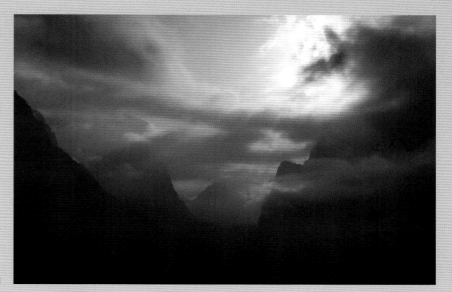

2
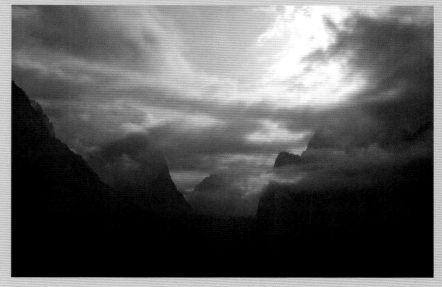

Manually Combining Exposures in Photoshop

The basic techniques for combining different exposures in Photoshop are similar to the dodging and burning methods described on pages 134-139. Both involve painting on layer masks, but instead of selecting part of an adjustment layer, you're hiding or revealing portions of a pixel layer.

Whether using Photoshop or HDR, make sure all the original images receive identical processing—the same white balance, contrast, etc.—before blending them.

1. Lighter original
2. Darker original
3. Layer mask
4. Final image

This image of Three Brothers provides an easy starting point. First I opened both of the original images in Photoshop, then selected the Move tool and dragged one image on top of the other while holding down the Shift key. Holding the Shift key aligns the two images precisely on top of each other. If the images are not aligned—if the camera was moved between exposures, for example—select both layers and choose *Edit > Auto-Align Layers*.

With the darker layer on top and selected (highlighted), I clicked on the Add Layer Mask button at the bottom of the Layers Palette. Next, as when dodging and burning, I inverted the layer mask by pressing ⌘-I (Mac) or Control-I (Windows). This made the layer mask black, hiding the darker top layer and revealing all of the lighter bottom layer. Then I selected the Brush tool, chose a large, soft-edged brush, made the foreground color white, and simply painted over the sections that were too bright and appeared overexposed. Painting with white allowed parts of the darker layer to become visible and override the lighter layer. The end result was a seamless blending of the two images.

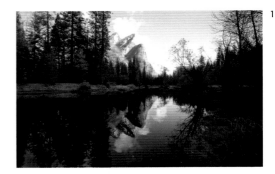

1

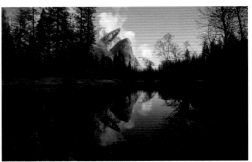

2

3

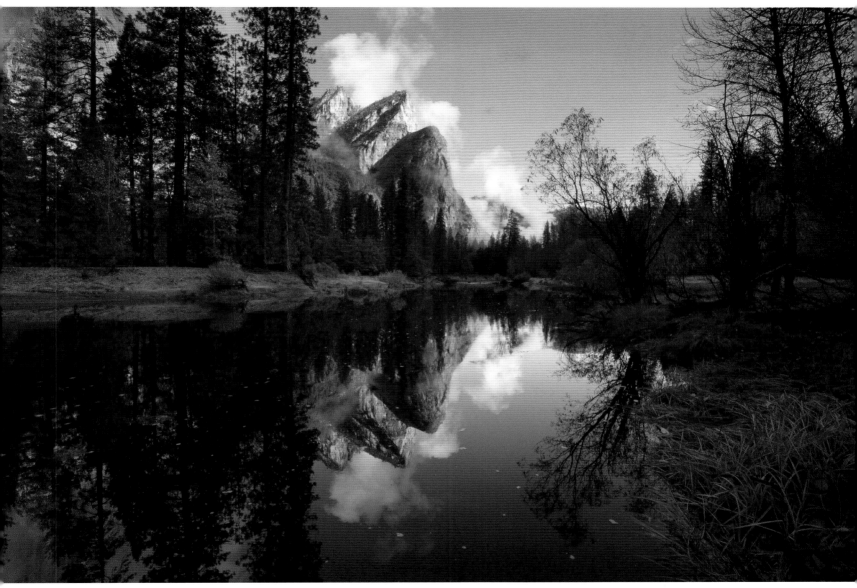

1

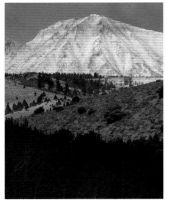

2

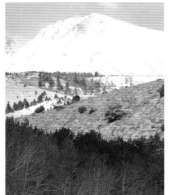

5

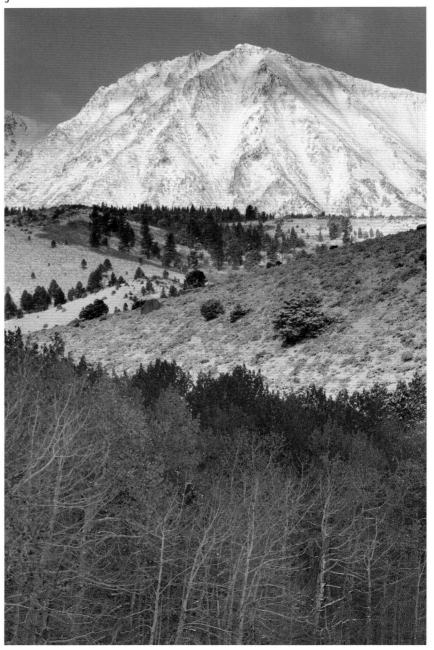

3

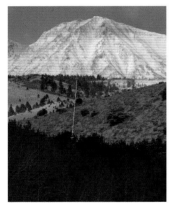

4

Gradient Blend

1. Dark original
2. Light original
3. Dragging the gradient
4. The resulting layer mask
5. Final image

Here's another simple blend, this time using the Gradient Tool to imitate the effect of a graduated neutral-density filter. This is similar to the technique described on page 137, but sometimes it's better to blend two images (1 & 2) rather than lighten part of one, as pulling detail out of dark shadows can reveal noise.

I started by shift-dragging one image on top of the other, as in the previous example. Here I put the darker image on top, then added a layer mask to the top layer. Next, I selected the Gradient Tool, chose a Linear Gradient with the "Black, White" preset, then clicked and dragged from bottom to top through the transition area (3). This made the layer mask (4) white on top and black on the bottom, with a gradual transition in between, so that the top section of this layer was visible but the bottom was masked off, allowing this part of the other, lighter layer to show through.

1

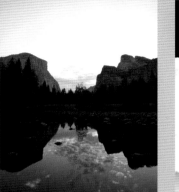

2

3

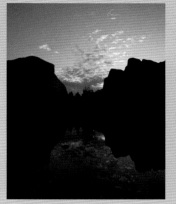

4

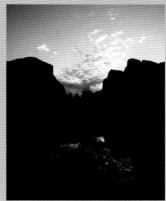

5

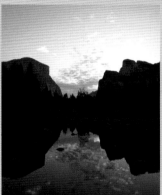

6

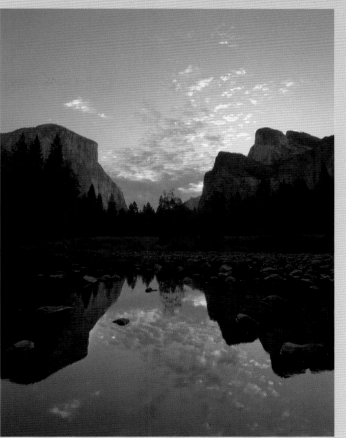

1. Top layer
2. Top layer's mask
3. Middle layer
4. Middle layer's mask
5. Bottom layer
6. Final image

In this more complex example I blended three exposures using the Color Range tool to create the layer masks.

I began by putting the middle exposure (5) on the bottom, the darkest layer (3) above that, and the lightest layer on top (1). Next I used the Color Range tool to select just the darkest areas—mostly the rocks and trees (2). With that selection active and the top layer highlighted, I clicked on the Add Layer Mask button at the bottom of the Layers Palette. Next I used the Color Range tool again, this time selecting the lightest pixels (4)—mostly the sky. With the middle layer highlighted I clicked the Add Layer Mask button again. These two steps essentially revealed the dark areas from the lightest exposure and the light areas from the darkest exposure, leaving some middle areas of the bottom layer (the middle exposure) showing through. Using Photoshop's Brush tool I manually modified the layer masks to smooth some of the transition areas to create the final result (6).

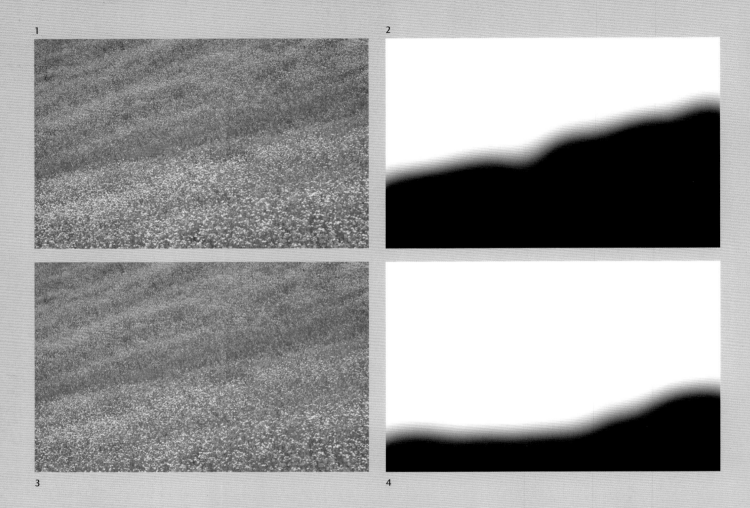

1

2

3

4

Expanding Depth of Field

Even at your smallest aperture it's not always possible to get everything in focus. The landscape masters of the past used the swings and tilts of their view cameras to change the plane of focus and achieve greater depth of field. With a digital SLR you can combine two or more images to keep everything sharp.

There are automated solutions for combining images for greater depth of field, including the Auto-Blend Layers option in Photoshop and several plug-ins. While these tools will undoubtedly keep improving, for now I get better results combining the images by hand in Photoshop.

1. Top layer
2. Top layer's mask
3. Middle layer
4. Middle layer's mask
5. Bottom layer
6. Final image

I blended these three images—one focused on the foreground, one on the background, and one in the middle—using layer masks in Photoshop. I put the layers in order from back to front—the layer focused on the background on top (1), and the layer focused on the foreground on the bottom (5). Next I added a layer mask to the top layer (2), selected the Brush Tool and a large, soft-edged brush. I chose black as the foreground color and simply painted over the out-of-focus areas—basically the bottom half of the image. This masked off those out-of-focus regions and allowed the sharper, in focus portions of the middle layer to show through. Next I added a layer mask (4) to the middle layer, and again painted with black to mask off the out-of-focus areas—mostly just the lower-right corner—allowing the sharp sections of the bottom layer to show through.

Printing

A well-crafted print is the ultimate expression of the photographer's art. Most of the work in making a digital print is done while preparing the master file, but a few essential steps remain, starting with choosing the printer and paper.

Printer Options

Digital/Chemical Hybrids

These printers, known by commercial names like Lambda, LightJet, and Chromira, use either lasers or LED lights to expose a digital file onto traditional, chemically-processed photographic papers. They are expensive, so you'll only find them at photo labs or service bureaus. Since the end result is an actual photographic print, these machines are good choices for creating a classic photographic look. The main drawback to using a lab for print output is that it's difficult to make accurate proofs. A reflective print is so different from a backlit screen that even the best monitor, accurately calibrated, can only provide a rough approximation of what the final print will look like. For critical work the only solution is to send proofs to the service bureau so they can be output on the actual device to be used for the final print, a potentially time-consuming and expensive process.

Inkjet Printers

These are by far the most popular digital printers today, and for good reason. They make beautiful prints, and are relatively inexpensive, giving photographers the opportunity to have a high-quality printer in their own home. To serious print-makers there is no substitute for experimentation and the ability to make many proofs in a short period time. The quality of the best inkjets is universally high, but there are differences. The manufacturers tend to promote features and statistics that are unrelated to print quality. The best test is a hands-on trial where you can print your own images and compare the results. Ask your friends if you can use their printers, or send files to a service bureau that uses a model you're interested in.

To render subtle gradations in tone with black-and-white prints, an inkjet printer should have black ink, of course, plus at least two gray inks. You may also want to look into specialized ink sets for black and white. Some third party manufacturers sell ink-and-software combinations that convert printers into dedicated black-and-white output using four, six, or more shades of black and gray.

Here are some other things to look for.

Blacks

While not all images need to have pure black in them, those that do benefit from having the deepest, darkest blacks possible. While not every Ansel Adams print contains pure black, the ones that do have a richness that only deep blacks can provide—something that Adams always strove for.

Color Gamut

How does the printer deal with highly saturated colors? Some printers do better with certain colors than others. Consider both the richness of the colors and the tonal separation in saturated areas. Do you see nice subtle gradations in tone, or large blotches of one color?

Gradations of Tone and Color

You should see smooth gradations in tone and color throughout the print, without banding or obvious dot patterns. Pay particular attention to the highlights and shadows to see how well the tones separate—whether you can see distinct values in these areas or whether they tend to pool into solid areas of black or white.

Bronzing and Gloss Differential

With glossy or semi-gloss papers hold the print at an angle to the light to see whether it has bronzing—a bronze sheen—in the dark areas. You may also see "gloss differential," where the print surface is shinier in the dark areas. To me, gloss differential is not as objectionable as bronzing, but it's a matter of degree.

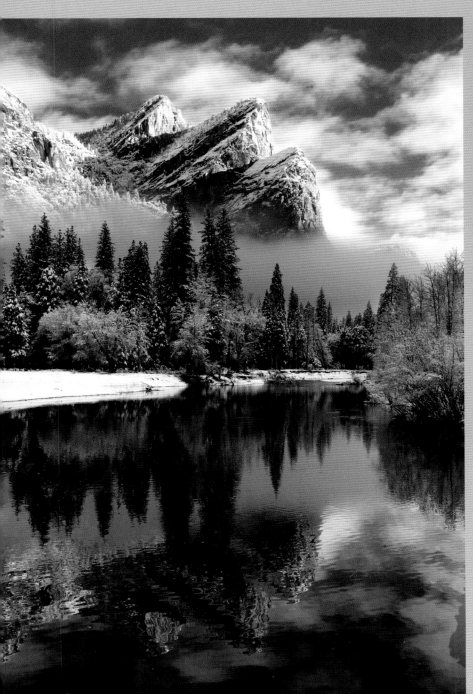

Print Quality

A good photo printer needs to be capable of rendering deep blacks, subtle gradations in tone, and highly saturated colors.

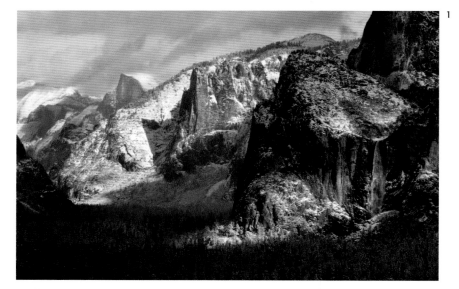

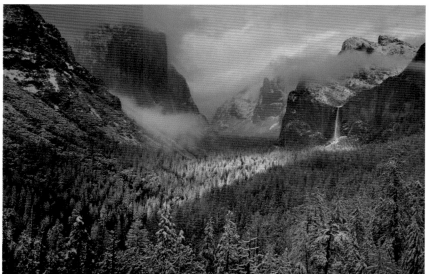

Paper Choice

Inkjet printers can produce beautiful images on almost any surface, including canvas, watercolor paper, and more traditional glossy and semi-gloss surfaces. Reacting to the soft-focus "pictorial" style of photography popular in the early 20th century, Ansel Adams and Edward Weston wanted to differentiate photography from other mediums, and advocated using smooth, glossy papers. Today, with photography firmly established as its own art form, the lines between photography and other art forms have become blurred, and any substrate can be an acceptable medium at the highest levels of photographic art.

The medium should match the message you're trying to convey. For an impressionistic look, by all means use canvas or watercolor paper. But if you want a more traditional photographic look then the crisp, clean look of glossy or semi-gloss (pearl, satin) papers will probably suit your style better and preserve more image detail and sharpness. Some of the newest inkjet papers bear an amazing resemblance to traditional black-and-white fiber-based papers.

1. Traditional Values

Classic landscapes lend themselves
to smooth papers with a traditional
photographic look and texture.

2. Proofing and Variations

The best calibrated monitor is no
substitute for making actual proofs
on the printer you'll be using for the
final output. After making a proof,
any changes you make to the image
should be applied to the master file.
The easiest way to do this is to print
proofs directly from the master file—
to send the master file to the printer
without flattening, sharpening, or
resampling it. It's possible to create
many variations of the master by
using layer groups in Photoshop,
virtual copies in Lightroom, or
versions in Aperture.

As with editing, time and distance
are vital. It's difficult to judge a print
immediately after pulling it from the
printer, but a week or month later its
flaws become obvious.

3. Soft Look, Soft Paper

Watercolor paper, rice paper, or canvas
might be appropriate surfaces for an
impressionistic high-key image like this.

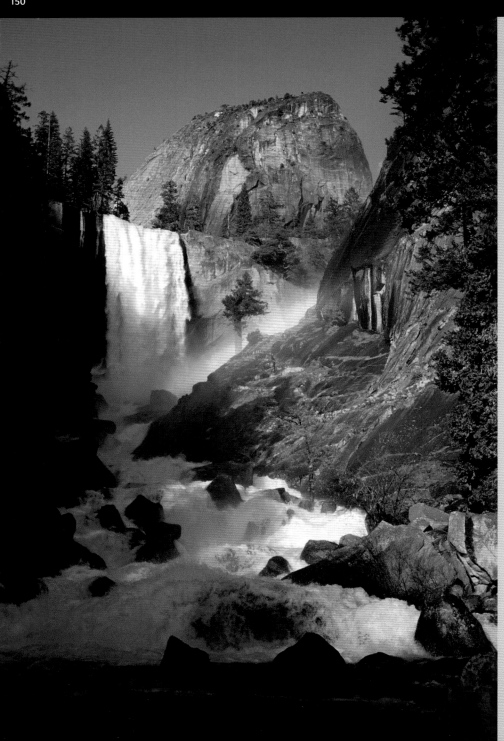

This image was captured with 35 mm film, so it has considerable grain. The upper enlarged section shows what happened when Photoshop's Unsharp Mask filter was applied to the whole image—the grain in the sky was sharpened and emphasized. Instead, I made a selection for the sky with the Magic Wand tool, inverted the selection and sharpened everything except the sky (lower detail and final).

Preparing the File for Final Output

After making proofs, a few essential steps still remain before making the final print. The specifics depend on the software and printer. The following steps apply to Photoshop. Even when I make a master file in a program like Lightroom or Aperture I usually open a copy in Photoshop to take advantage of its superior sharpening controls.

Make a copy of the Master File
If you made your master file in Photoshop, you don't want to flatten or resample the master. Make sure you've saved any changes to the master file, then select *File > Save As*. Choose a new name for the copy, and make all the following changes only on this copy, not on the master file.

Flatten the Layers
Layer > Flatten Image.

Resize
Since you're now working on a copy of the master file, it's okay to resample it—to change the number of pixels. In Photoshop go to *Image > Image Size*. Check Constrain Proportions and Resample Image. Set the print size in inches or centimeters, and select a resolution between 200 and 400 pixels per inch (ppi). Below 200 ppi the print may start to fall apart and become pixelated. There is no advantage to resolutions higher than 400 ppi, and no point in making the file larger than it needs to be.

Sharpen
In Photoshop use the Smart Sharpen or Unsharp Mask filters. Fine details like leaves, twigs, grasses, and the like can be enhanced by using a high Amount and low Radius with the Unsharp Mask filter. I typically use Amounts between 200 and 300, Radius settings between 0.3 and 0.5, and keep the Threshold at 0. If I want to avoid sharpening grain or noise in smooth areas like sky or water, I make a selection for those areas using any of the tools available in Photoshop (Magic Wand, Quick Selection, etc.), invert that selection, and save it as an alpha channel in the master file. Then, when I'm ready to sharpen a copy of that master file, I load the selection by ⌘-clicking (Mac) or Control-clicking (PC) the channel, then apply the Unsharp Mask filter.

Color Management and Printer Profiles

A printer profile translates the colors of the image to numbers that will look right on the printer. For example, Photoshop may describe a color as 80 red, 50 blue, and 120 green. The profile may need to send the numbers 90 red, 60 blue, and 105 green to the printer for that color to reproduce correctly—to match how it looks in Photoshop on a calibrated monitor.

Most printers come with their own profiles, installed with the driver software. How well these "canned" profiles work depends on the manufacturer's consistency. If all the same model printers are built to close tolerances (more likely with more expensive printers) then the same profile can work well for all the individual devices. If not, then you may have to make custom profiles for each paper you use. There are third party companies that make custom profiles, or you can purchase a software/hardware solution. You get what you pay for with these.

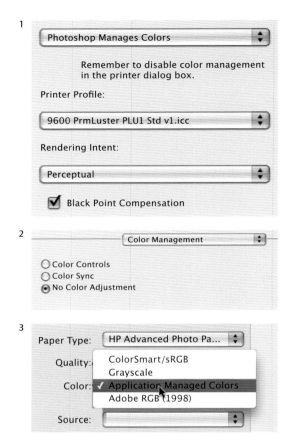

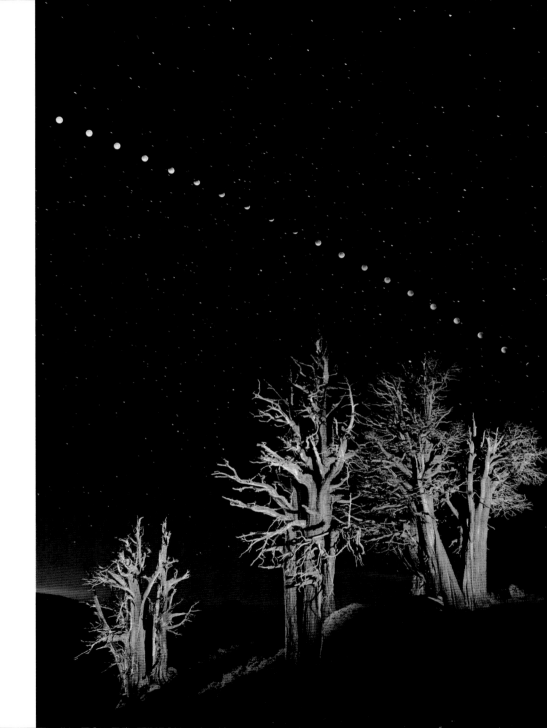

Managing Colors

1. Choosing Profile
2. Epson Color
3. HP Color

1. In most cases you're better off
choosing the printer profile yourself.
In Photoshop that means picking
"Photoshop Manages Colors," and
selecting the correct profile for the
printer and paper. Either Perceptual
or Relative Colorimetric are good
choices for the rendering intent.
Colorimetric may yield more saturated
colors, but subtle gradations of tone
in those saturated areas may be lost.

2 & 3. If you chose "Photoshop
Manages Colors" you'll want to avoid
having the printer software apply it's
own profile or color adjustment. Each
printer has it's own nomenclature;
Epsons and Canon printers it is usually
"No Color Adjustment;" while for HP
printers it's usually "Application
Managed Colors."

Lunar Eclipse Sequence

A calibrated monitor, precise printer
profiles, and proper color management
are essential for getting accurate
color in digital prints.

Black and White Settings

If your black-and-white image was captured in full color and then converted to black and white in software, your master file is still essentially a color RGB image with some instructions (either in the form of an adjustment layer in Photoshop or settings applied in a Raw processor) for the black-and-white conversion. When you copy this master file for printing, you can either keep it in RGB or convert it to Grayscale before sending it to the printer. The advantage of keeping it in RGB is that you can add an overall tint, but it's very difficult to add subtle toning reminiscent of traditional black-and-white prints this way—the tints are usually too strong, or not quite the right color. Some printers have options for tinting in the Print dialog, and these are often a better choice. You may also have an option for using only gray inks, which may not give you any toning options but may at least prevent your print from having an objectionable color cast. Special tinted ink sets are also available, but that locks you into the same tonal range for all your prints.

Toning Black-and-White Prints

Subtle toning of digital black-and-white prints is hard to achieve (and impossible to reproduce here). Inkjet printers designed for black-and-white output often have special settings for producing tints or neutral grays.

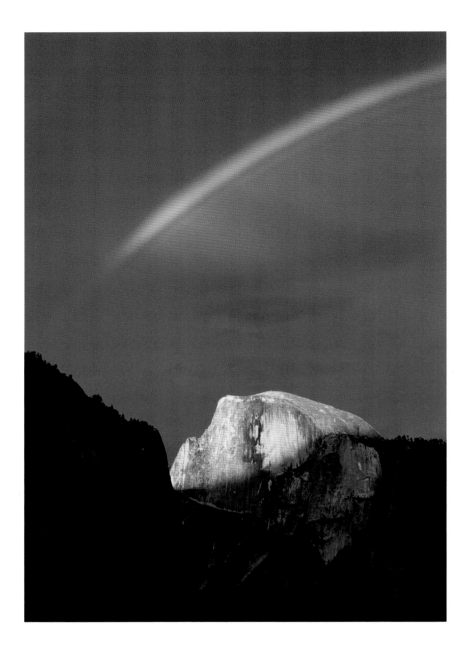

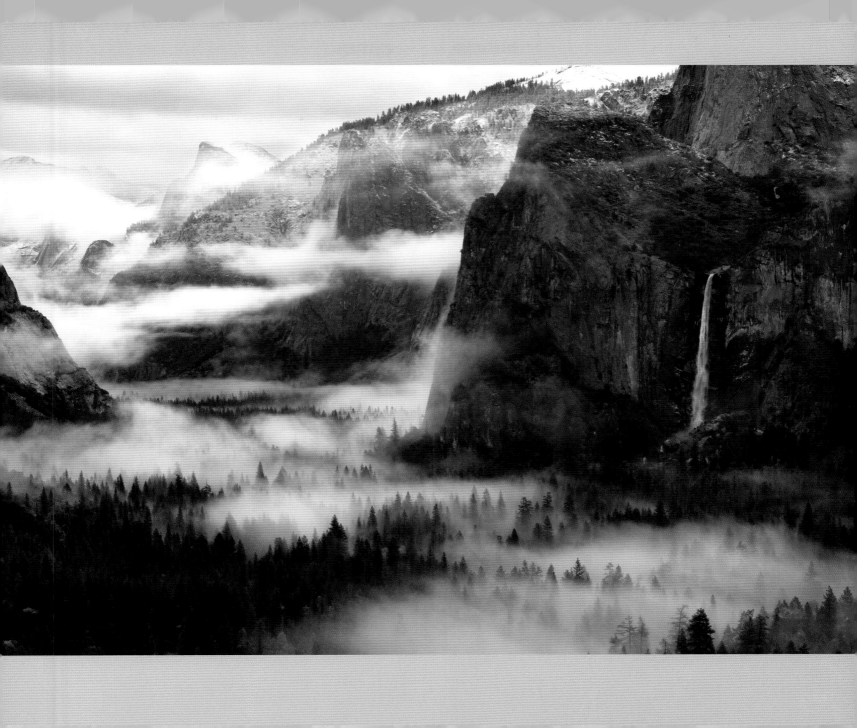

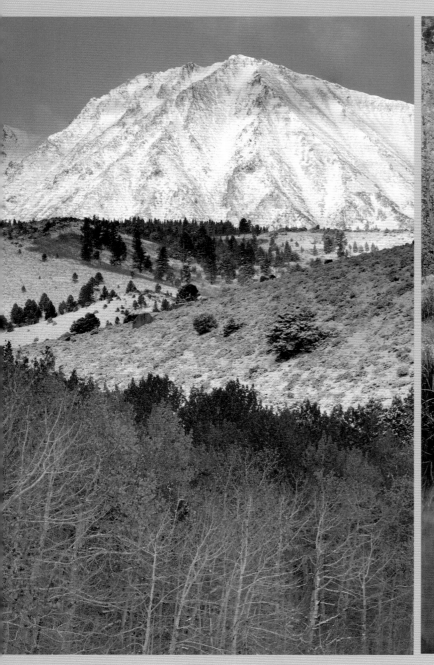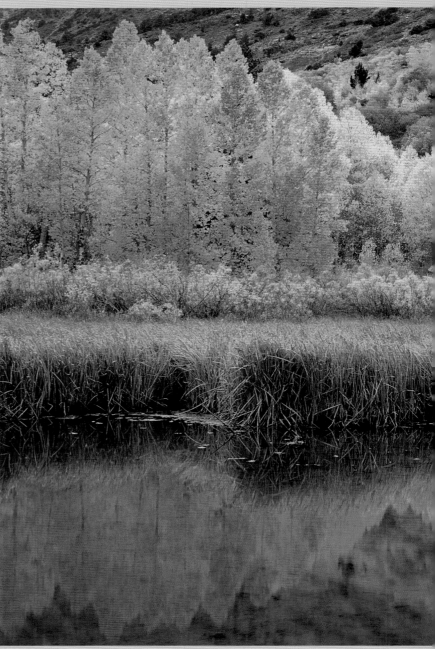

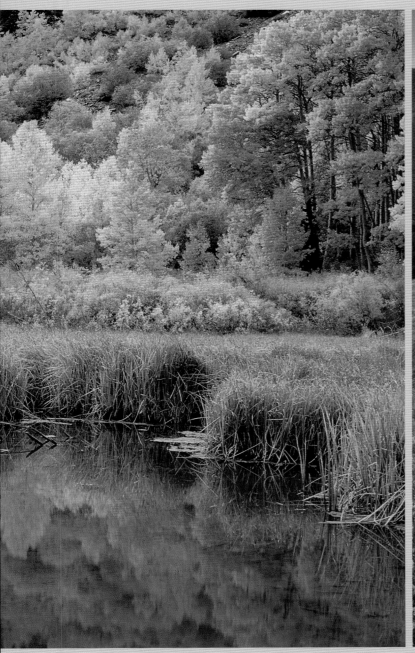

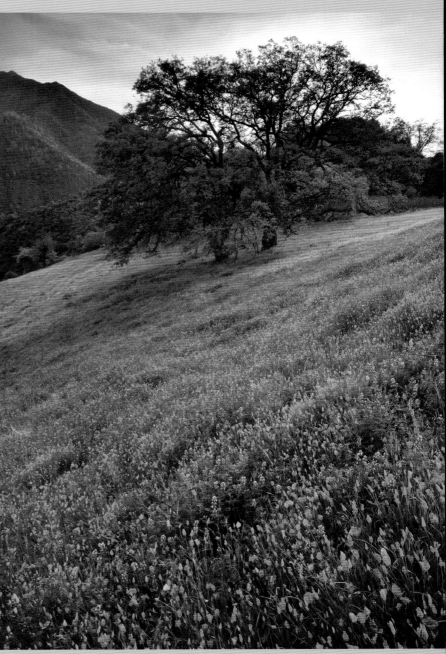

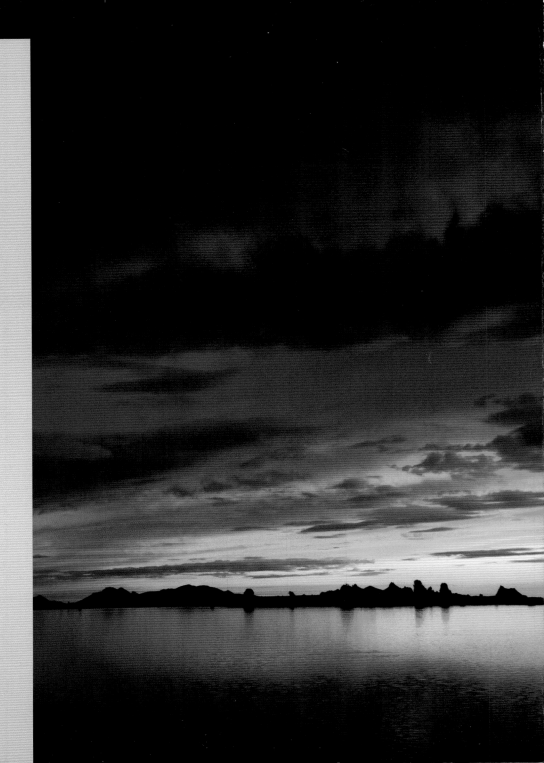

Picture Credits

Edward Weston Image, page 10
Dante's View, Death Valley, 1938
Photograph by Edward Weston
Collection Center for Creative Photography
©1981 Arizona Board of Regents

Eliot Porter Image, page 52
Eliot Porter, Pool in Mystery Canyon,
Lake Powell, Utah, 1964
Dye imbibition print (Kodak dye transfer)
© 1990 Amon Carter Museum, Fort Worth, Texas,
Bequest of the artist, P1990.51.5268.1
http://www.cartermuseum.org

Ansel Adams Images, pages 46, 68, and 102
© Ansel Adams Image Rights Trust / Corbis
www.corbis.com

SCARLET HILTIBIDAL

ANXIOUS

FIGHTING ANXIETY WITH
THE WORD OF GOD

Lifeway Press®
Nashville, Tennessee

Published by Lifeway Press® • © 2021 Scarlet Hiltibidal
Reprinted September 2021

ISBN: 978-1-0877-3386-9
Item: 005829921
Dewey decimal classification: 152.4
Subject heading: FEAR / ANXIETY / PEACE

To order additional copies of this resource, write Lifeway Resources Customer Service; One Lifeway Plaza; Nashville, TN, 37234-0113; FAX order to 615.251.5933; call toll-free 800.458.2772; email orderentry@lifeway.com; or order online at *lifeway.com*.

Printed in the United States of America

Lifeway Resources
One Lifeway Plaza
Nashville, TN 37234-0152

EDITORIAL TEAM,
LIFEWAY WOMEN
BIBLE STUDIES

Becky Loyd
Director, Lifeway
Women

Tina Boesch
Manager, Lifeway
Women Bible Studies

Sarah Doss
Team Leader, Lifeway
Women Bible Studies

Sarah Doss
Content Editor

Erin Franklin
Production Editor

Lauren Ervin
Graphic Designer

TABLE OF CONTENTS

DEDICATION

For Kaye Geiger, who led me through Bible studies on her living room floor, who discipled me without me knowing it by letting me come through the unlocked garage door, and who helped me laugh and cry and pray and learn.

ABOUT THE AUTHOR

Scarlet Hiltibidal is the author of *Afraid of All the Things* and *He Numbered the Pores on My Face*. She writes regular columns for *ParentLife Magazine* and devotionals for *She Reads Truth* and enjoys speaking to women around the country about the freedom and rest available in Jesus. Scarlet has a degree in biblical counseling and taught elementary school before she started writing. She and her husband live in Southern California where she loves signing with her three daughters, eating nachos by herself, writing for her friends, and studying stand-up comedy with a passion that should be reserved for more important pursuits.

INTRODUCTION—
ANXIOUS TO BE HERE

I HAVE TOLD YOU THESE THINGS SO THAT **IN ME YOU MAY HAVE PEACE.** YOU WILL HAVE SUFFERING IN THIS WORLD. BE COURAGEOUS! **I HAVE CONQUERED THE WORLD.**

John 16:33

INTRODUCTION

We live in a broken, sad, scary place. There is plenty to be anxious about:

- dying;
- black holes;
- cancer;
- the fact that our phones have cameras on them that just sort of turn on sometimes;
- hurricanes;
- failing as a mom/friend/wife/employee/intermittent faster.

And the world is full of insufficient solutions for our anxiety:

- food;
- clothes;
- friends;
- medicine;
- hobbies;
- achievements;
- _____

Here's the thing. Nothing really works every-moment-all-the-time-perfectly-and-forever, right? Have you gotten to that point? That point where the counselor's advice just doesn't seem to stop the mind spiral quickly enough? Your closet is full of clothes, but your heart is still full of worry? You get the promotion, win the award, and achieve the goal, but instead of the peace it promises, you only find more fears? The bottom of the queso cup appears alarmingly fast, and you're left asking yourself, maybe out loud, *AM I JUST MORE MESSED UP THAN EVERYONE ELSE?*

I've been in that place so many times. I've been a slave to my panic, planning and avoiding and doing everything I could to insulate myself from pain and discomfort. But none of it worked.

So I made my life quiet. Isolated. "Under control."

I thought that would make me peaceful.

It didn't. Isolation and "control" might produce a quieter life, but peace isn't a quiet life; peace is a quiet soul. Peace is the gift of Jesus through the work of Jesus that we can have no matter what is going on in our living rooms or our in-boxes or our Instagram® feeds. The loudest of lives can't overwhelm the quiet that comes from Christ.

True peace comes when we learn to hold God's Word up to what worries us. There, we learn we can't fix ourselves; we can't protect ourselves. Instead, the Bible tells us we can rest, knowing Jesus walked into the broken, sad, scary place to rescue us and love us. He is the One who fixes. His is the only protection that matters.

When we fear the Lord rather than fearing the brokenness in our world, we can take hold of the perfect peace that is only available in Him.

The peace we are looking for is found in the already finished work of Christ (more on that later) revealed to us over and over again in God's Word, through prayer, and with our Christian community. When those of us who live with tornado awareness and constant cancer concern see the power of Jesus in the pages of the Bible, we can say with certainty, "The LORD is on my side; I will not fear. What can man do to me?" (Ps. 118:6, ESV).

WHERE ARE WE HEADED?

In this study, we'll look at different people in the Bible and what we can learn from them about anxiety. We'll discover how to live in freedom by clinging to God's Word and God's gospel in community and in prayer. This Bible study book will challenge you to study Scripture as you fight your worries. It will help you put some spiritual disciplines in place that will aid you in keeping your eyes on the cross of Christ (even if you've just seen an article show up on your Facebook® feed about the real-life dangers of black holes).

HOW DO I USE THIS STUDY?

This study is meant to be used in a small group setting. You are welcome to do this book on your own, but the study is designed to be done with others. Fighting anxiety alone is a lot like fighting an army alone. Imagine walking onto a battlefield by yourself while surrounded by enemies with bigger guns and stronger muscles. Actually, don't imagine that. This is supposed to help you with your anxiety, not add to it.

Every person should have her own Bible study book, a Bible, a pen, and some snacks.[1] In this book, you'll find personal study that you can do individually and a memory verse that you can learn on your own (and review together as a group). Also, flip to pages 186–187 in the Appendix to keep some of my favorite on-the-go, anxiety-blasting Scriptures handy! Then, when you come together, you'll watch a video and discuss your answers from the week's work as a group. **You'll find detailed information for how to access the teaching videos that accompany this study on the card inserted in the back of your book.**

During the final session of this study, we'll dive into what God's Word says about fighting anxiety together—why it is important and how the body of Christ is so vital in our approach to combating the lies anxiety tells us. I hope this study helps you as you engage with Scripture personally, and I hope you can use your personal study and experiences to encourage the other people in your group when you meet together.

So grab your five nearest neighbors. Or text your twelve closest coworkers. As a last resort, call your grandma and your sister and the lady that knows your order at the local Starbucks® and ask them to join you.

You'll find detailed information for how to access the teaching videos that accompany this study on the card inserted in the back of your Bible study book.

1. Snacks are not required but strongly recommended.

WHAT IF I NEED MORE THAN A BIBLE STUDY?

This study probably won't fix all your problems.

In 2004, Tim Keller preached a sermon called, "The Wounded Spirit." It had such an effect on me that I shared a good portion of it in the book I wrote about my personal fight with fear—*Afraid of All the Things*.

The thing is, I've been on anxiety pills. I've sat across from Christian psychiatrists while they offered big-word diagnoses to explain my particular version of anxiety.

I lived years feeling shame and fear over my mental weaknesses. I thought if my friends really knew how I struggled in my mind, they would reject me.

This sermon changed that for me. In it, Keller talked about different sources that might contribute to our woundedness and weakness. He didn't say, "Why are you so messed up? Just pray more!" He said, ". . . you know what the biblical answer is? It's complicated."[2]

That's what I want you to hear from me as you walk into this study. Your brain is complicated. Your anxiety could be rooted in an existential issue, or maybe for you, it's mostly physical. Maybe you have a bum thyroid. (I had mine taken out last year and the hormonal imbalance it causes can absolutely lead to anxiety and depression.) Maybe, as Proverbs 28:1 says, you flee "when no one pursues" (ESV) because you are intentionally walking in wickedness. In that case, a pill or a therapy session won't fix you like repentance will.

That's the driving message of Keller's sermon. There are many contributing factors. We must rely on prayer and God's Word, but we can do so while knowing that we might be dealing with physical sources or sin sources or emotional sources or existential (the BIG questions, like *What is life?*) sources. It's important to recognize these things as you fight your personal battle in your own personal way.

This study will not replace thyroid hormone medication or any other prescribed and necessary medication or weekly meetings with a Christian counselor or taking care of your health and well-being. Pursuing those outside resources, if and when needed, is wise and wonderful. Rather, this study is designed to help you, wherever you're at and whyever you're at it, to pursue Jesus in His Word, give you a better understanding of who He is, and learn how to set your mind on the things above (see Col. 3:2) and how to live your life consumed by the ultimate peace and joy of walking with Christ. If you find yourself needing a bit more support than this study offers, I encourage you to reach out to your local church or some trusted friends. I can look back on so many times in my own life that I needed help, and my Christian community, friends, and counselors definitely held me together during those times.

WILL IT ALWAYS BE THIS WAY?

About that "ultimate peace." I've never written from the stance of "I've overcome anxiety and so can you." If you're looking for ten easy steps, you won't find that here. In our broken world, it's a constant temptation to find a final fix. We hope to check the box and expect smooth sailing from then on. We will absolutely have smooth sailing someday. Just not in this world. The seas of this world have hurricanes. But the Lord has reminded me again and again, through His Word and His Spirit, that ultimate peace is our hope someday, but abundant life is available today.

Forever peace is coming, but present peace must be pursued.

We must learn to expect and accept the suffering Jesus promised us—"In this world you will have trouble . . ." (John 16:33, NIV)—all the while straining to see through all the sad and scary to the second half of the verse. There is Jesus, who tells us, ". . . take heart! I have overcome the world" (v. 33, NIV).

My hope is you'll walk into this study not looking for magic words that make fear disappear from your life forever but rather looking to and leaning on Jesus, who has already overcome everything that makes you anxious.

NOTES

As you begin, give each member a Bible study book. Make sure to watch the video and go through the introductory material so everyone knows what to expect from this study. This week, you will complete the personal study for "Session Two: Anxious David." When you get back together next week, you will watch a video on Session Two and discuss your answers. As for this week, just watch the Session One video and use the discussion guide below to get to know one another.

WATCH

Write down any thoughts, verses, or things you want to remember as you watch the video for Session One of Anxious.

DISCUSS

Share names, family information, favorite restaurants, educational/vocational backgrounds, and current favorite things.

Do you struggle with anxiety? What does that battle look like in your life today?

Have you seen anxiety affect others in your community? Explain.

What are some ways you have tried to fight anxiety in the past? What helped? What didn't?

What are you hoping to take away from this study at the end of the eight weeks?

PRAY

As a group, take turns sharing prayer requests and figuring out how you want to pray for one another throughout the week. Maybe someone wants to take notes and send out a weekly email. Maybe you could all write your requests in a notebook. Find out what works for your group and make sure you have a way to touch base throughout the week. Close in prayer.

To access the teaching sessions, use the instructions in the back of your Bible study book.

NOTES

ANXIOUS DAVID

JESUS IS OUR SHIELD IN
THE FIGHT AGAINST ANXIETY

MANY SAY ABOUT ME,
"THERE IS NO HELP FOR
HIM IN GOD." SELAH.
BUT YOU, LORD, ARE
A SHIELD AROUND ME,
MY GLORY, AND THE ONE
WHO LIFTS UP MY HEAD.

Psalm 3:2—3

DAY ONE
PRETEND INSANITY

1 Samuel 21:10-15 and Psalm 34

I have a lot of great conversations with myself while boiling water. When I'm doing tedious household things, my mind tends to wander to hypothetical relational problems. What if there's assigned seating at my step cousin's baby shower in two months, and what if her former roommate/friend is there and we're seated right next to each other, and what if she asks if our kids can get together for a playdate, which should be no big deal, and I guess the normal answer is "Sure!," but last time our kids got together, her kids taught my kids how to break into a car and start it with a bobby pin. So what am I going to say if she asks about that playdate? Maybe I just shouldn't go to the baby shower.

I'm exaggerating, but please tell me I'm not the only one who practices conversations for uncomfortable scenarios that don't actually exist yet.

Check one.
- ○ You're the only one who does this.
- ○ You too? This is exactly why I don't boil water.

It sounds crazy when I think about it, but that's what my brain does. Sometimes I'm afraid of people and the potential problems that come with people, and I think I can conversation-practice my way to peace. Let's see what David did when he was worried about potential relational conflict.

Read 1 Samuel 21:10-15. How did David act in the face of a threat to his safety? Write any observations in the space below.

Today, in 1 Samuel, we read about when David was so afraid of how King Achish might treat him that he pretended to be a crazy person. Pretty brilliant, right? It is amazing how our worries can lead us to behave. Maybe you tend

to get tense and angry when you feel anxious about how others think about you or what they might say or do to you. Maybe you get defensive. Maybe you, like David, behave in ways that will scare people away. I mean, lion- and giant-slaying King David, of God's own heart, literally scribbled and drooled. Or maybe you isolate and put your phone on airplane mode so the texts and expectations can just stop for one minute, please!

How do you tend to struggle when it comes to relational anxiety?

Read Psalm 34.

Psalm 34 was actually written by David about this very time in his life—when he pretended to be a crazy person in the presence of Abimelech (probably the same guy mentioned earlier as "King Achish" in 1 Sam. 21:10-15).[1] David clearly knew what it was like to be anxious when he wrote this psalm.

Now let's focus on verses 1-4 of Psalm 34 for a second. How would you describe David's posture as he shared this message?

Sometimes, when I'm afraid, I forget how to pray. I forget how to think like a daughter of God. I panic and don't know what to say.

What do your prayers to the Lord sound like when you're stuck in a panic?

In verse 4, David said he "sought the LORD." Read the verse again and write what the Lord did as a result.

What do you think it means to seek the Lord?

What does verse 5 say is a result of looking to God?

When was the last time you felt joyful and void of shame? What was your relationship with God like at that time?

Read verse 8 from the CSB translation online. What emotion does the Bible say people who take refuge in God have?

On a scale of 1 to 10, how "happy" does your heart feel right now? (If you looked it up in a different translation, you may have seen the word blessed.) What do you think would move you closer to a 10?

Not too happy:

| 1 | 2 | 3 | 4 | 5 | 6 | 7 | 8 | 9 | 10 |

The happiest:

Take the next few minutes to think about what it means to take refuge in the Lord. What are some things you find refuge in, apart from the Lord? What do you need to cut from your life or add to it to help you seek Him when you feel anxious?

In verse 11, David talked about teaching "the fear of the LORD." Fear is not a bad thing when it is focused on our Father. It's when we fear the wrong things that we feel anxiety.

What does God's Word say the fear of the Lord leads to? Look up the following verses and write the answer beside them.

Psalm 25:14

Psalm 33:8

Proverbs 9:10

Proverbs 14:26

Proverbs 14:27

Proverbs 19:23

Proverbs 22:4

Luke 1:50

When we fear the Lord, we gain. When we fear the Lord, it is easier not to worry about the things the Lord has already defeated. When we fear the Lord, we remember He is our shield and protector.

Read Psalm 34:9.

When we fear the Lord, what do we lack?

What are some misplaced fears you have right now? How does the work of Jesus impact those worries?

I'm not into war movies or battle-y things in general, but the idea of being shielded sounds awesome to me. If I could just be shielded, at all times, from danger, from conflict, from sadness—my heart longs for that. When I'm doing the boiling-water-conversing thing I told you about, what I'm really doing is trying to prepare and protect myself. David's interpersonal conflicts were much more murder-y than mine tend to be, but it's convicting and inspiring to me that he sought protection and refuge in the Lord.

Close out this time asking God to help you rest in the reality that He is eternally shielding you from the things that would harm your soul.

DAY TWO
DOEG IS NOT COOL

1 Samuel 22 and Psalm 27

I sat in a therapist's office last week and used my fifty allotted minutes to detail every relational conflict I could recall being involved in for the past fifteen years. My counselor wanted to know what my goal was—why I was seeking counseling and why I wanted to talk about closed-door conflicts from years past.

I said, "I feel haunted by my relational failures. I feel shame over the times I felt misunderstood. I just want to feel peace even though there are people from my past who might not think happy thoughts when they think of me."

Sometimes, I feel trapped by anxieties, stuck with thoughts of those I've been at odds with at one point or another. Maybe I've not had the same kinds of enemies, who carried swords and sought to kill, that David had, but I've had people who weren't for me. To one degree or another, we've all experienced enemies. It sure can feel like you have an enemy when you lose a friend. It sure can feel like an enemy when things don't go as planned and you're walking through a divorce you never thought would happen, or when, yet again, an attempt to reconcile with an estranged family member ends in tears.

Enemies. No matter what form of conflict they bring to our lives, what do we do with them, and how can we find peace?

I'm really encouraged when I read about how David responded in prayer over his enemies. We're going to take a look at a psalm he wrote that theologian Charles Spurgeon thought was likely about a particular enemy of his named Doeg.[2] But first, let's get a little background on Doeg and how his life intersected with David's.

Read 1 Samuel 22 and answer the following:

What did Doeg tell Saul about what he witnessed between David and Ahimelech?

What did Saul command be done to Ahimelech and his priests for protecting David? Who carried out Saul's command?

Psalm 52 was written by David about the whole Doeg ordeal. It's definitely worth a read. But the Psalm I want you to open up to and focus on is Psalm 27. Though uncertain, Spurgeon believed David wrote this Psalm about Doeg as well.[3] And regardless of the motive, it is a powerful song for those of us who struggle with anxieties about enemies.

Read Psalm 27.

Write out the first phrase of each sentence in Psalm 27:1. Also, write out the two questions David posed in this verse.

David asked whom he should fear and whom he should dread, but he answered those questions even while asking them. What is the answer?

When the LORD is your light, salvation and stronghold, there is nothing else to fear. "LORD," or Jehovah, is the proper name of the one and only God of the universe. LORD means "The Existing One."[4] That means God doesn't just exist, but that He must exist. The LORD is the One from whom everything else that exists gets its existence. We may have enemies, but we also have the LORD. The ENT office receptionist who said you talked too fast, or the hurricane headed toward your coast, or even the hotdog you are scared to eat because your esophagus seems to be hotdog-shaped—everything and everyone is at the mercy of The Existing One. Your enemies are never more powerful than your LORD.

He is the stronghold of our lives. He is our light and our salvation. He is our source of true protection. We don't get to finish reading this page in this book without Him giving us the breath in our lungs, the sight in our eyes, and the clarity of our minds to do it.

What are some things/people/situations you sometimes fear rather than fearing the Lord?

Now back to Psalm 27. Reread verses 1-4. How do these verses help you get your mind off of your enemies and onto Jesus?

The Bible, the Old and New Testaments alike, are about the work of Jesus. When we read the first four verses of this psalm, as Christians living after the resurrection, we can see Jesus as the ultimate fulfillment of David's hope and the ultimate reason our enemies shouldn't cause anxieties. Through the work of Christ on the cross, we have received salvation forever. At the cross,

our greatest enemies stumbled and fell. We can be confident, as David was, because we have a Jehovah who is also our Rescuer and proves our enemies are no match for Him. See "Becoming a Christian" on page 184 in the Appendix for more information about the Christian faith and how to commit to being a Christ-follower.

What was David wanting and asking of the Lord in verse 4?

What other verses can you think of that remind you that the God whose power dwarfs enemies like Doeg and Satan and everyone else is also whom we should most desire and whom we can most be satisfied in?

Our Lord, the conqueror of enemies, isn't just "The Existing One." He is our good Father and the giver of joy.

Copy the following verses below each of them:

For you did not receive a spirit of slavery to fall back into fear. Instead, you received the Spirit of adoption, by whom we cry out, "Abba, Father!"

ROMANS 8:15

You reveal the path of life to me; in your presence is abundant joy; at your right hand are eternal pleasures.

When you're stuck worrying about your enemies, are you able to worship? If you can, get alone in this moment and sing God one of your favorite songs of praise.

If you don't feel like you can worship, and I know sometimes this happens to us, would you consider taking a moment to write an honest prayer to God below? Or reaching out to a trusted Christian friend with your struggle? God wants to know the truth of what's happening in your heart and mind and so does your faith family.

The last verse in Psalm 27 says, "Wait for the LORD; be strong, and let your heart be courageous. Wait for the LORD" (v. 14). The word wait, in the original Hebrew, means "to wait, look for, hope, expect."[5] When we look for, hope in, and expect our God to come through, we can be people of courage, even those of us (Hi!) who tend to lean more into worry.

What are some ways you can "Wait for the LORD" as you battle your fear of people?

God is able to shield us from pain because He went to the cross and took the pain. There is now no barrier between us. In Christ, there is a shield for us who trust Him. He is on our side. He is our defender. We don't need every human in the world to understand us when the God who made us and knows us—our best parts and the very worst ones—loves us that much.

At the end of the therapy session I mentioned earlier, my counselor helped me realize I was longing to tie up a bunch of loose, frayed ends in a world where not everything can have beauty and closure. Some things remain unfinished, unsaid, unheard, untied, unraveled. But see, we have a Shield. Not to protect us from all pain, but to protect us from pain that lasts forever. God is the only relational being who can love us perfectly and forgive us fully, and He does. The more I meditate on that, I know my eternity ends finished, tied, heard, and beautifully held together. Then it is easier for me to make peace with today's loose ends.

Close out this time asking the Lord to help you feel forever peace in a world that's lacking it.

DAY THREE

WHEN PRAYER TIME WAS THE WORST

Psalm 61

When I was nineteen, I was a hostess at a local restaurant known for its great salads. I started dating my husband who was a church planter/worship pastor and quickly left the great salad place to join the small church staff as the administrative assistant.

I'm embarrassed to admit this, but my least favorite part of our staff meetings was the prayer time.

Once a week, we'd all sit on the floor in our pastor's office and take turns praying. I'd listen to our pastor pray, then my husband, then the youth pastor, and, at that point, my heart would be beating out of my chest.

I hated prayer time.

Of course I understood the value of staff prayer. And of course I wanted to talk to God. But all I could think about while sitting in that little warehouse office space was what my words would show the other people in that office about how unspiritual I was. I wasn't in the prayer time to worship and to seek the Lord on behalf of the people we were serving together. I just hoped to say something that would garner a "Yes, Lord" or a nice, dramatic "Mmmm" from someone else in the room. I worried my prayers wouldn't seem potent enough for the people listening. But David modeled for us that prayer isn't something to worry about; rather, it is a weapon we can use against our worries.

Psalm 61 records one of David's prayers. It was definitely not the kind of prayer that might be said under duress in a church warehouse office space. David's prayer is earnest and needy and beautiful.

Scholars believe this psalm was written after David had come to the throne and was likely when his son, Absalom, was rebelling against him (which you can read about in 2 Sam. 15–18).[6] It was certainly a time when anxiety would be understandable.

Read Psalm 61:1-4 and reflect on David's tone with the Lord. Do you approach the Lord similarly?

When I read those first two verses, it struck me that David was pretty direct. He was so serious. He didn't say a bunch of words out of tradition or compulsion, as I did in the church office and still sometimes do today, but rather, he talked to God like he was talking to a real person.

Spurgeon noted that David's tone "was in terrible earnest." Then he said, "Pharisees may rest in their prayers; true believers are eager for an answer to them: ritualists may be satisfied when they have, 'said or sung' their litanies . . . but living children of God will never rest till their supplications have entered the ears of the Lord God of Sabaoth."[7]

Take a minute to read that over again. That convicted me so hard. I don't want to be a person who worriedly chants religious phrases in order to feel satisfied or make other people think I'm holy. I want to know and speak to the living God. Don't you?

Verse 2 says, "I call to you from the ends of the earth when my heart is without strength."

During seasons of anxiety or fear, we can approach the Lord in prayer and find Him to be a "refuge" and "rock" and "strong tower" as David described Him in verses 2-3. But anxiety often keeps us from that. It keeps us stuck in our own loop of fears—whether they are, *What will this church staff think of*

my prayer? or What will happen if my husband loses his job? or What is this lump under my arm?

What's your first course of action when feeling anxious? Is it prayer? Is it TikTok®? Is it chips and queso?

Reread Psalm 61:4.

How do you think it helped David to pray this while dealing with exile?

Have you ever found comfort in your eternal destination while dealing with right-now suffering? What made that possible for you?

I just love verse 4. In fact, I think it is worthy of a nice "Mmmmmm." In that verse, we witness David doing the most wonderful and biblical thing, which I imagine crushed the anxiety he was facing. He, as Colossians 3:2 tells us to do, "set [his mind] on things above, not on earthly things."

In the following space, write down some right-now anxiety-inducing things in your life. And beside each one, find a Bible verse that helps you "Set your mind on things above" in regard to that struggle.

Now, read Psalm 61:5-8. Notice the change of tone.

Commentary writer Matthew Henry said, "David, in this psalm, as in many others, begins with a sad heart, but concludes with an air of pleasantness—begins with prayers and tears, but ends with songs of praise."[8]

That is so beautiful to me because I've experienced it. We can look at David's prayer in Psalm 61 and model our own anxious prayers after it. We can speak to the Lord directly and earnestly without pretense. We can set our minds on the eternal hope He offers, and we can conclude our prayers experiencing real peace, real hope, and real communion with the Father who loves us.

Below, write a prayer from your own heart and try to model it after Psalm 61. Be honest, reflect on eternity, and praise the Lord who is bigger than your worries!

DAY FOUR
CHASED AND HECKLED

2 Samuel 16:5–14 and Psalm 3

The heading for Psalm 3 in the CSB translation says, "Confidence in Troubled Times." When do you feel confident? Do you usually feel confident in "troubled times"?

My answer is certainly NO. When we lost our first baby in an ectopic pregnancy, I barely left my bed for months. When we adopted our middle daughter, who appeared to have significant physical and cognitive developmental delays, I barely left my bed for days. I've often buried myself under blankets in troubled times.

How do you usually react when times are troublesome?

Before we get any further, I want to say that making space to grieve is important. And we can turn toward God, even in our grief. He wants to sit with us in it, to carry us in it. All clear? Great. Back to Psalm 3.

The Bible tells us this was "A psalm of David when he fled from his son Absalom." You may remember from yesterday's study that this is the same time period scholars believe David penned Psalm 61.[9]

The events that led to the writing of this psalm are found in 2 Samuel 15–18 when David was betrayed by Absalom and others in his life. Absalom was leading a rebellion against his dad, the king. People who were at one time

his friends turned against him. It was an undoubtedly troubled time in the life of David. It was, what some theologians might call, a "where's my blanket" moment.

Read 2 Samuel 16:5-14. Now, let's look more closely at verses 5-8. Who was Shimei, and what was he doing?

Read verses 11 and 12 again. What emotion do you pick up on from David? How did his response reflect a trust in the God of justice?

In verses 13 and 14, David moved on down the road, going his way while Shimei went on cursing him. Then it says, David "refreshed himself" (v. 14, ESV). It's really crazy to me that David was able to experience peace given his circumstances. Remember—he was on the run from his own son! His son, who should have been in his corner. And then, he was being heckled by this Shimei guy. And somehow, "he refreshed himself." There's no way unless God was helping him, right?

Now, flip to Psalm 3 and read the whole chapter. Take a closer look at verses 1 and 2.

I wonder if his "refreshing himself" was similar to the prayer we find in Psalm 3?

In Psalm 3:3, David called God his shield, his glory, and the lifter of his head. Below, next to these powerful names for God, explain how these terms were refreshing for David in his time of trouble and how they might be of help to you.

SHIELD	
GLORY	
LIFTER OF MY HEAD	

God is our protector (shield). Nothing can get to us without first getting through God. God is our source of significance (glory). We can fight anxiety knowing the things we worry about could never truly jeopardize the value we have because we are approved by God through Jesus. God is the lifter of our heads. God is the one who leads us to look up from our sorrows and worries and reminds us we can have joy and hope through our friendship with Him.

Which of these three descriptions of God's work in our lives means the most to you right now? Why?

Take another look at verses 5-6.

In these verses, David slept. It can be hard to sleep when you feel anxious (even if you rarely leave your bed). I love the idea of praying psalms like this one when your mind and body aren't cooperating.

Revisiting verses 7-8, what words or phrases show that God is for you in these verses?

How do you need God to fight for you right now as you battle anxiety and troubled times?

Close your time today thanking God for saving you and blessing you. Thank Him for rising up, in Jesus, to strike the enemies of sin and death and failure and fear. You belong to Him, and He has overcome. Ask Him to help you see Him as your shield, glory, and hope. Ask Him to help you sleep and not be afraid.

DAY FIVE
SHEPHERD AND SHIELD

Psalm 23

In Psalm 23:1, David wrote, "The LORD is my shepherd; I have what I need."

I have what I need. What if we really believed that?

Oftentimes when I'm anxious, my worry is rooted in feeling like I'm lacking something. My mind tells me, *If I just had this . . . or If that circumstance would just line up the right way . . . THEN, I'd have what I need.*

What is it, right now, that your mind is telling you that you need to have peace?

Read Psalm 23.

Look at verse 2 and highlight the phrase "he leads."

I heard an illustration from Elisabeth Elliot about Psalm 23 in which she talked about getting lost in the car and needing directions. Updating her example a little, imagine using your iPhone GPS to get somewhere, but then, while you are traveling, your phone dies, and you don't have your charger.

Maybe you pull over and ask someone how to get to where you're going, and he/she starts giving you a long, detailed, confusing explanation. But then imagine how you would exhale if someone were to simply drive ahead of you and lead the way. Elliot said, " . . . isn't it a relief if somebody just says, 'Follow me.'"[10]

There's no doubt that an anxious mind complicates a simple thing. Sure, we've all got complicated, painful relationships. Sure, we're juggling lots of responsibilities and wearing lots of hats and dealing with lots of incoming problems. And of course, you, if you were really smart, might be building a tornado shelter right now. But let's just remember this truest of true things. We are sheep, and we have a Good Shepherd who loves us and who leads us.

Read the following verses and write down the phrase Jesus kept saying to His people: Matthew 16:24; Mark 1:17; Mark 10:21; Luke 5:27.

When we think about the role of a shepherd, we remember that a shepherd takes care of his sheep, provides for them, leads them, and protects them.

What are some examples from your own life of when your Good Shepherd has taken care of, provided, led, and/or protected you?

Psalm 23:4 in the CSB translation uses the phrase, "darkest valley," but I love the imagery used in the ESV translation—"valley of the shadow of death." I used to think of that phrase as reflective of the very worst horrors life has to offer—things like disease and abuse. But, truly, this whole life is the "valley of the shadow of death," right? We are all dying every day. Some days are filled with pleasantries, and some days are filled with pain, but we live every moment in the shadow of death.

Even though we are all walking toward death, we can "fear no evil" (v. 4, ESV). Why?

Verse 6 refers to the day we will dwell in the house of the Lord. Is there a home you love to visit? Maybe it is your childhood home? Or maybe your own childhood home was filled with dysfunction, but every time you visited that one aunt or grandma or that one friend, you were met with warmth and food and comfort and love?

Describe that setting in the space below.

All week, we've been looking at David. There's so much of his life we didn't have time to cover. Have you ever heard about the time he was a scrawny young boy who slayed the giant, Goliath, with a sling, some stones, and without physical armor (1 Sam. 17)? Or, you know, that time he sinned against Bathsheba and then had her husband killed (2 Sam. 11–12)? I mean . . . David lived a *life*.

He had lots of great days and lots of bad ones. Based on his life events, he likely experienced the anxiety of being the victim and the anxiety of being the bad guy. But he was a bad guy with faith in a good God. He was often a bad guy whose prayer life demonstrated that he sought forgiveness and protection, not through an earthly shield (not even when fighting a giant) but an eternal One. God protected David from his fears and from following his sin to destruction. God guarded and guided His child through all kinds of circumstances we can hardly imagine.

Now skip over to the New Testament and read about when God, the Good Shepherd, was walking the earth in flesh. Read John 10:1–11. What did Jesus call Himself in verse 7?

What did Jesus call Himself in verse 11?

Look at Psalm 23 and read through it again, but every time you see the phrases "the LORD" or "He," say, "Jesus."

Jesus is my shepherd;
I have what I need.
Jesus lets me lie down in green pastures;
Jesus leads me beside quiet waters.
Jesus renews my life;
Jesus leads me along the right paths
for his name's sake.
Even when I go through the darkest valley,
I fear no danger,
for Jesus is with me;
Jesus' rod and his staff—they comfort me.

Jesus prepares a table before me
in the presence of my enemies;
Jesus anoints my head with oil;
my cup overflows.
Only goodness and faithful love will pursue me
all the days of my life,
and I will dwell in the house of Jesus
as long as I live.

Here's the thing. Because of Jesus, we have access to the Shepherd. Because of Jesus, we have access to safety and satisfaction. Because of Jesus, we are sheep who don't need to be afraid of the lingering wolves in our lives. He leads us. He loves us. He is with us.

We are like David in that we fail, but Jesus doesn't. We worry, but Jesus understands. Jesus knows this world is broken, sad, and scary. But when we hold up what we are anxious about next to the good news of the gospel, we

see that we actually can rest because He has already handled everything on our behalf. We are His, and He has won, is winning, and will win forever. It's not a onetime thing. It's an everyday opportunity to sit at His feet and in His Word, to claim His promises, think on His help, and believe in His power.

What can you do this week to remember the truth—that Jesus, your Shepherd, is with you—loving you, comforting you, leading you, holding you, and protecting you?

This past week, you completed the Session Two personal study in your books. If you weren't able to do so, no big deal! You can still follow along with the questions, be involved in the discussion, and watch the video. When you are ready to begin, open up your time in prayer and push play on Video Two for Session Two.

WATCH

Write down any thoughts, verses, or things you want to remember as you watch the video for Session Two of Anxious.

FROM THIS WEEK'S STUDY

As a group, review this week's memory verse.

Many say about me, "There is no help for him in God." Selah. But you, LORD, are a shield around me, my glory, and the one who lifts up my head.

PSALM 3:2-3

REVIEW SESSION TWO PERSONAL STUDY

From Day One: In Psalm 34:11, David talked about teaching "the fear of the LORD." What are some things we learned that the fear of the Lord leads to (include your favorite references from the chart on p. 21)?

From Day Two: Which Bible verses remind you that the God whose power dwarfs enemies like Doeg and Satan and everyone else is also whom we should most desire and whom we can be most satisfied in?

From Day Three: Do you approach the Lord similarly to the way David did in Psalm 61:1-4?

What's your first course of action when feeling anxious? Is it prayer? Is it TikTok®? Is it chips and queso?

From Day Four: Which of these three descriptions of God's work in our lives means the most to you right now? Why?

From Day Five: What are some examples from your own life of when your Good Shepherd has taken care of, provided, led, and/or protected you?

DISCUSS

What is the most interesting thing you worried about this week? ☺

What have we learned about who God is through our look at some of the anxiety-inducing events in David's life?

How have David's prayers helped you?

When David was fleeing from Absalom, he prayed, "But you, LORD, are a shield around me" (Ps. 3:3a). Share about a time in your life when the Lord was your shield.

Back in Day One, we looked at verses all over the Bible that show us what happens when we fear the Lord. Which of these benefits resonates with you? If you're comfortable doing so, share a testimony of that experience in your group.

PRAY

Take turns sharing anxieties you're dealing with right now and have your group talk about how the gospel speaks to those worries. Spend the remainder of your time in prayer for each other.

To access the teaching sessions, use the instructions in the back of your Bible study book.

ANXIOUS JONAH

JESUS IS OUR KING IN
THE FIGHT AGAINST ANXIETY

BUT SEEK FIRST THE

KINGDOM OF GOD AND

HIS RIGHTEOUSNESS, AND

ALL THESE THINGS WILL

BE PROVIDED FOR YOU.

THEREFORE **DON'T WORRY**

ABOUT TOMORROW,

BECAUSE TOMORROW WILL

WORRY ABOUT ITSELF.

EACH DAY HAS ENOUGH

TROUBLE OF ITS OWN.

Matthew 6:33-34

DAY ONE
RUN!

Jonah 1

I grew up in a time of old. In a time before GPS was a thing. A time when one could get "lost" in the city she lived in and have to drive around until something looked familiar.

Terrifying, I know.

The absolute worst was when I'd be riding in the backseat of the car with my mom behind the wheel and I'd see her shoulders tense up and hear her mumble, "We're lost . . . and this . . . is . . . a bad . . . neighborhood."

I was very aware of "bad neighborhoods" and all that they entailed because my adoptive dad worked the night shift as a SWAT cop/helicopter pilot in Miami-Dade. We were, at the time, the second most crime-ridden county in America. I know these things, because of course I do. So, as you might imagine, his answers to, "How was work last night, Daddy?" were . . . intense.

I remember regularly sliding out of my seatbelt and becoming one with the floorboard of the car. My large fear of being killed by bad guys overpowered my medium fear of dying in a car accident without a seatbelt on.

So I definitely identify with Jonah and his caution/fear/aversion/panic over "bad neighborhoods" and the "bad people" there. I identify with running away from a scary place. Let's look at his situation in the Book of Jonah.

Read Jonah 1.

now, take a look at verses 1-3.

What did God tell Jonah to do?

How did Jonah respond?

Here's what you need to know about Jonah and Nineveh. Jonah was an Israelite. Nineveh was the capital of Assyria, which was Israel's worst enemy. One thing commentators say that made them so scary was that the Ninevites had an established reputation for treating their enemies badly.[1]

In other words, Jonah's fear was warranted. It would be like if you'd asked me, during my one-with-the-floorboard moment, to go for a nice jog by myself on the same street where my dad had been shot at by murderous drug lords during his last shift. Jonah's fear was rational, but that didn't mean he couldn't be obedient.

Can you think of a time in your life when you "pulled a Jonah" and did the exact opposite of the thing you felt the Spirit prompting you to do because you were scared?

Read Jonah 1:4-17.

How did God respond to Jonah's disobedience?

In *The NIV Application Commentary*, James Bruckner, reflecting on Jonah telling the men of the boat to throw him overboard, wrote, "The captain hopes what Jonah already knows, that his God is compassionate."[2]

And then, as the story goes on, we see God's creative and perfectly timed compassion in the form of a big fish.

In verse 17, Jonah was eaten by a fish. I used to think of this part of the story as a punishment because . . . gross. But what mercy! God was saving Jonah's life. A big fish and a dark place brought a second chance.

Can you think of a time in your own life when God gave you a fresh opportunity or a second chance? Describe it below.

Maybe you grew up in church and the whole fish-eating-a-man-and-man-surviving thing sounds totally normal to you. But maybe you're more like, *This is the weirdest, most ridiculous religious story ever.*

If you're more in that second camp, I found this really fascinating. Have you ever heard of *Encyclopedia Britannica*? Well, apparently, if you were to reach out to them to request research about Jonah being swallowed by a whale, they would send you information that not only scientifically proves the possibility that a man could be swallowed and survive in a whale, but they'd include an actual article about an event that transpired in 1891. A large sperm whale swallowed a sailor named James Bartley. In time the whale was captured, and his stomach was opened the next day. The sailor was found in the stomach, unconscious, but alive. He survived.[3]

Good luck ever going in the ocean again, but I love that God allowed that to happen. What a horrible few days for that dude, but what a helpful story for skeptics. God is supernatural, working within this natural world He created, and He reaches in and rescues again and again, creatively and redemptively.

This week, we're talking about Jonah and how Jesus is our King in the fight against anxiety. Often, in my life, my fears are king. My doubts are king. But it is so huge to remember the power of the real King.

God didn't just make a giant fish swallow Jonah; He made the giant fish. Out of nothing. And He didn't just make the giant fish in the vast ocean; He made the vast ocean. The King of your heart can make worlds and move whales to help His kids take the right next step.

What is a next right step of obedience for you? What is something you've sensed the Spirit leading you to?

Read Jonah 1:17 again.

"The LORD appointed" can be such a comfort.

What is the situation you fear most right now?

How would you ask God to help if you really believed He's an ocean-making, whale-moving King?

Close this day out reflecting on ways you've seen God's hand in situations in which you were initially scared. Or write out a prayer asking the Lord to help you respond to the circumstances you face with faith instead of fear.

DAY TWO
STUCK IN A FISH

Jonah 2 and Romans 8:26-30

For several years in my young adulthood, I lived as a slave to a secret eating disorder. My food dysfunctions and the lengths I took to hide them completely ruled me. My anxiety surrounding my big secret was crushing. See, I wasn't just a person. I wasn't just a Christian. I was a church secretary. I was a young pastor's wife. I was a Bible college student. I was all these very super-Christian-y things, and I was certain that if I came clean about my sins, I'd lose everything.

So I fought in secret. I prayed and cried and quietly begged God for healing. My prayers didn't seem to go far though, and it was because my heart was full of pride. I was unwilling to be obedient to the Spirit's leading. My sin was the king in my life, and as much as I wanted to worship the real King, I felt like my fears kept me stuck. God kept bringing me to Proverbs 28:13—"The one who conceals his sins will not prosper, but whoever confesses and renounces them will find mercy."

But I was too afraid. I was afraid that if I obeyed, if I confessed, I would lose everything. I thought I'd destroy my reputation. I thought my husband would leave me. I thought my family would be disgusted and disown me.

What fears do you have that keep you from obedience when you encounter a command in God's Word or direction from the Holy Spirit?

My worries kept me stuck in sinful patterns for three-and-a-half years. But when I finally confessed my sin to others, God took my one, weak moment

of obedience, and He healed me. My desire to be dysfunctional with food evaporated, and I never struggled with it again. It was maybe the most miraculous thing I've ever experienced.

The disclaimer I always give when I tell this story is that there are things I've been praying for my entire life that are still unresolved. I know God doesn't always give miraculous overnight healing, but sometimes He does. Jonah and I have that in common. God is capable of orchestrating major, miraculous deliveries.

Do you have a story like mine? A time you hit rock bottom/the end of yourself and felt stuck in something you couldn't get out of? Did you run to the Lord for help or run from Him? Share a little bit about your experience below.

Commentator James Montgomery Boice said the following about this point in Jonah's story:

To concentrate so much on what happened inside the great fish that we miss noting what happened inside Jonah is to make a great mistake . . . So we must now turn to Jonah's prayer to God from inside the monster. As we read it we discover that the prayer reveals the truly great miracle. It shows that though Jonah had been brought to the depths of misery within the fish, he nevertheless found the mercy of God in his misery. He discovered that though he had forsaken God, God had not forsaken him, though it seemed that he had. In brief, Jonah found salvation even before the fish vomited him up on the land.[4]

Chills, right?

A human heart receiving God's mercy is a miracle.

Jonah didn't pray magic words that bought him a second chance. His heart shifted. His fear stopped ruling his actions, and he spoke to God with humility and desperation. That's a miracle.

In the space below, write about a time in your faith life when you experienced the miracle of a heart shift—an upward posturing—a moment when you stopped pursuing self and started pursuing the Savior. If you have never experienced anything like this, write about what you feel is holding you back. Is it fear? Is it pride? Is it a desire to hold onto control?

Read Jonah 2.

Until studying this passage, I never realized that Jonah's recorded prayer is referencing an earlier prayer. From the belly of the big fish, in verse 2a, he said, "I called out to the LORD, out of my distress, and he answered me . . ." (ESV) referring to whatever prayer of desperation he prayed when he was thrown overboard, facing death.

Here's what's cool to me. There's no way that in that moment, as he was flung from the boat into the storm, Jonah said a thoughtfully worded and perfectly crafted petition to the God who was in control of the storm. I wonder if his prayer was a simple "AHHHHHHHH!" or "Heeeeeeelp meeeee!" or "GOOOOOOOOOD!"

In some of my lowest moments, my prayers were less about words and more about desperation. One of the countless beautiful mysteries about the Holy Spirit is that when He lives in you, He intercedes for you. He helps you pray when you don't know what to say.

Read Romans 8:26-30.

How are you weak right now?

In light of your weakness, what do you think the Spirit might pray on your behalf?

In just that small Romans passage we not only have the Holy Spirit interceding for us but also the Father working all things for our good and the Son showing us how to live in the promise of being justified and glorified.

Whether you are alone on your couch right now or being flung over the railing of a storm-shaken ship, you have an incredible King in the fight against anxiety. You have a King who prays for you even as He promises you He'll make sure you win.

Look back at Jonah 2, specifically verse 9. What do we see as part of Jonah's prayer here?

I'm going to tell you the answer. ☺ It's gratitude. I've heard it said that thanksgiving is the remedy to anxiety. It's hard to be scared when you know why you're grateful. Remember the miracle of God's mercy and surrender your worry.

In the space below, write out a prayer of thanksgiving and ask God to deliver you from what you're anxious about today or help you give up whatever might be holding you back from following the Holy Spirit's leading in your life.

DAY THREE
BIG CITIES AND SACKCLOTH AND MOST LIKELY TO BE MUGGED

Jonah 3; Luke 11:11-13 and John 3:16

I presently (and since the beginning of time) get anxious when visiting big cities. *Will I be able to figure out how and where to park? Will I get mugged? Probably most carjackings happen in big cities, right? If I survive the attempted muggings and jackings, will I remember where I parked?*

At this point, we've already established that God was sending Jonah to a place called Nineveh and that there were scary people there. And, guess what, there are still scary people there. Nineveh is now called Mosul, Iraq, which might be the number one country you don't want to visit if you're a Christian. In 2019, the *BBC* put out an article titled "Iraq's Christians 'close to extinction.'"[5]

Thinking about such dangers helps me have compassion for Jonah when reading his story. Jonah went to a big city with scary, violent people because God asked him to go.

I know this is scary to write out on paper, but what is a place you would have a hard time being willing to go to if you felt God leading you there? Why?

I've always hated questions like the one I just asked. Some broken part of me sometimes forgets the kindness of God and assumes He is out to get me.

Like, I better not tell God what I don't want to do because then He will for sure make me do it.

Does your head ever sound like that?
○ Yes
○ No

Read Luke 11:11-13. To worry God is out to get us is to forget what kind of Father He is. List some of the "good gifts" God has given you in the space below.

Now let's look at Jonah 3. Perhaps the craziest part of this story is that when Jonah finally did go visit his literal worst, most violent enemies, they actually listened.

Read Jonah 3:5-10. How did the people of Nineveh respond to Jonah's message, and what did God do?

In ancient times, fasting and wearing sackcloth was a sign of mourning. Verse 5 begins by saying the Ninevites "believed God." The fasting and wearing of rough, goat-hair clothing was a response to their recognition of sin. They mourned their sin. Belief came first. Followed by repentance. Followed by the mercy of God. It's so amazing and simple, but this is another way worriers can get it wrong. It can actually be frustrating and scary to read an instance like that.

My brain, for instance, can easily read chapter 3 and think, *But how do I perfectly posture my heart? How do I ensure my repentance is enough? Is sackcloth Prime® eligible?*

However, it should be so much easier for us to repent and rejoice and rest in the forgiveness of God than it was for the Ninevites. We don't just have the message of Jonah; we have the actions of Jesus.

Read John 3:16 (or just recite it to yourself).

Now underline, circle, highlight, or burn this next sentence into your brain—*Jesus is enough.*

Jesus' perfection, not your sin, His sacrifice on the cross, not your sackcloth, His power, not your weakness, is what God sees and approves and why God loves without stopping and forgives without going back.

When we get so caught up in "our part," that's where the anxiety kicks in. As the old hymn says,

Turn your eyes upon Jesus,
Look full in His wonderful face,
And the things of earth will grow strangely dim,
In the light of His glory and grace.[6]

Inside the following graphic, make a list of "I believe . . ." statements about God and back them up with Scripture references. Here are some places to look:

ROMANS 6:22	2 CORINTHIANS 3:17	EPHESIANS 2:8-9
2 TIMOTHY 1:7	1 PETER 2:16	1 JOHN 1:9

I BELIEVE . . . For example, *I believe that nothing can separate me from the love of God (Rom. 8:38-39).*

Here's the thing. When we believe in the goodness of God, we won't care as much where He asks us to go. When we remember we too were the Ninevites and God responded to our repentance with grace and more grace, we can worry less about the cities we hope to never see or the fact that we've never owned sackcloth. The King who leads us loves us.

He wants us to have a vibrant, ever-growing relationship with Him. He wants us to experience the joy of trusting and obeying.

In the space below, write out a prayer. Ask the Lord to set you on a mission that helps you grow more and more aware that He is on the throne, that He is good, and that your anxieties don't have the power to rule over you.

DAY FOUR
WHEN PREFERRING DEATH

Jonah 4

A few years after we brought our sweet Joy home from China, I made myself a counseling appointment. I sat down in my counselor's office with a problem—I didn't feel what I thought I should feel. To echo the apostle Paul's sentiment in Romans 7, I didn't feel the way I wanted to feel. I felt a way I hated.

I wanted love to be the cure-all in our adoption story. I wanted the bonding to happen more quickly—instantaneously, even. I mean, aren't Christians supposed to come chock-full of supernatural love for others? How could I, new mother of this miracle, feel anything other than awe and gratitude? Why was I so easily frustrated with our child—a former orphan—when she didn't behave correctly or even when she couldn't do things easily? What kind of monster feels anything but compassion and affection for a child with disabilities?

I bring this up because, if reading Jonah 4 through the lens of my old, pious church-lady self, I'd be like, *Hang on. Jonah just got a second shot at loving his enemies—and they actually listened? And they turned to the Lord? Mission accomplished. Jonah was safe. Um . . . why does chapter four start the way it does?!*

I'm getting ahead of myself, aren't I?

Go ahead and read Jonah 4.

How does verse 1 tell us Jonah felt on the heels of all the great stuff God had just used him to do?

Do you, at all, resonate with Jonah here? Can you think of a time you knew how you ought to act/feel/believe but found yourself in the wrong?

If you're honest, I think you have to say yes. We long to be in control—little gods of our own universe—making the plans and calling the shots. Jonah was so angry that God had mercy on the evil Ninevites that he literally asked God to let him die (v. 3). Wow.

What is the last thing Jonah is recorded to have said in the Bible book named after him (v. 9b)?

Those are some pretty intense last words for a book of the Bible. It was not Jonah's best moment. Probably not the words he'd want on his gravestone, or, I don't know, at the very end of his titular book in the HOLY SCRIPTURES.

But here's what's cool. Jonah is not the hero of this book.

Even the WHALE, the accurately vomiting rescuer, is not the hero of this book. Author and Bible teacher Priscilla Shirer said it like this, "These four little simple chapters are not really about the whale; they're about our God."7

Read Jonah 4:10-11. What does the end of this book tell you about God?

There is so much to learn from Jonah's story. We learn that God is gracious and slow to anger. We learn that God's plan is redemption when our plan might be revenge. Jonah reacted wrongly to seeing God spend His mercy on the people of Nineveh, the same mercy that had saved Jonah again and again. He could have been moved and grateful for the compassion of God in His own life and the compassion of God for his enemies. But he wound up bitter and miserable.

Two things I don't want us to pass by here: 1. Jonah missed out on the joy he could have experienced being used by God in the redemption of the Ninevites. 2. Even when Jonah was feeling angry and hopeless, God continually tried to engage with him. God didn't leave him alone in his bad attitude. And God does the same for us. He engages our hearts, even when our hearts are hard.

When you look at the circumstances and struggles in your own life, do you focus on the role others play? Do you focus on your own part? Or do you look for God? Do you look for the hope—the healing, the redemption, the restoration project—that Jesus is working on?

In the space below, list out some of the circumstances you're currently struggling to sort out. Where is God? What do you think your King is doing?

I don't have the full picture, but I can already see so much of God's presence and power in the story of Joy and this adoptive family He's put her into. When I struggled to feel the right things, I was comforted by another adoptive mom who shared she'd felt the same things too. When God allowed us to walk through various medical issues with Joy, I was astounded by how He used those situations to bring us closer together as a family. I don't get how the whole thing works, guys. But I know God blesses us with the most amazing gifts. Gifts like healing. Gifts like growth. Gifts like the ability to lay our heads down at night without feeling the weight of our burdens. Gifts like having hearts that are able to say, "God, this hurts, but thank You for it." God knows how to love as He leads.

DAY FIVE
JONAH, NINEVEH, AND YOU!

Matthew 6:25-34 and Matthew 12:38-41

Last night, I had a dream about recording the videos for this Bible study. Brace yourself, because I know nothing is more riveting, interesting, and helpful than hearing the details of someone's super weird dream. ☺

So it was the first day of shooting the videos for this study (about fighting anxiety with the Word of God). In my dream, I got to the set, and everything I was wearing or had brought to change into was stained, pilling, and had huge holes in it. Then, the producer walked up and said, "Scarlet, we want you to wear this Anna costume—so you'll be dressing like the princess from Frozen® while you teach the Bible, OK?" And then I nodded and stepped into the changing room to learn that the costume was sized for a toddler. It was all a tragedy.

This just goes to show you where my mind was. *HOW CAN I TEACH A BIBLE STUDY WITHOUT THE RIGHT OUTFIT ON!?*

OK. Now, make me feel better by answering this next question, please.

When is the last time you fixated on a super non-important aspect while preparing for an important thing?

What was important in that situation and what were you focused on instead?

It's really sad that Jonah, even after failing to obey God in his fear, even after his second chance, even after obeying and being used by God in such

a clear way, lost focus. Jonah was essentially the toddler-sized-Anna-costume wearer of the Old Testament. Throughout this story, we see an anxious and cowardly Jonah turn into an angry and bitter Jonah, but all throughout the story, his eyes were on the wrong prize.

Both anxiety and anger usually reveal a heart that is focused on the wrong things.

So what are we to do? We're often anxious, angry, bitter, and resentful, aren't we? Or we are too busy stuffing our faces or our Amazon® carts to notice we are. So what's the cure? Who is our hope? How can we have peace and be people who are consumed by love instead of fear? How can we avoid an ending like Jonah's?

It's certainly not by trying harder and doing better and faking it till we're making it.

Let's read Matthew 6:25-34. What does the heading in your Bible say right before verse 25? If your Bible doesn't have a heading, what do you think the heading could be?

Looking at my version, the CSB (Christian Standard Bible), it says, "The Cure for Anxiety." Before you continue reading Jesus' living words in Matthew 6, I want you to pray that the Spirit will remove any cynicism or disbelief that leads you to think there's not real hope. Jesus says there is. Let's believe Him.

Now look at verse 25. Would you agree that "life [is] more than food and the body [is] more than clothing"? Why or why not?

It's easier to agree to than it is to believe. Maybe you agree life is more than food and clothing, but your actions say otherwise. Maybe you followed God to Nineveh, but your emotions don't line up with your mission. Maybe your focus is on shaky things because your heart is doubting what is solid.

So what's at the root of our anxiety? The ESV Study Bible says, "To be anxious . . . demonstrates a lack of trust in God, who promises that he will graciously care for 'all these things.'"[8]

Read verses 26-34. Jesus told us to consider the birds and the flowers. What else can we consider, not listed in this passage, that Jesus cares for and sustains? List as many things as you can in the space below.

We see Jesus here, in His infamous Sermon on the Mount, telling us why we're anxious. We worry about food and clothes and video shoots and getting even and getting rewarded, and it all boils down to ME-ME-ME-ME-ME-ME-ME!

So what do we do? Copy Matthew 6:33 in the space below.

What does "all these things" refer to?

"All these things" are the things we chase. Food. Clothing. Status. Security. The secret is that it's only when we pursue the King that we find our needs and, more importantly, our souls satisfied.

Jesus is our King in the fight against anxiety. He has to be.

Read Matthew 12:38-41. Even sinful, anxious, bitter Jonah was used by God. List some of the ways God used him to point people to Himself.

The most important thing about Jonah is that he points us to Jesus. "Something greater than Jonah is here" (v. 41). Thank God! Jonah knew how to preach repentance, but then he whined when it worked. Jesus preaches repentance, but then when we turn and call on His name, He forgives. Guys, Jesus forgives us! He forgives us when we're too anxious to obey. He forgives us when we obey with poor motives. He forgives us when we lose focus and fail to trust Him and make our fears our temporary king. King Jesus can take care of us. King Jesus is going to take care of us.

Do you meditate on this reality? Do you preach the good news of Christ's death and resurrection to your heart when you're feeling anxious, or do you rehearse, reflect, and ruminate on things that lead to bitterness? Practice writing a three- or four-sentence gospel sermon to your anxious heart below.

This past week, you completed the Session Three personal study in your books. If you weren't able to do so, no big deal! You can still follow along with the questions, be involved in the discussion, and watch the video. When you are ready to begin, open up your time in prayer and push play on Video Three for Session Three.

WATCH

Write down any thoughts, verses, or things you want to remember as you watch the video for Session Three of Anxious.

REVIEW SESSION THREE PERSONAL STUDY

From Day One: What did God tell Jonah to do, and what was his response? How did God respond to Jonah's disobedience?

From Day Two: What fears do you have that keep you from obedience when you encounter a command in God's Word or direction from the Holy Spirit?

From Day Three: How did the people of Nineveh respond to Jonah's message, and what did God do?

From Day Four: What does the end of the Book of Jonah tell you about God (Jonah 4:10-11)?

From Day Five: Other than the birds and the flowers, what else can we consider that Jesus cares for and sustains?

FROM THIS WEEK'S STUDY

As a group, review this week's memory verse.

But seek first the kingdom of God and his righteousness, and all these things will be provided for you. Therefore don't worry about tomorrow, because tomorrow will worry about itself. Each day has enough trouble of its own.

MATTHEW 6:33-34

DISCUSS

In this session, we looked at the Book of Jonah and studied the story of God mercifully and creatively offering Jonah a second chance. If you're comfortable with it, share about a time God gave you a second chance.

This session's main idea is "Jesus is our King in the fight against anxiety." What are some things you've made "King" in your life that contribute to anxiety? Why is Jesus a better King than those things?

What verses from this session have stuck with you and helped you as you fight to make Jesus King of your life and battle against your fears?

This week's memory verse is about seeking the kingdom. Try to recite the verse together as a group. Then, talk about what God might have you pursue individually or as a group for His kingdom this week.

PRAY

Take turns sharing prayer requests and thanking God for the power of His forgiveness and the power He gives us to forgive others. Spend the remainder of your time in prayer. Maybe, if you sit in a circle, each woman can pray for the woman on her right—that she will be able to seek first God's kingdom and find freedom from her worries.

To access the teaching sessions, use the instructions in the back of your Bible study book.

ANXIOUS MOSES

JESUS IS OUR STRENGTH IN THE FIGHT AGAINST ANXIETY

BUT MOSES SAID TO THE PEOPLE, **"DON'T BE AFRAID.** STAND FIRM AND SEE THE LORD'S SALVATION THAT HE WILL ACCOMPLISH FOR YOU TODAY; FOR THE EGYPTIANS YOU SEE TODAY, YOU WILL NEVER SEE AGAIN. THE **LORD WILL FIGHT FOR YOU,** AND YOU MUST BE QUIET."

Exodus 14:13-14

DAY ONE
WHEN THE BABY BASKET ISN'T SO CUTE

Exodus 3; Isaiah 6:1-8 and 1 John 3:1

In school this week, my five-year-old daughter did a "Baby Moses Craft." She colored a little baby, glued it to a basket picture, and stuck the whole thing to a sponge. Then she was supposed to put the sponge in a bowl of water and watch it float like baby Moses. Yippee! It floated! Adorable! Fun!

Right?

Here's some other words I think of when I look at this sweet little craft:

- drowning;

- separation-anxiety;

- trauma;

- genocide;

- slavery;

- general horribleness.

I have to confess something. I don't love crafts. But my daughter did love the craft. It's just that I felt less "Yippee!" and more disconcerted by the image. When you're little and cutting a piece of sponge to put a baby picture on, it's harder to imagine the gravity of that historical account than when you're a mother with babies of your own.

Here's the thing. The reality of that little sponge craft represents a real time when baby boys were being taken from their mothers' arms and slaughtered.

The sponge craft rested on a rough situation.

When we were in the process of adopting our daughter, Joy, we watched hours of video training and read required books detailing the trauma a child goes through when he/she is separated from his/her birth mother. We were told again and again that every international adoption is a "special needs adoption." We learned about how, when a mother instinctively rocks her baby, his/her inner ear is stimulated, which allows him/her to learn and helps his/her brain make connections. We learned about the mental and physical distress an infant goes through when he/she is unable to be with his/her mother.

I say all this to tell you Moses' experience with anxiety probably didn't start when he saw an on-fire bush not burning. It probably didn't even start when he killed an Egyptian and ran. It more likely started when he was a baby, separated from his mother and put into a basket into a river—by himself.

All adoptions are special needs adoptions birthed out of trauma. So here we are at the outset of Exodus 3. Up until this point, Moses had spent his life in a foreign family, discovered he was adopted, found out his people were mistreated slaves, and fled after killing an Egyptian. And now there's a bush on fire that's not burning up, and a voice is coming out of it.

Read Exodus 3. Draw a picture of what happened to Moses in this chapter.

Look at verse 1. What mundane and faithful thing was Moses doing when the angel of the LORD appeared to him in the burning bush?

It's often in the mundane moments of faithfulness that the Spirit will break through and prompt us, speak to us, move us, call us to action.

What are some parts of your life that feel mundane right now?

When the Lord called my family to adopt, I was active in a small group and walking in obedience in small, unseen, mundane ways. As I told you in the Session Three teaching video, the Spirit broke my heart over abandoned girls in China with special needs while I drove to the grocery store because I'd forgotten to pick up dishwasher detergent.

There's nothing like experiencing the supernatural, all-powerful God while you go about your natural, powerless-looking life—picking up detergent or taking care of sheep.

Reread verses 2–6.

How did Moses respond to God in verse 6?

What does Moses' response to God tell us about him and his feelings?

The way Moses responded, covering his face and feeling "afraid" (v. 6), as the Bible tells us, reminds me of when Isaiah entered the Lord's throne room in Isaiah 6 "and the train of his robe filled the temple" (v. 1b, ESV).

Real quick, flip to Isaiah 6 and read verses 1-5. How did Isaiah respond to what he saw?

He was terrified, "undone" (v. 5, NKJV), sharply aware of his unworthiness as he stood in the presence of the One who is Holy.

Read Isaiah 6:6-8. What led the undone Isaiah to go from "I am ruined" (v. 5a) to "Here I am. Send me" (v. 8b)?

God is merciful.

Looking back at Moses' story, here's something cool. Once God had his attention with the bush, He said Moses' name twice. Apparently, in ancient Jewish culture, saying someone's name twice was a way to show friendship, affection, and endearment.[1]

How beautiful that even as He revealed His impossible-to-comprehend power and commanded Moses to do a hard/scary/terrifying/life-threatening thing, He addressed Moses lovingly—as a friend, as beloved.

Do you ever read God's Word or hear about it in church and feel afraid, like Moses did, by what you encounter? Are there specific verses in the Bible that cause you to feel afraid?

The Bible isn't warm and fuzzy, and God isn't a teddy bear. I've often neglected the Lord because I was afraid of Him. I'd read the words of Jesus to His disciples, as He told them about the cost of following Him. Sometimes, Christian persecution overseas will break into my mind, and I long for comfort, fluff, and ignorance.

But that's because I forget how He speaks. Yes, He has the power to destroy all life with a flood or fire or just His voice. But that's not how He talks to His own. He calls me "daughter." He says, "Scarlet, Scarlet . . ."

Read 1 John 3:1. How should this reality affect our fear of God?

Because we're loved children, we can fear God with awe but approach Him as Dad. We can walk in obedience, knowing He doesn't promise us an easy life, but He promises us His love and presence and His strength as our own.

Read Exodus 3:7–11.

What did God ask Moses to do and how did Moses respond?

The compassion and care of the Lord is so evident in these verses. He told Moses that He heard the cries and saw the pain of His people and that He was going to rescue them. And He wanted to use Moses to do it. How crazy is that?

What does God's assignment for Moses tell us about His character and His purposes?

Read Exodus 3:12 and copy it down.

In the space below, I want you to write out the things you're afraid God could ask of you. Then write, "I will certainly be with you" after each one. God doesn't send us alone. When we go, we go in His care, His strength and His name. Whatever your worry, ask God to help you trust Him.

DAY TWO

WHY FEAR ACTUAL SCARY THINGS WHEN YOU COULD FEAR CONVERSATION?

Exodus 3:13–22 and John 8:56–58

I know, OK? I know we live in a world of legitimate problems. I know there are countless things a normal person should fear. There's no need for me to make a list of them because you know what they are. The grown-up realities. We can worry about evil, abuse, pain, and death. Those are the real scary things. So why is it that my number one anxiety often goes like this:

If I say this, and she says that, then what do I say? And if I do say that, will I say it the right way? What will she say? If she says something I don't think she'll say, then what should I say? What if I just don't say anything? But what if she's super upset because I don't say anything? What if Jesus could just come back right now and say something before I have to say something or not say something?

Maybe you're rolling your eyes because you would never be anxious about a situation so silly. But I'm sure you worry about other things that aren't exactly life or death.

Most of us do it. And I would argue that neglecting the actual scary things and instead worrying over relational awkwardness or other small concerns is a very human, very timeless way to respond to bigger problems. Most of the times I'm afraid of silly things like conversations that don't exist, I've got much more serious stresses in the back of my mind.

Spoiler alert—you're about to read about Moses doing exactly this.

Read Exodus 3:13. God told Moses to go lead the Israelites, who, mind you, had been slaves for four hundred years, out of Egypt. If God told you to do something of that magnitude, what would your first questions be?

God told Moses to return to a place where he was known as a murderer-runaway and rescue a nation of slaves. And if you read the conversation, it sounds a lot like, *If I say this . . . and they say this . . . what do I say next?*

Anxiety can lead us to focus on the wrong things. The little things.

Imagine you're standing in the middle of the road on a hill and a speeding car is coming right toward you. The normal-fear response would be to fear the imminent danger and respond by getting out of the way. The best response to that situation would be for your legs to start moving out of the path of the car. But what if you focused on smaller worries? *Hold on. What are you going to do if your insurance doesn't cover this hospital bill? If you dive out of the way and lose your phone, who will call the police? Please don't ruin your favorite jeans.*

When a car is about to hit you, you don't have time for anxiety. You get out of the way of the danger. You don't worry about insurance or cell phone placement.

Moses did the same things we do. He focused on problems when what he needed to do was remember God called him to this and God would carry him through this.

Do you find Moses' imperfect faith comforting? Why or why not?

We can take comfort knowing the heroes of the faith were were shaky people like us. People who questioned God's plan. People who probably had anxiety rather than feeling awe and confidence in their interaction with the great "I AM."

Read Exodus 3:13-22.

In verses 13-14, Moses basically asked God His name, and God gave a seemingly strange answer. What did God say His name is?

What did He mean? Do a quick Google® search or look inside of a study Bible to see what you find about this name for God. Record your findings in the space below. (And share some with your group when you meet together!).

I AM tells us God exists. In fact, "I AM WHO I AM" means God must exist. God is the one and only Necessary Being. That leads us to the truth that nothing can exist without God giving it existence. I AM WHO I AM. God can't not exist. And everything else can't exist without Him. But perhaps the most significant application of this name God gave Moses is that God has, as John Piper put it, "drawn near to us in Jesus Christ."[2]

Read John 8:56-58. In verse 58, we see Jesus said something very powerful. What did He say, and what does it have to do with God's name in Exodus 13?

Jesus was claiming the name of the great "I am." Jesus was telling the world that He isn't just a teacher, or just a healer, or just a worker of miracles. He is I AM. He is God. He is existence itself in a human body, come to save the world.

That's who Moses had on his team and that's who we have forever. We don't have to be anxious because Jesus is I AM. I AM existed before anything else did and everything that is, *is*, because He is. He can handle your awkward conversation no matter how it goes down.

I AM came into this broken, sad, scary place to live and die and rise again. He is more powerful than even death.

When we look at Moses' life, we see a weak man used powerfully by a strong God. Isn't that a relief? God doesn't need us to "be awesome." He's awesome. He wants us to love Him and obey Him—even when we don't feel brave, even when we fumble over our words and prayers and responses to His leading in our lives.

In the space below, list a few of God's awesome attributes that are on display in this story and thank Him for being so good.

DAY THREE
A BROKEN THYROID AND A GOD WHO SEES

Exodus 14:1–14

The year before writing this Bible study, I had a drawn-out season of HARD.

I began suffering mysterious symptoms that lasted for months. I was bounced around to different doctors and machines, ultimately leading to tumors at the end of whatever is the opposite of a rainbow. The doctors thought I had cancer, but they weren't sure. It was a rough run. I knew that because of my relationship with Christ, I could have (and should have) "count[ed] it all joy" when I experienced "trials of various kinds" (Jas. 1:2, ESV). But the thing is, I wasn't joyful. I wasn't thankful. Instead, I was sad and lonely. Scared and weak. I didn't understand why God was allowing my health to fail me. He was allowing a big heap of painful and scary and hard things, and I had more questions than answers.

What questions did you ask God in your last drawn-out season of HARD?

Read Exodus 14:1–4.

What did God tell Moses to do here?

What did God tell Moses Pharaoh would do?

The first handful of verses in Exodus 14 are striking. We've skipped ahead a little, but what's happened, in a nutshell, is God did as He said He would, and He used Moses to free the Hebrews from slavery. Moses then led them through the wilderness toward Canaan, "the promised land," where they would be free to flourish.

But then the story takes a turn. In chapter 14, we see that while God's people were probably still exhaling, trouble was coming again. Pharaoh changed his mind about freeing them and wanted to take them back as slaves. And, prepare yourself, it was GOD'S PLAN. What?!

Can you think of a time in your life when you felt God was causing or allowing something hard or negative to happen to you? What were the circumstances?

God, the Creator and Sovereign I AM, is so involved and in control of what's going on in the world that He hardened Pharaoh's heart and led him to pursue the Israelites with his army. And it wasn't because He's mean or wanted to scare anyone. He wanted, as He told Moses here, to "receive glory" (v. 4). His plan was to break through time and space, as He has done so many times and still does and still will do, to remind humanity that He is BIG and sea-splittingly trustworthy.

Now let's look at verses 5-12.

What happened to the Israelites in these verses?

How did the Israelites respond? (See verses 10-12.)

How do you think you would have responded in this situation?

If you've taken a good look at the darkness inside your own heart, you'll nod in understanding to the response of God's people.

How many times have you seen this play out in the movies, in the lives of your friends, in your own family? It's human nature to want to return to familiar problems rather than face an unknown danger. We often return to what we know, even when we understand it's bad for us.

What do you think was at the root of the Israelites' response to the danger they faced?

In his book, *The Knowledge of the Holy*, A. W. Tozer wrote, "What comes into our minds when we think about God is the most important thing about us."[3]

What comes into your mind when you think about God?

I look at this story and wonder what I'd be thinking and feeling if I were an Israelite. Depending on how well I'm understanding or trusting God at the time, I might have felt shocked or angry with God. I may have doubted His goodness and provision. I may have, like the Israelites, blamed the guy/girl/institution leading me.

Look at Moses' response to the people in verses 13 and 14 and copy it in the space below.

When I had my thyroid taken out last year, I went into that surgery expecting to wake up to a cancer diagnosis and a mortality rate. But God healed me. There was no cancer, and once my broken thyroid was out, He restored my health and most of my energy.

God is able on the days full of joy. God is able even when you get the hard diagnosis. God is able no matter what circumstance you find yourself in. "Stand firm and see the LORD's salvation" (Ex. 14:13). The God who allows cancer can kill cancer. The God who allows pharaohs to chase can drown them in the sea. But we'll get to that tomorrow.

As you go about the rest of your day, meditate on Moses' response to the people at the end of today's passage. "Don't be afraid. Stand firm and see the LORD's salvation that he will accomplish for you today . . . The LORD will fight for you, and you must be quiet" (Ex. 14:13-14).

DAY FOUR
BUT WHAT IF MY DAUGHTER DIES?

Exodus 14:15-31 and Matthew 6:34

I went through a season of major anxiety when my oldest daughter was about three. I became obsessed with the thought that I could lose her. I was constantly aware that she could die.

There were days it was all I could think about. I had bouts of hyperventilating and said no to anything fun if it sounded remotely dangerous. It was not a good phase.

How has your family had to deal with your anxiety in the past? How have your worries impacted them, and how have they responded?

Charles Spurgeon once said, "The worst evils of life are those which do not exist except in our imagination. If we had no troubles but real troubles, we should not have a tenth part of our present sorrows. We feel a thousand deaths in fearing one."[4]

In Matthew 6:34 (remember this verse from last week?), what did Jesus say NOT to worry about? Why?

Now read Exodus 14:15-18. In verses 17-18, God was explicit about why He was doing what He was doing. What is the reason He gave?

Sometimes, I experience suffering, and I can see glimmers of good in the midst of the bad. I see, as it's happening, some of the why God allows it. But other times, I don't see anything. There are situations in our lives that seem only evil and painful and hopeless. But this is exactly why we know not to look only at our own lives.

What you are doing right now, getting to know the character and greatness of God in His Word, is preparing you to trust God when you think you only see hopelessness. God's Word helps you fight with truth when you only feel fear. The Bible teaches you to recognize glory when, otherwise, you might only see pain.

Write down just three reasons God is worthy of glory at all times.

1.

2.

3.

All over the Old Testament, we see God in the stories of these heroes of the faith, like Moses, and we learn the way God acts and thinks.

All over the New Testament, we see Jesus sharing and showing His power. We learn that Jesus is the way to hope. That He brings redemption. He makes all things new. God's glory is displayed all over the place, and the more we see it the more we understand that as God is getting glory, He is bringing about our good.

READ Exodus 14:19-31.

Try to draw a picture of the miraculous things that happened.

What is your favorite part of this miracle? Why?

Read verse 31 again. How did God's people respond to what God did?

God parted the sea and led His people to safety. The result was that instead of fearing the unknowns and potentials for pain, they feared the Lord.

Anxiety crushes us because it makes us fear the wrong things.

What are some of the wrong things you're fearing right now?

When we fear the Lord, when we recognize He is worthy of our fear, awe, and glory, the smaller things that make us "feel a thousand deaths" are swallowed in the sea.[5]

When I focus on the glory of God, I don't find myself praying in a panic that my daughters won't die. I find myself praying for their souls, for their understanding of God's love, for their future callings to make Him known to their generation.

God is doing miracles all the time. And He uses regular, flawed, cowards like us. When we look to Him, see His power, and trust His plan, we find freedom from our fears.

Make a list in the space below. What would you like to see God do this week? Think of the people in your life who don't know Him—who don't know freedom and peace. Commit to praying for them this week and see what God will do. Ask the Lord to help you fear Him rather than the unknowns in your life.

DAY FIVE
IS THAT A FIRM NO?

Exodus 4:10-13 and Hebrews 3:1-3

I have this thing with my husband. I know husband-wifery is a team thing, but the problem is, I really like things to go my way.

Sometimes I want one thing, and he wants something else. I don't really want to be the boss. I don't want to do anything that will bankrupt us or ruin our kids. I just want everything I want to always happen immediately. Is that so much to ask? ☺

There are times, if you can believe it, I have a clearly amazing idea he should definitely be on board with, and he says, NO.

But then I ask, "Is that a firm no?"

I question his answer, in hopes it might change. (It works a lot by the way.)

Read Exodus 4:10.

In Exodus 4:10, Moses questioned God in hopes the plan might change.

What was Moses' excuse for not wanting to do what God told him to?

Look at verses 11-12. How did God respond?

Moses was persistent in his resistance. How did he respond to God in verse 13?

The story of Moses is a beautiful picture of God's faithfulness in the midst of our fear and hesitation. Moses was a worrying, doubting, God-questioning, messed up human, just like me and just like you, who did a really hard thing. And God was with him, just as He promised He would be.

Have you ever gotten to witness this in someone's life? When have you seen God use someone unlikely to do something impressively compassionate or miraculous?

Looking at and attempting to mimic Moses' obedience (no matter how fear-filled or questioning) is a wonderful idea. But the clearer, better way to move toward peace and obedience is by looking at and chasing after Someone else.

The story God was inviting Moses into wasn't actually about Moses. It was always about God.

Read Hebrews 3:1-3. Who is considered "worthy of more glory than Moses" (v. 3)?

In verse 3, the writer of Hebrews compared Jesus' superiority to Moses to a builder getting more honor than the house. What do you think this comparison tells us about God?

A created thing can't be better than the Creator. Jesus is the I AM, remember? Jesus is the builder of all things. Jesus created Moses and the stuttering, questioning, staff-raising miracles that came through him. Jesus is immeasurably greater than Moses.

What are some ways Jesus is better than Moses?

Moses confronted Pharaoh. Jesus confronted Satan, sin, and death.

Moses led from physical slavery to the promised land. Jesus leads from spiritual slavery to freedom.

Moses lifted up his staff to make a way for his people to cross the sea. Jesus lifted up His body to make a way for His people to cross from death to life.

Moses served, died, and was buried. Jesus served, died, was buried, left the grave behind, ascended to glory, lives forever, and rules the world every minute of every day.

So, yes, Moses was good, but Jesus is better.

Jesus is the reason anxious Moses could move forward and find freedom. Jesus is the reason anxious you can move forward into whatever God has planned. You are scared, but guess what? Jesus isn't.

What are some ways Jesus is better than you?

How do you need Jesus to be strong in you today?

As you go about the rest of your week, remember that you don't have to fight your way to peace. Jesus is your strength in the fight against anxiety. He will lead you through the waters, to the other side, to the promised land. And in the ways that matter most, He already has. He has saved you. In Jesus, you're on the other side of the sea, and it's time to rest.

This past week, you completed the Session Four personal study in your books. If you weren't able to do so, no big deal! You can still follow along with the questions, be involved in the discussion, and watch the video. When you are ready to begin, open up your time in prayer and push play on Video Four for Session Four.

WATCH

Write down any thoughts, verses, or things you want to remember as you watch the video for Session Four of Anxious.

REVIEW SESSION FOUR PERSONAL STUDY

From Day One: Do you ever read God's Word or hear about it in church and feel afraid, like Moses did, by what you encounter? Are there specific verses in the Bible that cause you to feel afraid?

From Day Two: In Exodus 3:14, God told Moses His name was I AM. What did you learn about this name as you studied it this week?

From Day Three: Can you think of a time in your life when you felt God was causing or allowing something hard or negative to happen to you? What were the circumstances?

From Day Four: In Matthew 6:34, what did Jesus say NOT to worry about? Why?

From Day Five: Compare and contrast Jesus with Moses. What can we learn from Moses, and why is Jesus better than Moses?

FROM THIS WEEK'S STUDY

As a group, review this week's memory verse.

But Moses said to the people, "Don't be afraid. Stand firm and see the LORD's salvation that he will accomplish for you today; for the Egyptians you see today, you will never see again. The LORD will fight for you, and you must be quiet."

EXODUS 14:13-14

DISCUSS

This week, we studied Moses. We saw him scared and sinful, but also obedient and faithful. He was fully a human and fully loved by God. He went through scary things, and He followed God to what looked like scary places in order to be used in accomplishing God's purpose for His people. If you're comfortable with it, tell your group about a time God asked you to do something hard or scary.

This session's main idea is "Jesus is our strength in the fight against anxiety." What are some things you lean on as "strength" that can't hold up under the weight of life? How is Jesus better?

What verses from this session have stuck with you from and helped you as you fight to make Jesus your strength as you battle against your fears?

PRAY

Take turns sharing prayer requests and thanking God for His strength that lets us rest. Thank Him for showing us how to walk with Him and for being merciful when we forget that it's His strength we depend on. Spend the remainder of your time in prayer. Pray specifically that you, as a group, would rely on the strength of the Spirit as you seek to love the people you've been scared to love and do the things you've been scared to do. Ask the Lord to unite your group and remove all anxiety that is keeping you from service to Him and peace in His Spirit.

To access the teaching sessions, use the instructions in the back of your Bible study book.

ANXIOUS
ESTHER

JESUS IS SOVEREIGN IN OUR
FIGHT AGAINST ANXIETY

IF YOU KEEP SILENT AT

THIS TIME, RELIEF AND

DELIVERANCE WILL COME

TO THE JEWISH PEOPLE

FROM ANOTHER PLACE,

BUT YOU AND YOUR

FATHER'S FAMILY WILL BE

DESTROYED. WHO KNOWS,

PERHAPS YOU HAVE COME

TO YOUR ROYAL POSITION

FOR SUCH A TIME AS THIS.

Esther 4:14

DAY ONE
A HAND-ME-DOWN BARBIE DREAM HOUSE AND A VERY ROMANTIC LOVE STORY

Esther 1–2 and Colossians 1:16–17

When I was in fifth grade, a neighbor from down the road gave me a hand-me-down Barbie® DreamHouse™. Pretty much all I remember from that year is locking myself in my room and playing out what I thought was the ULTIMATE romantic situation, over and over again.

I know this is what you're here for, so let me explain.

Barbie and Ken™ are at a party. Sorry, I meant to say a ball. They're at a ball. They're talking, laughing, waving goodbye to people. They both happen to be walking backward when they bump into each other and fall on the floor. Both clearly annoyed, they argue, in unison, "How dare you! Where do you thi–" And then, they pause. This is the moment that they both realize their whole lives have been leading up to this moment. And that they're destined for love.

That's the magic of playing dolls. Two lives (plastic dolls), led by the hands of destiny (tweenage Scarlet) to find each other, fall for each other, and "enjoy" a lengthy, awkward plastic doll kiss.

Would you believe this is a way I've taught my daughters about sovereignty? They have their own hand-me-down Barbie house (thanks Autumn) and their own plans for romantic doll destiny, and I want them to trust the powerful guidance of a loving God.

Now, God is not a preteen, and we're not brainless plastic dolls, but we can take comfort in the fact that He exists outside of our world, outside of time itself, and is in total control of every situation we experience. We are anxious Kens and worrying Barbies. But God is sovereign all the time.

As we study Esther this week, we're going to look at the sovereignty of God that exists even when life looks impossibly bad or scary, and we'll remember why and how that can nudge us toward peace.

Look up the word sovereignty in a dictionary, and write down the definitions you find in the space below.

As much as I'd like to be sovereign over my home and my life the way I was sovereign over my Barbies, I'm just not. To be sovereign is to possess supreme or ultimate power. I don't have power over the behavior of the people in my life, over the cells in their bodies doing what they're supposed to do, over their safety, or even their happiness.

When God allows pain I don't understand, probably nothing is more comforting to me than to remember He has ultimate power over all things.

Let's look at this idea through some of the scarier situations that went down in the life of a woman named Esther.

Read Esther 1–2 and try to see if you can find any mentions of God. Did you find any?

Esther is the only book in the Bible that doesn't mention God one single time. How strange is that? How is there a book in the Bible, all about God, that fails to mention God? In reading commentaries on this book, I learned that not only is God not mentioned, but neither are there any recorded prayers or references to the Torah (the first five books of the Hebrew Bible) or the temple.[1]

So why is this book here? As we'll see, it's all about sovereignty.

Esther was a Jew living in Persia being raised by her cousin, Mordecai. During those days, the Jews were in exile. They were religious minorities in a God-opposing culture led by an absolute monarch.

So in the first chapter of Esther, we learn that King Ahasuerus (you've probably also heard him called by his Greek name, Xerxes) was getting rid of his queen, Vashti, and looking for a new one. That's the kind of thing he could just do without any consequences.

Look back at Esther 1:10–12.

Why was the king mad at Queen Vashti?

What did the king's advisers encourage him to do? (See verses 13-21.)

Esther 2:10 says Esther didn't reveal her ethnicity because Mordecai told her not to. Have you ever experienced anxiety over being different than people around you, whether it was because of physical, socioeconomic, ethnic, or racial differences? If yes, what happened?

Have you ever experienced anxiety because of someone in power who was doing things you disagreed with? Explain.

How do you tend to cope with this sort of anxiety?

King Ahasuerus had absolute earthly power. That's scary. When there are employers or presidents or family members whom we don't agree with in any position of power, it can lead us to feel insecure, especially when politics or racism are involved, like what we see in Esther's story.

When we see people in power who are making sinful decisions, it's tempting to believe God's gone missing.

Read Colossians 1:16-17. Write the following in your own words, "He is before all things, and by him all things hold together" (v. 17).

The story of Esther, the story of Colossians, and the story of the universe itself is that God never goes missing. Whether you're struggling with a circumstance, a relationship, or a person, you can fight your anxiety by holding on to the truth, the reality, that God is before all things. He is powerful over all powerful people. He doesn't need to be named, but He can't be ignored because He holds life itself together. When life looks like bad decisions and chaos and a big mess we can't control, we don't have to control. The sovereign God is leading the way.

In the space below, list the situations in your life that look bad. Surrender them to the Lord and trust He will hold you together. He will hold everything together. You can trust He will sustain His people just like He sustained the Israelites through Esther and Mordecai.

DAY TWO
A SNIFFLE, A SURGERY, AND A GIANT TOOTH

Esther 3:1-11; Psalm 4:8; Psalm 121:2-4; Romans 8:28 and 1 Peter 1:8

Recently, my daughter, Joy, had her last of three ear surgeries. I'd been up all night with another sick kid the night before and woke up to an alarm at 4 a.m. to take Joy to the hospital. My husband couldn't take her because he was also sick. That was already a less-than-ideal day, but while I was sitting in the waiting room, I felt a telltale sign of a dental abscess (not my first abscess rodeo—I've got troubled teeth). I called my dentist friend, drove to the dentist chair, and had to have my largest molar pulled out of my head for an hour and a half.

A few things:

1. Why does it take an hour and a half?

2. Always say yes to laughing gas. Always.

3. Expressions like "When it rains, it pours" exist for a reason.

4. The week of sickness, surgery, and emergency molar removal has filled me with more gratitude than I've had in a long time.

Isn't that weird?

We looked at this James verse earlier, but let's look again—James 1:2 says, "Consider it a great joy, my brothers and sisters, whenever you experience various trials."

I used to read that and feel panicked by it. I thought various trials were always coming for me—that failure, danger, and pillagement were around every corner and that if I didn't do every Christian thing just right, I'd miss the joy, ruin the moment, and experience all the things I was afraid of for no good purpose at all. I was missing the whole point.

Every living and active word of the Bible points us not just to the steps to take in trials, but to a sovereign Savior, whose perfection is completely given to us and whose power is always working.

Today, we follow more of Esther's story as she took steps in a terrifying trial as a great God worked behind the scenes.

Read Esther 3:1–11.

What do we see Haman attempted to do?

At this point, did it look like he would succeed in his objective?

Have you ever had one of those moments when it just felt like your whole life was falling apart? What is the hardest season you can remember in your life?

What did you do?

What did God do?

Look up 1 Peter 1:3-9. Focus on verse 8 and copy it in the space below.

We can see our problems, and they scare us. We don't physically get to see God right now, but we love Him. We believe in Him. We can rejoice, knowing He is at work even throughout absence emergencies, political emergencies, and personal trauma we didn't see coming.

Turn to Romans 8:28.

What does God do in every situation for those who love Him?

What are some trials you're walking through right now that you can praise God for today, knowing He is at work and will use it for good?

God is sovereign, which means He's never not working.

Read Psalm 121:2-4.

Where does our help come from?

What is God called in verses 3 and 4?

What does verse 4 tell us God does not do?

When I was little, I couldn't fall asleep unless I heard my parents watching TV and puttering around. I didn't want to be awake when they were asleep because then I'd feel alone and scared. I sensed safety when I knew they were awake and could take care of me. I trusted them to protect me if something happened while I was off the clock. So I've always loved this truth—that my Protector, the only one who actually has real control over my safety, never sleeps.

Read and copy Psalm 4:8 in the space below.

Life with Jesus means hope for later and abundant life today. It means trials are temporary, and joy is eternal because we place our hope in His hands that run the world and never tire.

You might be having a less-than-ideal day, or week, or moment in your home, but you have a "let us not grow weary" hope in your heart (Gal. 6:9, ESV). You can have peace instead of panic because you have access to the God who is in control, even when it feels like your Hamans are going to win.

Write a prayer asking the Lord to help you trust He is working in situations that look hopeless. Ask that He will help you rest and trust and sleep, knowing He is awake, present, and loving.

DAY THREE
A SWAT REFLEX AND A BUNK BED RESCUE

Esther 4 and Romans 11:36

My most "for such a time as this" memory involves my SWAT officer dad. When I was twelve, my little sister was exploring the bedroom of a little girl named Beth. I was loitering around with the grown-ups waiting for dinner to be ready when our hosts asked if we wanted a tour of the house.

They took us from room to room and then we got to Beth's. Beth was four with a little blonde bob and a bunk bed. For whatever reason, right as we walked in, everything seemed to change to slow-motion as we watched little Beth dive headfirst from the top bunk toward the floor.

My adoptive dad and his SWAT muscles were, thankfully, in the room at that moment, and he calmly raised his hands and caught Beth by the ankles right before her head hit the ground.

It was a little bit like witnessing a miracle. The strong, trained officer was standing at the right place at the right time to save a little girl from breaking her neck. That's the type of providence we see in the life of Esther.

In chapter 4, the messenger relayed information between Mordecai and Esther, ending on Mordecai's famous plea, "Who knows, perhaps you have come to your royal position for such a time as this" (v. 14b).

Read Esther 4. In verse 7, what did Mordecai share that he learned was to happen to the Jews?

Mordecai suggested Esther's position and her opportunity to serve her people wasn't simply a coincidence. Mordecai, a believer, knew God orchestrated everything, and maybe He put Esther in this position of power so that she could save God's people.

Look up Romans 11:36 (CSB translation) and fill in the blanks.

For from _____ and through _____ and to _____ are all things. To _____ be the glory forever. Amen.

Guys, please never forget that God has all the power. He doesn't have some of the power. He doesn't have most of the power. From Him and through Him and to Him are all things.

Sometimes that means Paul Wessel is standing at the right bunk bed at the right time. Sometimes that means Esther is in the right court in front of the right king to save a people from genocide.

Read Esther 4:15-17. What brave action did Esther plan to take?

Courage like that looks impossible from the outside. We think only "super Christians" do super brave things. But the longer I live, the more I see that God takes anxious people with simple obedience to accomplish extraordinary things in His sovereignty.

How do you think Esther may have felt in the days of fasting and planning to go before the king?

The Bible doesn't tell us how she felt, but I bet she felt great anxiety. She couldn't know how it would go. She didn't know if she'd be killed or banished (like Vashti) or if lives would be saved. But she trusted in God's sovereignty.

Why is it comforting to read about Esther and all the uncertainty she walked through that led to freedom for her people?

Maybe you haven't recently witnessed a miraculous moment. Maybe life feels ho-hum, and God just feels far away, and maybe that makes you nervous. Take heart. God uses every season and every circumstance to draw us closer to Himself. (See Romans 8.) When life looks scary and faith feels hard, remember that God is sovereign as you fight to feel peace.

Try to list three situations you've witnessed or been through where you saw the sovereignty of God on display.

1.

2.

3.

Close out your study time today thanking Him for His power and care and asking Him to help you do what He's called you to today, trusting that He is working, He is present, and He loves you.

DAY FOUR
DID GOD REALLY FIND YOUR PHONE?

Esther 5 and Esther 7:1-6

When my oldest was six, she gave me the following pep talk:

Mommy, God knew this was going to happen. From the moment Adam and Eve sinned, He knew you were going to lose your phone.

I thought it was hilarious and adorable and such a churched-kid thing to say. Obviously, I'd lost my phone. But I didn't think to involve God in the issue.

Like, "Hey God, I know You are probably busy caring for orphans and widows and listening to prayers about peoples' cancer and stuff, but can You just help me find my phone because I haven't checked Instagram in a few seconds?"

I often live parts of life as if God's not involved. Sure, He's involved in big things. But, like, lost iPhones? It just seems like a job not for Him. In our fight against anxiety, we need to know everything is a job for Him.

Today, we'll continue to look at God's involvement in the details of Esther's story.

Read Esther 5.

What did Esther ask the king?

How did the king respond to Esther's request?

Once again, we witness a "coincidence" of good fortune for Esther.

I used to kind of giggle when older Christians would talk about how God answered their prayers about finding their missing car keys or keeping them safe on airplanes. I failed to recognize what those older saints knew to be true—God is in the details, the little ones and the big ones. Recognizing He is present and active in every circumstance is an excellent way to quiet anxiety.

Throughout the rest of the Book of Esther, we read about a banquet with the king and Haman. We see Esther requested another banquet and then a drunk Haman left and saw Mordecai. I'll say the horrifying part as unobtrusively as I can. Haman got mad and ordered that Mordecai be impaled on a big stake on top of having already ordered that all Jews be killed in chapter 3.[2] We good?

Read Esther 7:1-6. What was the first thing the king said to Esther in this chapter, and how did she respond?

The gist of it is, the night before, the king had trouble sleeping. (See Esth. 6:1.) While the royal chronicles were being read to him, he heard about how Mordecai saved his life. So in the morning when Haman was about to tell the king he wanted Mordecai dead, the king ordered the opposite. He made Haman honor Mordecai. You can read the rest of the story in Esther 8–10. Long story short, Esther and Mordecai worked with the king to save the Jews. There were celebration banquets; Mordecai became second in command; the Jews prospered. That's the story.

There's no amen. There's no prayer. There's no tell-all theological explanation in the Book of Esther. But let's read between the lines.

Let's move ahead to the New Testament. Look up the following verses and write what it says about God next to the reference. *Some of these verses may look familiar because we studied them earlier this week!*

Romans 8:28

Ephesians 1:11

Colossians 1:16-17

1 Timothy 6:15-16

Which of these verses is most encouraging to you and why?

What would you do differently this week if you totally believed these verses were true?

No king, no ruler, no evil of any kind can keep God from caring for His people. Remember this as you wait for your biopsy results. Remember this when you get frustrated with your colicky newborn. Remember this when you get ready to share Jesus with your neighbor. Remember God is there, and He is sovereign over every small, massive, and medium thing in your life.

I want to challenge you today to include God in the little things. Bring your small concerns and your big ones and trust He is working behind the scenes

in ways you can't see. He is looking on you with favor as the king looked on Esther. The difference is you don't have to worry or wonder about it. You don't have to hope your King doesn't change. Your King is perfect and powerful and favors you forever in Jesus.

List some of the little things that are on your mind today.

Now list the big ones.

What do you hope to see God do in each circumstance you wrote down?

In the space below, pray about some of these little and big things and ask God to speak to you in the details. Ask Him for an awareness of His presence and His providence in your life and a faith that says "I trust You" when you can't understand what He's doing.

DAY FIVE
THE PSALM I LEARNED
IN HIGH SCHOOL

Psalm 103 and Hebrews 11:1,6

In tenth grade, my teacher made us memorize Psalm 103. I'm thirty-four, and I could still say it in my sleep.

Bless the LORD, O my soul,
and all that is within me,
bless his holy name!
Bless the LORD, O my soul,
and forget not all his benefits (vv. 1-2, ESV).

Read Psalm 103.

Look closely at verses 3-13. List what "his benefits" are below.

In the following blanks, personalize these verses a bit and list what God has done for you in each of these ways.

A sin of mine He forgave _____

A way He healed me _____

A time He showed me mercy _____

A way He renewed me _____

Which of those benefits is most meaningful to you right now, in this season of your life? Why?

The Book of Esther may not mention God, but we see so many of His behind-the-scenes benefits. We see Him redeem His people from the pit. We see Him execute acts of righteousness and give justice to the oppressed. We see His compassion and grace toward sinful people.

read Psalm 103:19 and copy it below.

If I had to summarize the Book of Esther, I would do it by quoting Psalm 103:19. The Lord rules over all. That's it.

Paul Tripp spoke about the Book of Esther like this:

This God who seems absent is actually working to protect and preserve His story. You shouldn't conclude, because you can't see the hand of God, that God isn't at work anymore [than] you should conclude that the sun isn't shining because you're in your basement and you can't see it. These are these moments where you have to do what Hebrews 11 says, "You must believe that God exists and He rewards those who seek Him." I'm not going to give way to belief in the functional death of my Redeemer even in moments where I do not see His hand.[3]

Do you ever feel like God is absent in your life? On the scale below, mark down how tangibly you're currently experiencing His presence.

I don't feel God near. God feels close to me.

| 1 | 2 | 3 | 4 | 5 | 6 | 7 | 8 | 9 | 10 |

It's so difficult to walk through seasons of life when God feels absent. If you're a believer, you know He's there. But sometimes you sense Him, and other times, He feels far away.

What are some ways you can pursue communication with God when He feels far away?

Turn to Hebrews 11:6. What do we need to please God?

What *is* faith? (Look at Heb. 11:1 for the biblical definition.)

When I read the Book of Esther, I see proof after proof after proof that God is working. Look at your own life. Maybe it's been some time since your relationship with God felt ablaze, but look at His blessings in your life. Your life is hard, but has He provided? Your life is sometimes scary, but has He protected?

List some of the ways God met your needs during those harder seasons when He felt far off.

You can believe in a God you can't see. You can trust He's working in your life even if your life looks like a bunch of Hamans and unfair beauty contests and conversations that could ruin you.

Esther went through a lot, and she came through it prosperous—not because she was awesome, but because God is. He had a plan for her, for her cousin, and for His beloved people. And He has a plan for you too. You don't have to save the day. God has already saved it. He's saved you. He's so, so powerful and nothing can touch Him. "The Lord rules over all." You can rest.

Pray through your anxiety by praising God for the work He does that you cannot see. Thank Him for being faithful and above all things.

This past week, you completed the Session Five personal study in your books. If you weren't able to do so, no big deal! You can still follow along with the questions, be involved in the discussion, and watch the video. When you are ready to begin, open up your time in prayer and push play on Video Five for Session Five.

WATCH

Write down any thoughts, verses, or things you want to remember as you watch the video for Session Five of Anxious.

REVIEW SESSION FIVE PERSONAL STUDY

From Day One: Esther 2:10 says Esther didn't reveal her ethnicity because Mordecai told her not to. Have you ever experienced anxiety over being different than people around you, whether it was because of physical, socioeconomic, ethnic, or racial differences? If yes, what happened?

From Day Two: Have you ever had one of those moments where it just felt like your whole life was falling apart? What is the hardest season you can remember in your life?

From Day Three: Why is it comforting to read about Esther and all the uncertainty she walked through that led to freedom for her people?

From Day Four: How do you approach God with the little things? Did you see God in the smaller details of your life this week?

From Day Five: Which of God's benefits, as laid out in Psalm 103, is most meaningful to you right now, in this season of your life? Why?

FROM THIS WEEK'S STUDY

As a group, review this week's memory verse.

If you keep silent at this time, relief and deliverance will come to the Jewish people from another place, but you and your father's family will be destroyed. Who knows, perhaps you have come to your royal position for such a time as this.

ESTHER 4:14

DISCUSS

This week we studied Esther. We looked at a book of the Bible where God is harder to find. We read between the lines, and we learned that though life is scary and complicated and people are sinful and messed up, God is always working things together for the good of those who love Him.

Did you learn anything new about the story of Esther this week? Share with your group.

What are you going through right now that causes anxiety because you can't see God's purpose in it? What do you think God's purpose might be? Share with your group and ask them to lift you up in prayer.

Which Bible verse was most impactful to you this week? Why?

This session's main idea is "Jesus is sovereign in our fight against anxiety." What are some action steps you can take this week to help yourself remember God is in control and He is trustworthy?

PRAY

Take turns sharing prayer requests and thanking God for being above all things and taking care of us. Pray He might use you to help people find spiritual freedom the way He used Esther to redeem the Jews. Ask Him to give you compassion for others and to dwell on His goodness and power rather than on the brokenness you see in the world.

To access the teaching sessions, use the instructions in the back of your Bible study book.

ANXIOUS PRAYER

PRAYER IS OUR POSTURE IN
THE FIGHT AGAINST ANXIETY

HUMBLE YOURSELVES, THEREFORE, UNDER THE MIGHTY HAND OF GOD, SO THAT HE MAY EXALT YOU AT THE PROPER TIME, **CASTING ALL YOUR CARES** ON HIM, BECAUSE HE CARES ABOUT YOU.

1 Peter 5:6—7

DAY ONE
JESUS TOOK MY BIRD AND SAW AWAY

1 Peter 5:6-7

I have a bunch of snapshot memories of the year my parents were getting divorced. I was very young, but I know there was a barbeque. A trampoline. A secret rock in the yard with nooks where I would stash pennies. I remember being in a lawyer's office with a copy machine and colored Wite-Out®. There are images of Grandma Marlene coming to stay with us to take care of me for way longer than usual.

I didn't understand my family was splitting apart. I didn't know whether to be sad or scared yet.

Grandma Marlene was amazing. She'd sit me on her lap outside by the pretty yellow flowers and sing hymns. So many hymns.

I'm so happy and here's the reason why;
Jesus took my burdens all awayyy.
Now, I'm singin' aaaas the days go byyyyy;
Jesus took my burdens all away.[1]

I loved the songs. But that one confused me.

"Jesus took my burdens all away" sounded to me a whole lot like, "Jesus took my bird and saw away."

I didn't understand why Jesus wanted a bird and saw and why my Grandma was so happy He took hers.

I got older and figured out the lyric misunderstanding but remained confused about how, specifically, to give Jesus my burdens. I'd sit through church youth events as a teenager and hear adults plead, "Come forward and leave your burdens at the cross!"

And I'd obey and think as hard as I could, *BURDENS, HERE, I LEAVE YOU. AT THIS CROSS MURAL IN THIS HIGH SCHOOL GYMNASIUM. ABRA CADABRA! AND AMEN!*

I so wanted my burdens to go away. I so wanted God to help me. But goodness—I didn't know how to do my part. Maybe you've wondered about that too. We all have burdens. What can we do with them?

Write 1 Peter 5:6-7 in the space below and circle the first two words.

When I first saw that and realized that it came before the "cast your anxiety" command, I felt like I'd cracked a secret code! So THAT'S how you do it! That's how you cast your cares on God! You humble yourself!

Wait—oh no—another abstract-sounding command.

Look up the word *humility* in the dictionary and write down what you find.

In the original Greek, *humility* denotes "not rising far from the ground"[2] and *humble yourself* means "to make low, bring low."[3]

The season I read that, I actually started praying on my knees. I'd always had a bit of an aversion to on-my-knees praying because once I discovered God

loved me, not because of what I do, but because of what Jesus did, I relished in my freedom to pray with my eyes open, to pray in the middle of a meal or the end instead of the beginning. *Freeeeedooom!*

But when I read that, I wanted to physically lower my body when I was talking to God. To train my body to remind my brain that I am low, that I am aware of God's bigness and power and my own weakness and frailty.

It was an incredible season where I tasted supernatural peace more often than I ever had before.

Write some other practical ways you can think of to "humble yourself" before God.

Here's the incredible thing. When I humbled myself, when I came before the Lord, lowly in Spirit, "casting my cares" on Him was a natural response. It just sort of happened. I remembered my status, as a created being, wholly dependent on a good, perfect, loving Father, and all those worries seemed to float to Him because I remembered He knows what to do. After I humbled myself, I was able to hum to "Jesus took my bird and saw away." (I don't think I did, but I could have!) After I humbled myself, I could smile, because I actually meant it, because I actually felt it.

I know this may not look exactly the same for each of us in our individual lives on our individual days, but God has promised to provide grace for each one of us as we humble ourselves before Him and cast our cares on Him.

Use this space to draw a picture of a time in your life when you felt free from burdens. How old were you? What was happening?

In Christ, we're born again. We can be like little children who have never been wounded by the big, bad scary world. Children who know our Dad is going to protect us. We can be like that because we are that.

If you've never considered that pride might be a big part of your anxiety, confess ways in which your heart has been prideful in the space below. It's hard to confess sin because it requires humility. But remember 1 John 1:9 says, "If we confess our sins, he is faithful and righteous to forgive us our sins and to cleanse us from all unrighteousness." And James 4:6 reminds us that God "gives grace to the humble."

Jesus isn't in the business of taking birds or saws away. He's a lover of souls and a lifter of burdens. When we communicate with Him through prayer, remembering the reality that He has that kind of power, we can echo Grandma Marlene (with the correct lyrics), singing, "I'm so happy and here's the reason why; Jesus took my burdens all away. . . ."[4]

DAY TWO
WEIRD NOSE-MOUTH-LIP-FINGER SEASON

Philippians 4:1-9

The first six months after I had my thyroid removed, my body freaked out a little. Weird stuff started happening. For example, I had a photo album saved on my phone titled, "Weird nose mouth lip finger thing" that I brought to doctors' offices all over Nashville.

I don't want to gross you out, but there was ample oozing and swelling and crusting involved. ON MY FACE. Itching and tingling and burning. Is that enough? I'm sensing that you, reading this in the future, are uncomfortable. I'll stop. After just one more descriptor—gook.

So I'd just gone through the thyroid ordeal. I'd had blood tests and CT scans and all sorts of testing. So I guess I should have taken solace in that. But, in my mind, every throat tickle and allergic reaction was a symptom of something bigger. A sniffle is never just a sniffle with me. A sniffle is nasal cancer. An itch is lymphoma. A stomachache is clearly internal bleeding.

Toward the end of my weird nose mouth lip finger thing (WNMLFT from now on), I saw a specialist and described my symptoms. I showed him photos of all the sores, and I gave him a detailed timeline of events. When I was finished, he said, "Some of the words you used to describe your condition . . . are you in the medical field?"

Here's the point I'm getting at: what you put into your mind—what you think on—what you pray for—matters. I spent so much time worrying about being sick that I sounded like a doctor.

Maybe you already have this week's key sentence down. Maybe prayer is already your posture as you fight your anxiety. But if your prayers sound like mine did during WNMLFT season, you might find yourself remaining anxious, even as you pray.

During WNMLFT, my prayers were extremely similar to all the words I typed into WebMD's Symptom Checker. It was kind of like:

God, does the tip of my tongue feel numb? Lord, why is it so smooth here and bumpy there? Is that normal? Isn't it supposed to be bumpy in all areas? And my ring finger on the left hand has been itchy for way more than a week. That can't be normal, right, God? Let's You and I see what Google has to say about this for the next two hours.

I don't know that I ever got to the "Amen" because my prayers weren't really prayers as much as they were obsessively-fearful-brainstorming sessions.

What you think on matters.

Read Philippians 4:1-9. What are some words in verse 1 that let you know how the author (Paul) felt about the people he was writing to?

I point out that introduction because it is helpful as we apply the gospel to this passage. In the past, I've often attributed a tone to God's Word that just isn't there. This passage is not angry and obstinate. It's loving and helpful.

The Book of Philippians is Paul's letter to the people of Philippi, but it's also God's Word to us, today. God is not attacking us in this chapter for not thinking on the right things. He's lovingly helping us, just as Paul did with the Philippians, to think on the things that will bring life to our souls.

Read verses 4-7 again. What are the four things Paul said to do in these verses?

Which of these four things are you best at? Which do you need the most growth in?

In this letter, Paul was speaking to a church that was in the midst of persecution. So the "worry" these people were dealing with was valid, life-or-death fears.

Have you ever feared persecution for your beliefs? If so, what triggered that fear? If not, how do you feel when you consider persecuted Christians in the world today?

Look back at verse 9. What did Paul say is a result of following his instruction?

It's much harder to fear the broken, sad, and scariness of this world when you are experiencing the tangible presence of the more-powerful-than-ANYTHING God. Praying places your mind on God, and, when your mind is on God, your mind is on peace.

This next exercise might take you some time, but it will be worth it. Use Google (don't get side-tracked on *WebMD*) or a Bible dictionary to look up each of the terms in the chart. Then, write down something in each category that you are grateful for in the blanks beside the terms and back up your answers with a Bible reference. In the third blank, write down what that means for your battle with anxiety. I'll do the first one to give you an example.

	THING TO THINK ON	REFERENCE	WHAT THAT MEANS AS I FIGHT
WHAT IS TRUE?	"I am the way, truth, and the life."	John 14:6	Jesus is the Word, and His words are true, so when I'm afraid, I can remember that if He promises me hope and sharing in His glory for all eternity, I can be comforted by that.
WHAT IS HONORABLE?			
WHAT IS JUST?			
WHAT IS PURE?			

THING TO THINK ON	REFERENCE	WHAT THAT MEANS AS I FIGHT
WHAT IS LOVELY?		
WHAT IS COMMENDABLE?		
WHAT IS MORALLY EXCELLENT?		
WHAT IS PRAISEWORTHY?		

Close out this day thanking Jesus for the blessings you listed. Ask Him to help your prayers be more worshipful and less doubting, more grateful and less anxious.

Oh, and by the way, it turns out WNMLFT was just an allergy to chapstick.

DAY THREE
WORLD'S MOST AMAZING PENCIL SHARPENER

Matthew 6:1-8

I don't know how extreme your teen angst was when you were in high school, but mine went deep. Pretty much everything I did in ninth grade was an effort to be seen/noticed/respected/admired by, well, every male that existed.

I remember sitting in my third hour class, making intense listening faces during lectures, asking the teacher what I considered to be thoughtful or funny or interesting questions, and getting up to sharpen my pencil with these thoughts in mind: *Are any of the three to seven boys that I'm in love with in this room looking at me, and, if so, are they daydreaming about how they will propose to me when I'm finished sharpening this pencil? And, if they do propose, what will I say? And if they ALL propose, whom will I choose?*

As you can tell, my early ideas about love were very much about, um, me. I was so extremely wrapped up in my desire to be loved that I didn't love other people very well. My whole life was some sort of weird performance art that was, with zero subtlety saying, *LOOK AT ME! LOVE ME! PLEASE, I BEG OF YOU!*

I was also the kid who volunteered to close nearly every class in prayer at my Christian school. Because, I mean, then the teachers and even GOD would love me more, right?

I was a classic example of what Jesus said not to do in today's passage.

Read Matthew 6:1-8.

What did Jesus tell His disciples not to do in verses 1-4?

Is there anything you do in life for the sole purpose of being noticed/praised?

Those first few verses we just read were about generosity—helping the poor and doing good. But the next few we're going to look at are specifically about prayer.

Reread verses 5-8. What do you think Jesus meant when He said that the hypocrites who love to pray in public have their reward?

A lot of us are wired to look for reassurance that we're doing things the right way. There's no anxiety quite like the anxiety that comes with wondering if you got what matters for ETERNITY right. These verses are a gentle reminder to me that prayer isn't a formula to earn something. Prayer is its own reward.

What do the following verses tell you about the benefits of prayer?

2 Chronicles 7:14

Psalm 107:28-30

Psalm 145:18

Jeremiah 33:3

Matthew 7:7-8

Acts 9:40

Romans 8:26

Philippians 4:6-7

James 1:5

James 5:16

1 John 5:14-15

People who pray falsely for attention don't get the reward of friendship, intimacy, and actual, experiential, back-and-forth conversation with their Creator. There's nothing more incredible, nothing more peace-giving, nothing more worth your time, than talking to God in secret.

Describe the best prayer time you can remember experiencing.

What are some practical ways you can organize your schedule and life to make time and space for one-on-one alone time with God in prayer?

Examine yourself today. Are you still walking up to pencil sharpeners, anxious to be approved by fellow flawed people? You don't need to impress Jesus with your words or actions or pencil-sharpening-prowess. You're loved because you're His. You're forgiven because He's merciful. Dwell on that today in your thoughts, in your prayers, and in your deeds.

DAY FOUR
THE WORST PRAYER I EVER PRAYED

Matthew 6:9-13; Matthew 11:28-30 and Romans 8:26-27

The worst prayer I ever prayed was on an operating room table. I was about to have the surgery that would save my life after an ectopic pregnancy left me with no baby, a quart of blood loose in my abdomen, and the worst pain I've ever felt.

The medical staff went from ultrasounding me to sprinting with my gurney in a single second. Papers that said things like "DNR" and "living will" were being shuffled near me, and nurses kept covering me with heated blankets because my teeth were chattering. I was going into shock.

When they transferred me from the gurney to the operating table, a stranger said, "Okay, I want you to count backwards from ten," and I knew I had less than ten seconds to tell God what might be my last words.

Silently, I prayed, *If I should die before I wake, I pray the Lord my soul to take . . .* [5]

What a tragedy. I'd been trying to walk with the Lord for a decade at that point, and my rhyme-y childhood prayer revealed that I was still anxious about my eternal security. Back then I'd had ten years of studying the Bible, praying, trying to pursue the things of the Lord, and, still, I wanted to just MAKE SURE if I'd "done it wrong" all those other times, I'd still make it into heaven.

God used that near-death tragedy in my life to give me assurance of my faith. And that prayer itself is an example of how that works.

Here's the beautiful thing. My worst prayer ever didn't change God's love for me. I could have sung my doubting nursery rhyme, died on the table, and woke up in His arms. It is not our skill that makes prayer powerful. It's the God we pray to. The weakest prayers have worth when we are children of God. And, amazingly, our Father not only makes prayer powerful, He helps us know how to do it.

Can you think of a time you prayed a "weak" prayer? What was happening? What about your prayer makes you consider it "weak"?

Read Matthew 6:9-13. Use it as a model and write your own prayer, verse by verse. For example, I might rewrite verse 9 ("Our Father in heaven, your name be honored as holy") by saying, "God, you are so much higher and bigger than I am. You are good and pure and clean and so different than me.")

Your Version:

Verse 9 _____

Verse 10 _____

Verse 11 _____

Verse 12 _____

Verse 13 _____

The Lord's Prayer here might sound very formal, but the point of Matthew 6 is that God doesn't want you to pray or talk or act to perform. Because of Jesus, God is our Dad. Because of Jesus, we don't have to feel guilty when we talk to Him.

I look at this prayer to help me when I'm not sure how I should pray. It reminds me to thank God for who He is and what He's done, rather than grow desensitized and forgetful. It teaches me I am fully dependent on Him to meet my every need.

Reread Matthew 6:9-13. What does Jesus' example of prayer teach you?

Remember what God does in our weakness? Review Romans 8:26-27. What does He do?

Here's a thing. I don't think God considered my "worst prayer" to be the worst. I don't think that's true, based on what I know of Jesus.

Flip to Matthew 11:28-30. What did Jesus say in these verses?

Isn't that crazy? Jesus is humble. Jesus is the only being who doesn't NEED to be humble!

He and the Father are one. But He lowers Himself. He associates with us, sinners. He has compassion for our weaknesses. We can pray weak prayers. We can pray silent prayers. We can pray frustrated or sad or joyful prayers.

Jesus loves us. It's that simple. And He knows it's hard to talk to someone we can't see. So He gives us this beautiful example. This beautiful reminder.

Close this day out thanking Him for showing us the way and for loving us when we do it wrong or when we feel too weak or anxious to do it at all. Ask Him to transform your prayer life and help you learn to pray in a way that glorifies Him and helps your heart toward peace.

DAY FIVE
JOY'S SECRET LANGUAGE

Matthew 10:22; John 10:10; John 15:18-27 and Romans 8:18-28

The doctors at Vanderbilt don't think our daughter Joy will ever be able to talk. She's such a miracle, but she had so much stacked up against her in those early years that as much as she tries and as much as she thrives, when she tries to vocalize, her sounds just don't come out as words.

People can't understand her.

It's something that was way harder to deal with at first. When we weren't all fluent in sign language, it would kill me to not know what she was saying. Sometimes she'd cry and get upset and make noises, and none of us could figure out what they meant.

Now, she signs, and we usually get it, but once in a while, we're all left scratching our heads, and she usually shrugs and signs, "Never mind—it was nothing," and she walks away.

It's a hard thing. It's a hard thing for her; I'm sure. And it's a hard thing, as her parent, to want to connect and understand what she's thinking and not be able to. Maybe you've experienced something similar when trying to communicate with someone who doesn't speak your language.

We humans, even those of us without any physical or mental special needs, are limited in our communication. Have you ever been speechless? Even people with the most sophisticated vocabularies sometimes find themselves in situations where they just don't have the words.

Read Romans 8:18-28. Which of these verses means the most to you today and why?

In verses 18-22, Paul reflected on how much different it will be when we are free from suffering, free from "labor pains" (v. 22). Can you even imagine it? During my most intense seasons of anxiety, my mind has made me feel like the suffering would never end.

What is a circumstance about which you "groan within" yourself (v. 23) today? What do you look forward to being relieved from?

Read John 10:10 and copy the second sentence in the space below.

For Christians, it can be tempting to look at today's passage and feel hopeless about today and like everything will be pins and needles and the wringing of hands until heaven. The gospel tells us this isn't true, though.

If you've been part of the church for a while, you may have heard the term *abundant life* thrown around. That term comes from this verse, when Jesus was explaining He has come so we can have life in abundance.

Some people misinterpret this and think Jesus is saying if you follow Him, you'll have all the good stuff of life. In reality, Jesus promised otherwise.

Read Matthew 10:22 and John 15:18-27. How did Jesus say our lives as followers of Him would be?

Life can be hard and still be abundant. Jesus told His disciples and is telling us now that joyful life is from Him. Life in abundance is only found when we pursue Him and His kingdom. Anything and everything else will leave us anxious and unsatisfied.

Have you tested that truth? Have you pursued peace and pleasure in things outside of Jesus and found they didn't work?

Share below about the things your flesh craves and where those roads lead.

So we pray. We pray, remembering the truth of Romans 8. We pray, remembering the truth of Jesus as our way to life and peace. We pray, remembering the reality that after this life, we will someday be in actual glory with everlasting peace that can never go anywhere. We pray that way, and it changes us right now.

We pray that way, and the casting of cares and releasing of burdens actually happens.

One day, my youngest asked me if Joy would be able to talk in heaven. It got me emotional. I'd never considered it. My communication with my non-verbal daughter is limited. But Philippians 3:21 tells me that at Christ's return, we'll get new bodies. Perfect ones where all the parts work and we won't fear them breaking down anymore. And Joy's ears and mouth will work. And we'll never wonder what she's saying as she praises her Maker with us around the throne.

What are you grateful for right now? Tell God about it. He's listening.

This past week, you completed the Session Six personal study in your books. If you weren't able to do so, no big deal! You can still follow along with the questions, be involved in the discussion, and watch the video. When you are ready to begin, open up your time in prayer and push play on Video Six for Session Six.

WATCH

Write down any thoughts, verses, or things you want to remember as you watch the video for Session Six of Anxious.

REVIEW SESSION SIX PERSONAL STUDY

From Day One: What are some practical ways you can "humble yourself" before God?

From Day Two: In Philippians 4:4-7, what four things did Paul say to do?

From Day Three: What are some practical ways you can organize your schedule and life to make time and space for one-on-one alone time with God in prayer?

From Day Four: What does Jesus' example of prayer teach you?

From Day Five: Which of the verses that you looked at from Romans 8 means the most to you this week and why?

FROM THIS WEEK'S STUDY

As a group, review this week's memory verse.

Humble yourselves, therefore, under the mighty hand of God, so that he may exalt you at the proper time, casting all your cares on him, because he cares about you.

1 PETER 5:6-7

DISCUSS

This week, we studied prayer. We talked about how to do it, how not to do it, and how we can cast our cares on Jesus. If you're comfortable with it, discuss your own experience with prayer. In which ways do you struggle? What are some disciplines you have put in your life to help you? Do you have any amazing stories of answered prayer?

What is one thing you have been anxious about this week? How can this group pray for you?

This session's main idea is "Prayer is our posture in the fight against anxiety." Are there any ways you now intend to pray differently when taking your burdens to the Lord? Discuss ideas with your group.

PRAY

This would be a great week to use most of your time to pray for one another. Consider praying through the Lord's Prayer (Matt. 6:9-13) together. Maybe take one verse at a time and add to it in the direction Jesus leads. Look back to Day Four and see how you changed each verse's example into your own words. Take turns praying like this and for one another's burdens.

To access the teaching sessions, use the instructions in the back of your Bible study book.

ANXIOUS READER

THE BIBLE IS OUR WEAPON IN
THE FIGHT AGAINST ANXIETY

[THE ORDINANCES OF THE LORD] ARE MORE **DESIRABLE THAN GOLD—** THAN AN ABUNDANCE OF PURE GOLD; AND SWEETER THAN HONEY DRIPPING FROM A HONEYCOMB. IN ADDITION, YOUR SERVANT IS WARNED BY THEM, AND IN KEEPING THEM THERE IS **AN ABUNDANT REWARD.**

Psalm 19:10–11

DAY ONE
SO HOW'S LEVITICUS GOING FOR YA?

Hebrews 4:1–12

In 2008, a friend and I decided we were going to hold each other accountable to read through the Bible from Genesis to Revelation in one year.

It was a good goal to set, and the first few days of texting back and forth went really well.

The thing is, we both dropped off. One of us missed a day. One of us had a crisis. The texts stopped. The plan was thwarted. We never finished it.

I write this in the year 2020 and smile because every few years, she and I will check in with a text: "So . . . what are you on now . . . Leviticus?

Bible reading can be hard. The Bible was written in different languages across years and years to multiple audiences. It contains books like Leviticus and Revelation. Add to that complexity the reality that we have an enemy who comes "only to steal and kill and destroy" (John 10:10), and it should be no surprise that there are days Bible reading seems like work.

But the Bible isn't just a book from history; it is a book from heaven (Ps. 119:89). It doesn't just have old words; it has God's words (2 Tim. 3:16). It isn't just long; it is alive (1 Pet. 1:23). The Bible literally does supernatural work in your heart while you read it (Isa. 55:11).

Our own weakness, anxiety, selfishness, and sin, at times, make the Bible hard to read, but it is light and life itself (Ps. 119:130; Matt. 4:4). The Bible is our weapon as we fight to trust God and find the peace He gives.

What are some of the most common reasons you don't read your Bible?

I'll answer that question as well. One of the primary reasons I will ignore the Bible is because I sometimes bring my anxiousness filter into the text.

When my anxiety is fierce, I find I can misread Scripture and, instead of a loving God with an easy yoke, I see a judging One with a list of demands I can never adhere to. God's plan for us is peace, but it is possible to read the Bible and panic.

Read Hebrews 4:1-12. What does your heart and mind latch onto when you look at verse 1?

This is a great example of how anxiety can impact the reading of Scripture. Some of you probably saw "the promise to enter his rest remains" (v. 1) and thought Yeeeeeeees.

Others of you saw, "beware that none of you be found to have fallen short" (v. 1) and thought, *I'm dooooomed.*

Which reaction did you have? (Feel free to add your own write-in reaction. I've given you an extra box.)

○ *Yeeeeeees.*
○ *I'm dooooomed.*
○ _____

Both phrases are true. Here in Hebrews 4 is the hope of rest, as well as a warning about unbelief. It can be pretty scary to read if you're used to listening to the lies your anxiety tells you. But the perfect love of Christ "casts out fear" (1 John 4:18, ESV), so let's look, soberly, at this text and examine our hearts—not in a panic but as children of God.

Look at Hebrews 4:2-4.

What keeps people from entering the rest?

What are some things you do when you're trying to rest?

The Lord, the One who invented rest (see verse 4) when He created everything you know and see, knows how to satisfy your soul. He knows how to give you peace because He invented peace.

Our Hebrews 4 passage deals with several types of rest, among them are— ultimate rest in salvation, eternal enjoyment in heaven, and peace that we can experience even now on earth through Christ's provision.

How does the eternal rest promised by God through salvation in this passage form the way that you can rest your anxious heart even in the here and now?

Entering into the rest can be as easy as entering into His presence. If God's Word is alive and true and made to lead you to Him, time in God's Word should be a comfort, not a chore.

Now look back at verse 10. When we imitate God by resting, what is it that we are resting from?

It's exhausting trying to do everything right, isn't it? Because we fail! Eventually our working turns to worrying turns to wandering away. And if our hope and our peace and our rest is all tied up in us "doing good," we will be crushed when we have a bad day.

Reread verse 11. Rather than pursuing our own goodness, what does God's Word tell us to make an effort to do?

In verse 12, what are some things we learn the Word of God is able to do?

Isn't it crazy that a book can read your mind? I mean, it sounds crazy until you remember that the Bible is inspired, or "God-breathed." If God's Word is alive and active in that book, He is certainly able to know you and speak to you, shape you and teach you through those words. It's such a beautiful truth.

My friend and I or your friends and you can plan to try to read through the Bible in a year or three months or a weekend. And maybe you'll do it! But if you're doing it to earn God's approval, to check a box, or to stay out of hell (that was me), you're missing it. You're missing the rest. You're missing the magic. You're missing the gift that God's Word is to our anxious hearts. God wants you to read His Word and enter His rest here on earth and eternally.

Close out this day by thanking God for His Word, this gift, this weapon. In your prayer, reflect on a time God's Word was a weapon in your fight against fear, if one comes to mind.

DAY TWO
"GOOD PEOPLE" AND BIBLE READING

Psalm 19:1–11

Here's some of what I battle when it comes to Bible reading:

- I get anxious about "doing it right" or "doing it enough," and I forget that it is a living, active gift.

- I get distracted thinking about using the wrong kind of Bible. Do super Christians read the Bible on their phones? That's not as good, right? I need a big, worn study Bible. I need a Bible that doesn't have the Tiny Wings™ app on it. Man, Tiny Wings is great. Can you believe your daughter has gotten better than you at Tiny Wings? Unacceptable, Scarlet. Be better. Just be better. We're going to practice Tiny Wings today, and we will absolutely win the race to Island 4 tonight.

- I get anxious/frustrated when I read things I don't understand.

- I focus so much on potential dangers or problems I feel like I need to fix that I fail to look to the Lord.

It takes discipline to read the Bible regularly and well. What sort of rhythms have you put in place in your life to help you stay consistent?

Reading the Bible doesn't have to be a battle. Today, we're going to look at the first part of a psalm David wrote, and we'll reflect on what it tells us about the Bible. But first, let's look at the beginning of this psalm.

Read Psalm 19:1-6. In these verses, what is it that is declaring and proclaiming the glory of God?

General revelation is the phrase used to explain how God's glory and character are revealed to mankind through nature.[1] It's that thing when you stand at the ocean, speechless. The thing when you see a baby being born or you stand on top of a mountain or look out over a valley and just think, Wow.

The natural world tells us God is glorious. Creation, in its scope and life, reveals some of the beauty and grandeur of God.

But God doesn't leave us staring at trees and "Wowing" at seas while wondering what it all means.

Read Psalm 19:7-11.

Special revelation is supernatural communication between God and humanity.[2] Verses 7-11 are speaking directly to that.

What key words in this passage tell us these verses are about the Bible?

What words did David use in verses 7 and 8 to describe the Bible?

Read verse 11. What did David mean when he said, "in keeping them there is great reward" (ESV)?

When I was a teenager, I'd leave to hang out with my friends or go on a date, and my dad would stop me and say, "Scarlet, remember, all sin leads to heartache." He said that so many times.

He was giving me freedom. Freedom to go sit in movie theaters or go to parties with other seventeen year olds. But, a warning. His warning wasn't, "Don't do bad stuff, or I'll ground you." His warning was, "If you sin, you will hurt. I love you, and I don't want you to hurt."

That's what the Bible does for us so often! It is like God, leaning over the kitchen counter, saying, "This is how to live, child! Remember, sin leads to heartache."

The reward of "keeping" God's Word as a priority in your life is peace—joy—happiness! He doesn't give us rules to harm us. He gives us instruction to protect us. He is a good Father.

In the space below, write out some personal reasons you treasure God's Word.

DAY THREE
A LETTER WE CAN LEARN FROM

Matthew 16:25 and 2 Timothy 3:10-17

Paul, the apostle, (the guy who was also known as Saul—a serious big-time Jew who killed Christians, but then Jesus blinded him and revealed Himself and then he spent the rest of his life serving and preaching and writing Bible books—that guy) . . . well, let me just stop and take a breath. I'm just really proud of myself for that summary of Paul's life.

If you want the non-abridged version, read about his amazing conversion story in Acts 9.

Moving on. Paul wrote a bunch of Bible books—letters to churches and to people—letters that were written then and for then but that God designed to be applied to us today.

Author and Bible teacher Jen Wilkin did an Instagram Q&A, and I loved what she said about applying Scripture. She said, "All Scripture applies first to its original audience . . . This is important because how we apply it today must relate to how they applied it then. It can't mean something to us that it could never have meant to them then. Once you examine what it said to them-for-then, think about its message to us-for-always."[3]

So first, let's look at the "then" context of our 2 Timothy passage. Paul was writing this letter to Timothy, whom he met during a missionary journey.

In the chapter we're looking at today, he was encouraging Timothy not to lose heart during times of stress and suffering.

Read 2 Timothy 3:10-17.

What was Paul reflecting on in verses 10 and 11?

Who did Paul credit for his rescue from troubles?

What are some difficult circumstances you've endured recently?

Are you able to echo Paul in any similar ways? How did the Lord provide for you?

Reread verses 12-13. What did Paul say all who want to live a godly life will experience?

I used to get so caught up in verses like these. I'd think, NO THANK YOU. I WANT A GOOD LIFE. But I've lived plenty of seasons of "good life" and still been miserable.

I've lived fearful I'd lose what I had. Stressed over things that didn't matter. We can get caught up fearing the bad stuff of this life when we forget that we have a prize that can't be taken from us.

We think if we cling to the things we love in life, we'll save them. But the opposite is actually true.

read matthew 16:25.

What did Jesus say will happen to someone who gets caught up in "sav[ing] his life"?

Then, Jesus went on to describe a group that will find life. What are believers to do with their lives, according to Jesus?

If we are anxious to cling to anything in life other than Jesus, we'll find that we're never at peace. No matter how good we are at worrying, we aren't capable of holding on to anything. We don't have the power to keep life going and to keep jobs safe and to keep bodies healthy. When we "lose" our lives or surrender them, when we trust that Jesus knows better than we do, there is where we find the peace.

read 2 Timothy 3:14-17.

What did Paul say Scripture gives us (v. 15)?

I love verses 16 and 17 so much. What a beautiful list of benefits. In the chart below, I want you to take each benefit and write down in the blank how that specific thing can help you as you fight your anxiety.

Teaching _____

Rebuking _____

Correcting _____

Training in _____
Righteousness

The Bible teaches us about the God who died to free us from slavery to fear. The Bible rebukes us when we are numb to sin and indulging in self-centeredness. The Bible corrects us when we look to the wrong things for comfort and security. The Bible trains us to live lives centered on enjoying the love we have in Christ and sharing it with others. The Bible reminds us that to lose our lives is to find our lives.

It really does equip us. It equips us to be happy, healthy children. It prepares us to be ambassadors—service-minded, fulfilled, contented people who bring their burdens to the only One who is strong enough to carry them.

Close this day asking the Lord what He wants to speak into your life in regard to your fears today. Ask Him. Read. Listen. Write it down below. Remember it. God is for You. He loves you. His Word is a gift and a weapon.

DAY FOUR
THE WORD IS A PERSON

Genesis 1:26; Matthew 24:35; Luke 21:33 and John 1:1-5,14

Remember in Day One when we talked about Hebrews 4:12 and how the Word of God can discern your thoughts and intentions? Well, I could barely wait to get here, to Day Four, because we are going to talk about why this book has such power. Why is this book able to change us and help us and even KNOW us? Today, we're looking at one of my favorite parts of the Bible—John 1. John 1 tells us who the Word is.

Read John 1:1-5. What do we learn about "the Word" from these verses?

Now, look down the Bible page to verse 14. If the Word is God, and the Word was made flesh and dwelt among us, who is the Word?

Commentator James Montgomery Boice wrote,

What do you think of Jesus Christ? Who is he? According to Christianity this is the most important question you or anyone else will ever have to face. It is important because it is inescapable—you will have to answer it sooner or later, in this world or in the world to come—and because the quality of your life here and your eternal destiny depend upon your answer. Who is Jesus Christ? If he was only a man, then you can safely forget him. If he is God, as he claimed to be, and as all Christians believe, then you should yield your life to him. You should worship and serve him faithfully.[4]

The reality that Jesus is God isn't just a fact you have to memorize to excel at the Christian faith. It's the basis of our faith. If Jesus isn't God, then we aren't forgiven. If Jesus isn't God, we still await punishment for our sins. If Jesus isn't God, we have no access to our Creator, no access to the joy we can only find in His presence, and no access to eternal life beyond the grave.

Jesus is God. Jesus has always been God and will always be God. But Jesus isn't only described as God. Jesus is "the Word." Jesus, our Rescuer, our Hope, our Peace, is alive in the pages of Scripture.

Now, look at Genesis 1:26. Are there any words in this verse that lead you to believe God the Father wasn't alone when He created the world? List them here.

John 1:2-3 affirms Jesus was there with God the Father, in the beginning. So in this little handful of verses, we learn that Jesus is called the Word.

We learn He is God—that He also, as God, created all things. Listen, maybe that makes your brain hurt. No problem. Just thank God He is smarter than us!

But it's really important as we seek to worship Jesus to recognize He isn't just a guy, and He isn't even "just" God. Jesus is revealed to us in the Bible. God is speaking through those pages.

Have you ever been reading the Bible and experienced Jesus? (By that, I mean, have you ever been reading the Bible and felt you were not just reading a book about God but that you were communicating with God through the power of the Holy Spirit?)

What are some specific passages He has used in your life? Share about them in the space below.

Look up Matthew 24:35 and Luke 21:33. What do these accounts tell us Jesus said?

Isn't it comforting to know that Jesus created us, that He is forever, that no matter what comes against them, His words are forever too? When you hear them, when you read them, when you commit them to memory, the Spirit stirs in your soul and helps you believe the truth—the truth that this scary world isn't forever, but Jesus is.

What is the most recent thing you've done when you felt overcome by panic?

Sometimes, I wake up in a panic. Maybe it's a bad dream, or, often, I just wake up to get water and a horrible thought crosses my mind. What if such and such happened to my husband? What if one of my daughters does this or that? What if-what if-what if

Often, I lie back down and either think of the Word or read the Word, or sometimes I just whisper the Word's name, "Jesus."

But if you only have one word, that's the one. He is the One. He is the Word.

Take the next few minutes to look through my list of favorite anxiety-fighting memory verses in the Appendix on pages 186–187. Pick out a verse that will give you some words to carry with you for the rest of the day. Write out the verse you picked that reminds you how loved and protected you are by the Prince of peace in the space below and try to memorize it.

If you read the Bible and don't experience Jesus, examine your heart and ask yourself what your motives are.

Try to answer these next few questions honestly by checking the one that best fits your response.

When you open the Bible, are you looking to experience God, or are you trying to "do what good people do"?

○ Looking to experience God.

○ Trying to do what good people do.

When you read the Bible, do you open it randomly and pull verses out not knowing what they mean and then close it, feeling like you've done your duty for the day?

○ Yes.

○ Nah, not my style.

If you don't understand something you've read, do you give up, or do you press in and research what it means?

○ **Throw in the towel.**

○ **Research is my middle name.**

A lot of our Bible frustrations exist because we forget that God meets us when we open the Bible. We read it because we should. Or we read it because that makes us feel like we're winning at life. Don't read the Bible like you're completing a homework assignment you don't want to do. Read it like you're on a coffee date with your best friend and what you're reading is what He's saying (and what He's saying are the words of life). Go to the Bible like what you're reading is His advice to you, His encouragement to you, His comfort for you.

Now, write out a prayer, worshiping and thanking God for giving us access to Himself through His Word.

DAY FIVE
WATCHING JOY PRAY

John 17:1-19

Watching Joy pray in sign language is one of the most rewarding things I get to experience as a mom. It's amazing, because when I met her, three years ago, she didn't have any language. She had no words. When she felt things or needed things, she didn't know what to do.

For a week and a half, while still in China, we actually didn't think she'd ever learn any words. She was so medically not ok. But our first glimmer of hope came at the buffet table when she realized that every time Daddy fed her a bite of vanilla yogurt, it was after he brought her fingers to her lips. The sign for *food*.

Next, she learned the word *drink*. Then, *cracker*. Sweet Joy was hungry. And those three words changed her life.

Now, she prays.

This week, I had a tooth pulled (my teeth hate me), and before I left for the dentist, I told the girls I was a little scared. My oldest offered to pray for me, and it was so precious. And then, Joy took over. She squeezed her eyes shut, and her hand went to work praying for every detail of what I was about to experience. She prayed that I wouldn't be afraid.

Read John 17:1-19.

In John 17:1-19, we read about Jesus, the Word made flesh, praying for His disciples. Two times in His prayer, He made requests in connection to the Word. What were those two requests?

In verse 13, Jesus desired for His disciples to have completed joy. Write about a time you have obeyed God's Word and felt joy.

In verse 17, Jesus asked that God sanctify His friends through the Word. Let's give this some attention. Look up the word *sanctify* in a dictionary and write out the definition below.

To be *sanctified* is to be separated from things that are evil, things that are not pleasing to God. When we talk about being sanctified, we are talking about living as followers of Christ. So, naturally, we see plenty of instruction about how Christians are to live in the Word.

We're not going to walk perfectly. But to be sanctified means to take steps of obedience and pursue the Lord through prayer and through His Word. That is how we become like Him. That is how we experience the joy of verse 13. This is how we learn to be less anxious people. The Word leads us toward sanctification and away from anxiety.

Think back to the most peaceful season of your life. What were you doing? What was happening?

Where were you in your relationship with Christ?

One of the most peaceful seasons of my life was when we were in the adoption process. We didn't have the money to do what we were doing. We didn't have medical answers or even hope that things would work out at all. But we knew we were walking the direction the Lord was leading. His Word comforted us when we were sad. It convicted us out of our fears. It humbled us when we forgot He was the only reason anything good ever happens to us.

Why does it matter that Jesus asked God to sanctify His friends through the Word? Because, essentially, what He was asking was that His friends would be safe—have peace—be happy. Safety, peace, and happiness are the opposites of anxiety. And God wants that for us. God wants that for you.

Copy this week's memory verse (found at the beginning of this lesson in the margin. (I've shown you where). →

Now, let's look back at the memory verses we've already learned. See if you can fill in the blanks from memory without looking back. God's Word is a weapon. His Word is a comfort. His Word is a way to fight anxiety. Praise God.

SESSION TWO

Many say about me, "There is no _____ for him in God." *Selah.* But you, LORD, are a _____ around me, my _____, and the one who _____ up _____.

PSALM 3:2-3

SESSION THREE

But seek _____ the kingdom of God and

his _____, and all these things will

be _____ for you. Therefore _____

about tomorrow, because tomorrow will worry

about itself. Each day has enough _____ of its own.

MATTHEW 6:33-34

SESSION FOUR

But Moses said to the people, "Don't be _____.

Stand _____ and see the LORD's _____

that _____ will _____ for you today; for the

Egyptians you see today, you will never see again. The

LORD _____ for you, and you must be _____."

EXODUS 14:13-14

SESSION FIVE

If you keep _____ at this time, relief and

will come to the Jewish people _____ another

_____, but you and your father's family will be

destroyed. Who knows, _____ you have come to

your royal position for _____ a _____ as _____.

ESTHER 4:14

SESSION SIX

_____ yourselves, therefore, under the

_____ hand of _____, so that he may exalt

you at the _____ time, _____ all your _____

on _____, because he _____ about you.

1 PETER 5:6-7

This past week, you completed the Session Seven personal study in your books. If you weren't able to do so, no big deal! You can still follow along with the questions, be involved in the discussion, and watch the video. When you are ready to begin, open up your time in prayer and push play on Video Seven for Session Seven.

WATCH

Write down any thoughts, verses, or things you want to remember as you watch the video for Session Seven of Anxious.

REVIEW SESSION SEVEN PERSONAL STUDY

From Day One: What are some of the most common reasons you don't read your Bible?

According to Hebrews 4:2-4, what keeps people from entering the rest?

From Day Two: What sort of rhythms have you put in place in your life to help you stay consistent with your Bible reading?

From Day Three: What are some of the benefits of Scripture, as found in 2 Timothy 3:16-17?

From Day Four: Have you ever been reading the Bible and experienced Jesus? (By that, I mean, have you ever been reading the Bible and felt you were not just reading a book about God but that you were communicating with God through the power of the Holy Spirit?)

From Day Five: Think back to the most peaceful season of your life. What were you doing? What was happening? Where were you in your relationship with Christ?

FROM THIS WEEK'S STUDY

As a group, review this week's memory verse.

[The ordinances of the LORD] are more desirable than gold—than an abundance of pure gold; and sweeter than honey dripping from a honeycomb. In addition, your servant is warned by them, and in keeping them there is an abundant reward.

PSALM 19:10-11

DISCUSS

This week, we talked about fighting anxiety with the Word as our weapon. If you're comfortable sharing, discuss ways and circumstances in which you've used God's Word to fight your worries.

What are some ways you've struggled with your Bible reading? Since you're together as a group, this is a great opportunity for those of you who have walked with the Lord for a long time to share what has helped you in your pursuit of studying the Word.

Do you have a key Scripture passage you turn to when you're feeling afraid? Discuss that passage with your group.

Is there something you could do together as a group to hold each other accountable for time in the Word/Bible memorization? Brainstorm together.

PRAY

Today, challenge yourselves as a group to pray Scripture. Take five minutes to look through the Psalms or other parts of the Bible for some Scripture you can use in your prayer time together. Then spend the rest of the prayer time lifting up the needs of your group and asking God to help you as you encourage one another and fight, side by side, with the living and active Word as your weapon.

To access the teaching sessions, use the instructions in the back of your Bible study book.

ANXIOUS TOGETHER

COMMUNITY IS OUR LIFELINE IN THE FIGHT AGAINST ANXIETY

AND LET US CONSIDER ONE ANOTHER IN ORDER TO PROVOKE **LOVE** AND **GOOD WORKS**, NOT NEGLECTING TO GATHER TOGETHER, AS SOME ARE IN THE HABIT OF DOING, BUT **ENCOURAGING EACH OTHER**, AND ALL THE MORE AS YOU SEE THE DAY APPROACHING.

Hebrews 10:24–25

DAY ONE
MEDICAL SHOWS, SNACKS, AND PLEASE, NO PEOPLE

Hebrews 10:19–25

Shortly after my near-death ectopic pregnancy experience, I got pretty dark.

I couldn't return to work for a month because I couldn't move. I was married without any kids yet, and my husband had gone back to work, so all there was in my life that month was the TV medical dramas I binged on, the snacks I binged on, and the deep sadness I weirdly relished.

I wanted to be sad. I wanted to be distracted. I wanted the world to leave me alone.

I remember my small group trying to invite me back into civilization, and I remember ignoring their calls. I remember Super Bowl party invitations I threw away. And I remember staying home from church on Sundays, even when I was well enough to go.

I didn't want to hear people telling me God had a reason for this. I didn't want people to smile sympathetically and say, "When are you going to try for another baby?" I didn't want people encouraging me to pray. I didn't want any of it. I just wanted to escape with my *Grey's Anatomy*, *House*, and my bedside bag of Hot Tamales®.

Have you ever experienced a season of discouragement?

What were the circumstances, and what were you feeling?

I pushed people away. I pushed God away. I didn't want to fake-smile or fake-talk or fake-pray. I just wanted to be distracted from my sadness, and I thought the way to do that was to isolate myself.

Deep down, I was afraid to approach God with my feelings because I knew my feelings were misguided. It felt wrong to be mad at Him for the circumstances I was in. So I stayed silent. I stayed away. And my soul started to shrivel.

Read Hebrews 10:19-25. Because of Jesus, what does verse 22 say our hearts will be full of?

I think the enemy jumps at the opportunity when he sees a discouraged Christian. Since he can't take us out, he just tries to shut us out. If he can keep us from wanting to approach the throne of grace, he can keep us shriveling up.

The truth is, we can approach God with boldness, even if we're discouraged. Even if we're messed up and angry and at our worst. We can approach our Father and talk to Him and trust Him because of the blood of Jesus. (If this phrase is unfamiliar to you, flip over to pages 184–185 in the Appendix.)

Look again at verse 23.

Why is it that we can hold on to our confession of hope?

In the space below, write out your own confession of hope in a couple of sentences. What has Jesus done for you?

Read verses 24–25.

God created us for community. God created us to help each other and to remind each other that we have the same confession. What Christ did for one messed up, angry, sad, flawed human, He did for all of us. His sacrifice bought us access to the only One who can comfort us and heal us and assure us we are loved and okay, even when we don't feel like it.

He uses other believers to remind us of this.

Can you think of a time in your life when the body of Christ held you together when you were weak? Describe it below.

Sometimes anxiety doesn't look like being scared of bad things. Sometimes it looks like being afraid of God, being anxious about asking Him the hard questions and being worried about letting other people help us and love us and see us at our worst.

The community of other Christians is our lifeline in the fight against anxiety. I don't know how I would have crawled out of my TV and candy crises if it hadn't been for Brandi and Nicole bringing me meals, Pastor Rick telling me the disciples struggled with doubting Jesus too, Toni telling me I could tell God how I felt even if my feelings were painful, and Jackie praying and fasting on my behalf and being a non-judgmental ear when I said I didn't want to pray. Those people brought me back to life with Jesus.

What can you do this week to lean on other believers or let them lean on you?

DAY TWO
ON HATING HELPING
Acts 2:42-47

I've cycled through a lot of church-y anxieties. Maybe you can relate. I have often dreaded Sunday mornings in fear of:

- being asked to serve in children's ministry;

- being approached by eager, passionate mission trip leaders;

- being told unexpectedly that someone had a "word" for me (I'm not anti-"word," but it has, during anxious times, certainly caught me off guard).

I think, if you'd given me some sort of truth serum during the years I was a very young pastor's wife, I would have confessed something to the effect of, "I hate helping."

If you get anxious about other people placing expectations or demands on you, that's probably not something you'd like to admit on paper. So I won't ask the question, lest someone look over at your Bible study book when you're sharing answers. But I suspect you've sometimes felt the same way.

The church can, at times, feel like a steady stream of *DO MORE. HELP ME. GIVE THIS. BOY, DO I HAVE A CALLING FOR YOU.* At just the wrong time, it can send you over the edge.

As Christians, we want to please the Lord, so when we feel like we're not or feel like other people think we're not, it can lead us to run away from the people we need and the people who need us.

Let's compare this tendency to the activity of the early church.

Read Acts 2:42-47.

What were the early Christians devoted to?

How do these things compare to what you or the believers in your life are devoted to?

This next part is for those of you who are wired like me to read your own experiences and fears and failures into the text. Let me reassure you.

I don't want you to start breathing into a paper bag over this passage as I have in the past. We have to look at the cultural context of the early church. Just because they gathered daily doesn't mean you're out of the will of God if you don't have daily worship gatherings at your church.

On this note, Ajith Fernando wrote,

Nowhere is it stated that Christians should continue to meet daily as they did in the first days of the Jerusalem church (v. 46). Considering the responsibilities one has in family life and in witness and vocation in society, it may not be a good idea for Christians to have a program in church every day of the week. History has shown that usually at the start of a revival there are daily meetings. After that it tapers off into a less frequent but regular pattern. Certainly it is helpful for new believers to be with Christians daily until they are more stable in their faith.[1]

All this to say, breathe in and breathe out if your small group isn't on a daily schedule. Don't throw away your traditional church programming experience because of this text. The early church was a community. They ate together. They worshiped, side by side.

In our culture, this might look like texting the family in your small group to see if they need help organizing meals after a surgery. It might look like giving your bag of hand-me-down toddler clothes to the young family that shares one car. (We were that family and my daughters still wear those clothes—thank you, Beverly!) It looks like making attendance and participation in your local church a priority. Not because you will be punished if you don't, but because you will be loved and able to love and encourage others when you do!

Look at verses 46 and 47. What two adjectives describe the hearts of the people in this early church?

I remember reading Acts 2 when I was in the I-hate-helping phase of my life and thinking, OK, this sounds terrible. *I don't want to have people in my house/room/world. I don't want to give away my stuff. I want to eat nachos by myself, thank you.* (I actually still stand by that one. Eating nachos alone is the only way to eat nachos.)

Our inherent selfishness can lead us to believe we will feel peaceful if we're alone with our nachos, detached from people's drama. But in the Spirit, we have everything in common. When we learn to let go of our other-people-anxiety, we can actually experience things like JOY, sincere love, and peace.

Share about a time you experienced joy in being there for a brother or sister in Christ.

There's so much beauty in being dependent on each other. There's beauty in needing other believers. When we approach the Lord and one another with the humility that says, "I need Jesus, and I need you," we find that we're not alone. When we're scared, we're held together and surrounded by a body of believers who share our hope and remind us of our hope and embody our hope in their actions.

I'm happy to report I don't hate helping anymore. That's because as I got a little older and a little more world-weary, I discovered how much I needed help. I've experienced the deep need for the sincere love and generosity of other believers. I've known the joy of being weak when others who were strong in the body of Christ comforted me and restored me and led me back to the peace I have because I am held by Christ.

Close out this day praying for the people in your life that you might be used by the Lord to love them and comfort them and assure them they are loved and safe. Ask the Lord to help you have the courage to imitate the early church and become a person who loves helping and being helped.

DAY THREE

WOULD YOU RATHER CHANGE DIAPERS OR LEARN SIGN LANGUAGE?

John 13:34-35; 1 Corinthians 12:12-26 and Philippians 2:8

Being part of the body of Christ feels a little bit like playing that game "Would You Rather?"

One of my favorite church moments happened while discussing a sermon with some friends. We'd been meeting together for a while, and we were a smorgasbord of people. There was a couple in their twenties—the husband a Christian musician and the wife in nursing school. There was a single guy, an older married couple, and a handful of other people in varying life stages and situations. We didn't have a whole lot in common besides Jesus.

So this one day, we started discussing what our pastor had taught and what his message was encouraging us to pursue. We went around the circle sharing what we felt personally called to.

One person said she wanted to sign up to rock babies in the nursery on Sundays. A newlywed couple said they had a heart to foster middle school boys from troubled homes. We talked about the struggles of communication we were experiencing in our adoption. And after a few minutes of sharing, we all started laughing.

We all felt called to such different things, and not a single one of us wanted anything to do with what the person next to us felt called to.

It was a happy moment because we all realized we were being the body, as God intended it.

I remember my husband saying, "I would never, ever want to rock babies on Sundays. That is the last thing I would sign up to do." And whoever said that laughed and said, "Well, I don't know how you all adopted a deaf daughter. That sounds impossible to me."

It was a really great reminder that surrendered people are called to serve in ways that lead to joy. We don't need to fear what God will ask us to do.

Anxiety can lead us to be scared of callings, but love leads us to pursue serving in ways that fit how we were made.

Read 1 Corinthians 12:12–26.

What are we, as believers, called in this passage?

What "body part" do you think you are, or could be, in the body of Christ?

What gifts or desires has God planted in you that led you to that conclusion?

Look at verses 15-24. Have you ever wished you were a different part in the body of Christ? Have you ever been envious of someone who was called to something different?

What did that person have that you felt you were lacking? How do you think Jesus would speak into that feeling?

God didn't design us to be a people who tear each other down and pursue someone else's calling. We are to work together in unity with concern for each other.

Read John 13:34-35.

How does Jesus command us to treat one another?

What will this you-first love show the world, according to verse 35?

Christ set the ultimate example for us in this. He certainly could have wanted an easier job. Instead, He humbled Himself.

How does Philippians 2:8 tell us Jesus humbled Himself?

Jesus left the majesty of heaven and came here as an infant. He lived His life meeting the needs of others, and He died that excruciating death that brought His people life.

When we delight in the Lord, we are able to delight in how He made us. We are able to use the gifts He's given us to love and to serve, and it's there that we find joy. It's there that anxiety disappears. It's there that we stop worrying about our comfort and safety because we're too busy being blessed serving the needs of our friends.

What are some ways in which you feel God has uniquely equipped you to be able to serve the body?

In the space below, think of three people who have been "the body" to you, suffering in your suffering, rejoicing in your joys and delighting in your honor. Make an effort to reach out to them and encourage them this week.

1.

2.

3.

Who can you serve this week? What can you do? Who has God called you to love right now?

If you're feeling anxious about your calling, use the space below to pray for God to grant you clarity of purpose and joy in giving yourself to the work of His kingdom. Pray for joy and peace and pray God uses you to help others see they are loved.

DAY FOUR
SCARY PEOPLE ON MONDAY NIGHTS

Romans 15:7-13 and 2 Corinthians 3:18

When I was pregnant with my youngest, I had aversions to meat and small groups. My husband was leading our group, and I was—um—vocally opposed to pregnant participation.

"I'm keeping a baby alive! How am I supposed to also be with people on Monday nights?" I would, of course, panic about it.

In my mind, small-grouping while with child was an impossible task. It meant babysitting-arranging and long-listening and people asking for help. I spent Monday afternoons worried someone on Monday night would need my help while I was trying to give all my energy and focus to baby growing. What horror!

Yep. That's me. That's your Bible study coach.

I'll never forget the night the group brainstormed about a service project we could do together.

I wanted to be transported to another planet. *What if they voted for us to go find murderers mid-murdering and tell them about Jesus? What if they asked us to gain the trust of the mid-murdering murderers by letting them babysit my newborn?*

I pondered excuses. I dreaded Monday nights.

And then, something happened. I sat beside other Jesus followers enough nights in a row that I started to love them. They answered study questions with Bible verses they had memorized. They held my baby (who was eventually born) when my arms got tired. They brought us meals when we'd had a rough week. This group loved my fear away, and their love made me want to love them back. Then, it made me want to love the whole world.

In fact, God called us to adopt Joy while we did life alongside those people.

Read Romans 15:7-13.

What does verse 7 tell us we are to do to one another as Christ has done for us?

What did Christ become on behalf of God's truth?

What did He confirm to the fathers?

In your own life, your own church, your own local body of believers, what unique opportunities do you personally have to be a servant to the people around you?

We, as the body of Christ, are able to imitate Christ by welcoming people into our lives, by serving them, by reminding them of God's promises. We do this for each other, and, as a result, we receive blessing.

What blessings does God fill us with as we believe? (See verse 13.)

"Now may the God of hope fill you with all joy and peace as you believe so that you may overflow with hope by the power of the Holy Spirit" (v. 13). That's it, guys. Welcome one another until your worries fall away. Serve until suddenly you are filled with peace. Be in the body. Please, be in the body, so that you may overflow with hope. We have such an amazing situation together in Jesus.

During my anti-small-group season of fear, I was so anxious about what people would burden me with, but it never felt like a burden. They were just people like me who pursued service in Christ, and, as a result, they had joy and peace, and it overflowed and changed me.

My anxiety evaporated when I was plugged in with those people. I felt strong around them because they were so good at meeting my needs, and I delighted in finding ways to meet theirs. It was just a natural overflow of the joy and peace I'd been given by God, through them.

It's what we are made for.

In the pie chart below, fill in what percentage of the time you feel like you are overflowing with joy and peace and what percentage of the time you are a slave to your fears.

slave to my fears

overflowing with joy and strength

It ebbs and flows. But I believe our pie charts will look different in ten years. I believe that 2 Corinthians 3:18 is true.

We all, with unveiled faces, are looking as in a mirror at the glory of the Lord and are being transformed into the same image from glory to glory; this is from the Lord who is the Spirit.

God is always transforming His children, and He often uses His other children to do it. What a gift. What a joy. We get to be part of the healing and hope and freedom of our friends.

A big contributor to anxiety is isolation. If you've been actively pushing people away from your pain, what can you do this week to bring people in?

Name another believer you can reach out to for prayer and support and help.

If you're not currently struggling, who can you support this week? Who can you encourage and support and remind that they are loved and that they are not alone?

DAY FIVE
A BALLET STUDIO, A BIOPSY, AND A BRAVE MOM

2 Corinthians 1:3-7

My mom and I were in the bathroom at my daughter's ballet studio when she told me she'd found a lump. It took my breath away. Cancer? The very worst of the bad, scary things? My mom?

It was a surreal year. She had surgery. She had chemo. She had radiation. She went bald. She was living out my worst nightmare.

The first time I went to go see her during her chemo treatment, I was struck by my surroundings. She was at the end of a long, white, sterile hallway. In every room I passed, I saw bald women with sad faces and tired faces and scared faces.

All I could think was, *This is the valley of the shadow of death.*

And then I got to my mom's room, and there she was. Curly rainbow-colored wig. Venti Frappuccino®. Her laptop on the table and her big Bible in her lap.

"My baby!" she chirped.

There she was, at the end of the valley, showing me how to walk through it. My mom was being comforted by the Word of God, and she was able to comfort me with her testimony.

Years later, when I walked through a cancer scare, I thought of her and her faith and her peace. I remembered the hope we share in Jesus, and the surgeries and the waiting weren't as scary.

Read 2 Corinthians 1:3–7.

Anyone would agree that the cancer patient who is currently having red poison infused into her bloodstream is the one who needs comfort. But, through the power of Christ, God is able to use the afflicted to reveal His power. The power He has gives us peace when life is the opposite of peaceful.

What did Paul call God in verse 3?

Commentator David E. Garland said, "Here he identifies him as the Father of all mercies and God of all comfort and implies that mercies and comfort are brought to realization through Christ."[2]

This is important because through Christ, God is able to comfort us since Christ defeated sin and death. Christ broke the curse so that all this broken-sad-scariness we live with will one day be gone. God can comfort us because He is the only One with the power to comfort us. His comfort isn't false or temporary. It's powerful. It's eternal. It's shareable.

According to verse 4, what are we able to do with the comfort God gives us in our affliction?

Verses 4-5 tells us the comfort of Christ overflows out of us as believers. A Christian comforting another Christian isn't just a "there, there" with a pat on the back. A Christian is a Spirit-filled messenger, sharing tears and sharing hope that one day, as Sally Lloyd-Jones put it, "everything sad will come untrue."[3]

What are some ways other believers have comforted you when you were feeling anxious or afflicted?

You can't be convinced the world is caving in while being convinced that the world is being made new. Anxiety is complicated. And there are so many reasons for it and so many biological and emotional factors. But when we bring our fears and our doubts into the light, when we do life alongside other believers, we see that though they walk through scary things, like cancer, they also walk with hope and comfort. That stuff is contagious. The hope, not the cancer. Praise God.

My mom's peace poured out in that infusion clinic when she was having her cancer treatments. It touched me, and it touched nurses, and it touched doctors, and it touched other people suffering the same sickness.

Her joy made people think, *Why? What is this hope? Where is this comfort coming from?*

In the space below, ask God to comfort you in the areas of your life that trigger anxiety. Ask Him to use that comfort not just to remind you of your soul's safety and hope, but to spill onto others who are anxious too.

Alone, we're anxious. Alone, we're convinced this world is going to eat us alive. But together, we're walking reminders, we're walking proof, that though Jesus was right when He said, "In this world you will have trouble" (John 16:33, NIV), He was also right when He said we can "take heart!" because He has overcome the world.

I wish I had the words and the power to end this study promising you that completing this book would help you overcome anxiety. I can't make that promise though. I'm powerless; I'm sinful; and I'm so often scared too. But I know God made us to bring Him glory. I know He is glorified when anxious people remind other anxious people of the truth. The truth that raises dead people to life and gives hopeless people hope. This truth that is so powerful, it changes us from self-centered, isolated, insulated people into joy-filled, purpose-driven, ambassadors of peace. We live in a scary place, and we are weak. But that's not all. We are held together by a Savior who has won and is winning and will win forever over every anxious thing.

Cling to His Word. Cling to this thrilling hope. Cling to others who are held together by Him and rejoice with me that we are loved, that we are free, that we are safe in all the ways that matter most, and that one day we'll be safe forever.

NOTES

This past week, you completed the Session Eight personal study in your books. If you weren't able to do so, no big deal! You can still follow along with the questions, be involved in the discussion, and watch the video. When you are ready to begin, open up your time in prayer and push play on Video Eight for Session Eight.

WATCH

Write down any thoughts, verses, or things you want to remember as you watch the video for Session Eight of Anxious.

FROM THIS WEEK'S STUDY

As a group, review this week's memory verse.

And let us consider one another in order to provoke love and good works, not neglecting to gather together, as some are in the habit of doing, but encouraging each other, and all the more as you see the day approaching.

HEBREWS 10:24-25

REVIEW SESSION EIGHT PERSONAL STUDY

From Day One: Have you ever experienced a season of discouragement? What were the circumstances, and what were you feeling?

From Day Two: According to Acts 2:42-47, what were the early Christians devoted to? How do these things compare to what you or the believers in your life are devoted to?

From Day Three: Have you ever wished you were a different part in the body of Christ? Have you ever been envious of someone who was called to something different?

From Day Four: What does Romans 15:7 tell us we are to do to one another as Christ has done for us?

From Day Five: According to 2 Corinthians 1:4, what are we able to do with the comfort God gives us in our affliction? What are some ways other believers have comforted you when you were feeling anxious or afflicted?

DISCUSS

This week, we looked at how God created us for community. He created us to comfort and encourage each other. He created us to hold each other together in this often scary and unpredictable life. Allow time for anyone who wants to share a testimony of God comforting them in a way that comforted others or of them being comforted by God through others.

Do you tend to isolate or seek community when you feel anxious? If you isolate, who will you ask to hold you accountable, to reach out, to make sure you're not trying to fight alone when you're struggling?

Reflect on what God has taught you about fighting anxiety throughout this week. What have you learned that helped you the most? Which Scriptures have been most comforting? What will you do differently going forward as you fight the good fight and finish the race (2 Tim. 4:7)?

PRAY

Close out your time together in prayer, thanking God for what He's done, thanking Him for being our source of comfort and hope in a world full of scary things. Lift up the specific requests of your group members to the Lord in faith, believing He is sovereign and working all things together for the good of those who love Him and are called according to His purpose (Rom. 8:28).

To access the teaching sessions, use the instructions in the back of your Bible study book.

Aᴘᴘᴇɴᴅɪx

BECOMING A CHRISTIAN

Romans 10:17 says, "So faith comes from what is heard, and what is heard comes through the message about Christ."

Maybe you've stumbled across new information in this study. Maybe you've attended church all your life, but something you read here struck you differently than it ever has before. Or maybe you are exhausted from wrestling with anxiety, and you are looking for the rest and peace that can only come from casting your cares on Jesus, who cares for you. If you have never accepted Christ but would like to, read on to discover how you can become a Christian.

Your heart tends to run from God and rebel against Him. The Bible calls this sin. Romans 3:23 says, "For all have sinned and fall short of the glory of God."

Yet God loves you and wants to save you from sin, to offer you a new life of hope. John 10:10b says, "I have come so that they may have life and have it in abundance."

To give you this gift of salvation, God made a way through His Son, Jesus Christ. Romans 5:8 says, "But God proves his own love for us in that while we were still sinners, Christ died for us."

You receive this gift by faith alone. Ephesians 2:8-9 says, "For you are saved by grace through faith, and this is not from yourselves; it is God's gift—not from works, so that no one can boast."

Faith is a decision of your heart demonstrated by the actions of your life. Romans 10:9 says, "If you confess with your mouth, 'Jesus is Lord,' and believe in your heart that God raised him from the dead, you will be saved."

If you trust that Jesus died for your sins and want to receive new life through Him, pray a prayer similar to the following one to express your repentance and faith in Him.

Dear God, I know I am a sinner. I believe Jesus died to forgive me of my sins. I accept Your offer of eternal life. Thank You for forgiving me of all my sins. Thank You for my new life. From this day forward, I will choose to follow You.

If you have trusted Jesus for salvation, please share your decision with your group leader or another Christian friend. If you are not already attending church, find one in which you can worship and grow in your faith. Following Christ's example, ask to be baptized as a public expression of your faith.

SCARLET'S FAVORITE FEAR-FIGHTING VERSES

Put these in your pocket. Tape them to your mirrors. Write them on your childrens' faces! This is truth. These words have power. This is how we fight.

Be strong and courageous. Do not fear or be in dread of them, for it is the LORD your God who goes with you. He will not leave you or forsake you.
DEUTERONOMY 31:6 (ESV)

Have I not commanded you? Be strong and courageous. Do not be frightened, and do not be dismayed, for the LORD your God is with you wherever you go.
JOSHUA 1:9 (ESV)

I sought the LORD, and he answered me and delivered me from all my fears.
PSALM 34:4 (ESV)

When I am afraid, I put my trust in you.
PSALM 56:3 (ESV)

You will keep the mind that is dependent on you in perfect peace, for it is trusting in you.
ISAIAH 26:3

Fear not, for I am with you; be not dismayed, for I am your God; I will strengthen you, I will help you, I will uphold you with my righteous right hand.
ISAIAH 41:10 (ESV)

Therefore I tell you, do not be anxious about your life, what you will eat or what you will drink, nor about your body, what you will put on. Is not life more than food, and the body more than

clothing? Look at the birds of the air: they neither sow nor reap nor gather into barns, and yet your heavenly Father feeds them. Are you not of more value than they? And which of you by being anxious can add a single hour to his span of life? And why are you anxious about clothing? Consider the lilies of the field, how they grow: they neither toil nor spin, yet I tell you, even Solomon in all his glory was not arrayed like one of these.
MATTHEW 6:25-29 (ESV)

Therefore, since we have been justified by faith, we have peace with God through our Lord Jesus Christ. Through him we have also obtained access by faith into this grace in which we stand, and we rejoice in hope of the glory of God. Not only that, but we rejoice in our sufferings, knowing that suffering produces endurance, and endurance produces character, and character produces hope, and hope does not put us to shame, because God's love has been poured into our hearts through the Holy Spirit who has been given to us. For while we were still weak, at the right time Christ died for the ungodly.
ROMANS 5:1-6 (ESV)

For our sake he made him to be sin who knew no sin, so that in him we might become the righteousness of God.
2 CORINTHIANS 5:21 (ESV)

Do not be anxious about anything, but in everything by prayer and supplication with thanksgiving let your requests be made known to God. And the peace of God, which surpasses all understanding, will guard your hearts and your minds in Christ Jesus.
PHILIPPIANS 4:6-7 (ESV)

For God gave us a spirit not of fear but of power and love and self-control.
2 TIMOTHY 1:7 (ESV)

There is no fear in love; instead, perfect love drives out fear
1 JOHN 4:18a

ENDNOTES

SESSION ONE

1. Snacks are not required but strongly recommended.

2. Tim Keller, "The Wounded Spirit," *Gospel in Life*, December 5, 2004, accessed February 18, 2021, https://gospelinlife.com/downloads/the-wounded-spirit-5389/.

SESSION TWO

1. Bible scholars say that Abimelech was sometimes used as a proper name but was also a common title for a Philistine king. So, as explained in the *Holman Illustrated Bible Dictionary* (p. 9), Abimelech may have been King Achish's title. It is likely they are the same dude.

2. C. H. Spurgeon, "Psalm XXVII" and "Psalm LII," *The Treasury of David*, Vol. II (New York: Funk & Wagnalls, 1885).

3. Ibid.

4. "Jehovah Rapha (The Lord Who Heals)," *Blue Letter Bible*, accessed February 23, 2021, https://www.blueletterbible.org/study/misc/name_god.cfm.

5. Strong's H6960, *Blue Letter Bible*, accessed February 22, 2021, https://www.blueletterbible.org/lang/lexicon/lexicon.cfm?Strongs=H6960&t=CSB.

6. *Holman Old Testament Commentary: Psalms 1–75*, Steven J. Lawson, ed. (Nashville: Broadman & Holman Publishers, 2003).

7. C. H. Spurgeon, "Psalm 61," *Treasury of David*, *Blue Letter Bible*, accessed February 22, 2021, via https://www.blueletterbible.org/Comm/spurgeon_charles/tod/ps061.cfm?a=539001.

8. Matthew Henry, "Commentary on Psalms 61," *Blue Letter Bible*, accessed on February 22, 2021, via https://www.blueletterbible.org/Comm/mhc/Psa/Psa_061.cfm?a=539001.

9. Ibid, *Holman Old Testament Commentary: Psalms 1–75*.

10. Elisabeth Elliot, "The Lord is My Shepherd," Series: *Elisabeth Elliot Speaks About*, accessed February 22, 2021, https://www.blueletterbible.org/audio_video/elliot_elisabeth/misc/Elisabeth_Elliot_Speaks_About.cfm#The_Lord_Is_My_Shepherd.

SESSION THREE

1. Joshua J. Mark, "Assyrian Warfare," *World History Encyclopedia*, May 2, 2018, accessed February 25, 2021, https://www.ancient.eu/Assyrian_Warfare/.

2. James Bruckner, *The NIV Application Commentary* (Grand Rapids, MI: Zondervan, 2004).

3. James Montgomery Boice, *The Minor Prophets, Vol. I* (Grand Rapids, MI: Baker Books, 1983.

4. James Montgomery Boice, *About The Minor Prophets (Hosea–Jonah): An Expositional Commentary, Vol. I* (Grand Rapids, MI: Baker Books, 2002).

5. Frank Gardner, "Iraq's Christians 'close to extinction,'" *BBC*, May 23, 2019, accessed March 1, 2021, https://www.bbc.com/news/world-middle-east-48333923.

6. Helen Howarth Lemmel, "Turn Your Eyes Upon Jesus," 1922, accessed March 1, 2021, https://hymnary.org/text/o_soul_are_you_weary_and_troubled.

7. Priscilla Shirer, *Jonah: Navigating a Life Interrupted*, video (Nashville, TN: Lifeway Christian Resources, 2010), https://www.youtube.com/watch?v=-Vb19mJcb48.

8. Note on Matthew 6:25, *ESV Study Bible* (Wheaton, IL: Crossway, 2008).

SESSION FOUR

1. Douglas K. Stuart, *The New American Commentary: Exodus*, Vol. II (Nashville: B&H Publishing Group, 2006), 113–114.

2. John Piper, "I Am Who I Am," *desiringGod*, September 16, 1984, accessed March 3, 2021, https://www.desiringgod.org/messages/i-am-who-i-am.

3. A. W. Tozer, *Knowledge of the Holy* (New York: HarperCollins, 1961), 1.

4. Charles Spurgeon, *God Always Cares* (Shawnee, KS: Gideon House Books, 2017), 33.

5. Ibid.

SESSION FIVE

1. Karen H. Jobes, *The NIV Application Commentary* (Grand Rapids, MI: Zondervan, 1999), 19–21.

2. Some translations actually say hanged (CSB, ESV, KJV) and others (NIV, NLT) say *impaled*.

3. Paul Tripp, "018. Esther Summary," *Paul Tripp Ministries: The Gospel One Chapter At a Time*, September 2, 2019, accessed March 8, 2021, https://www.paultripp.com/bible-study/posts/esther-summary.

SESSION SIX

1. Stanton W. Gavitt, "I'm So Happy And Here's the Reason Why," Singspiration Inc., 1936.

2. Strong's G5011, *Blue Letter Bible*, accessed March 30, 2021, https://www.blueletterbible.org/lang/lexicon/lexicon.cfm?Strongs=G5011&t=CSB.

3. Strong's G5013, *Blue Letter Bible*, accessed March 11, 2021, https://www.blueletterbible.org/lang/lexicon/lexicon.cfm?Strongs=G5013&t=CSB.

4. Gavitt, "I'm So Happy And Here's the Reason Why."

5. John Cotton, *The New-England Primer* (Aledo, TX: WallBuilder Press, 1991, reprint, originally pub. 1777).

SESSION SEVEN

1. Don Stewart, "What Is General Revelation," *Blue Letter Bible*, accessed March 17, 2021, https://www.blueletterbible.org/faq/don_stewart/don_stewart_370.cfm.

2. Don Stewart, "What Is Special Revelation," *Blue Letter Bible*, accessed March 17, 2021, https://www.blueletterbible.org/faq/don_stewart/don_stewart_1196.cfm.

3. Jen Wilkin, "Q&A: Applying," Instagram story, September 2020, accessed March 17, 2021, https://www.instagram.com/jenwilkin/?hl=en.

4. James Montgomery Boice, *The Gospel of John: The Coming of the Light (John 1–4)*, Vol. I, (Grand Rapids, MI: Baker Bookos, 1985,1989).

SESSION EIGHT

1. Ajith Fernando, *The NIV Application Commentary: Acts* (Grand Rapids, MI: Zondervan, 1998), 125.

2. David E. Garland, *The New American Commentary: 2 Corinthians*, Vol. 29 (Nashville: B&H Publishing Group, 1999), 59.

3. Sally Lloyd-Jones and Sam Shammas, *The Jesus Storybook Bible Curriculum*, 2011, https://www.sallylloyd-jones.com/wp-content/uploads/2014/02/jesus_storybook_bible_currkit_ot_NoMoreTears.compressed.pdf.

LET'S BE FRIENDS!

BLOG

We're here to help you grow in your faith, develop as a leader, and find encouragement as you go.

lifewaywomen.com

NEWSLETTER

Be the first to hear about new studies, events, giveaways, and more by signing up.

lifeway.com/womensnews

SOCIAL

Find inspiration in the in-between moments of life.

 @lifewaywomen

APP

Download the Lifeway Women app for Bible study plans, online study groups, a prayer wall, and more!

 Google Play App Store

Lifeway women

MORE FROM SCARLET

AFRAID OF ALL the THINGS
TORNADOES, CANCER, ADOPTION, AND OTHER STUFF YOU NEED THE GOSPEL FOR

SCARLET HILTIBIDAL

ANXIOUS
8-SESSION BIBLE STUDY FOR TEEN GIRLS

SCARLET HILTIBIDAL

FIGHTING ANXIETY WITH THE WORD OF GOD

HE NUMBERED THE PORES ON MY FACE
SCARLET HILTIBIDAL

HOTTIE LISTS, CLOGGED PORES, EATING DISORDERS, AND FREEDOM FROM IT ALL

AVAILABLE WHERE BOOKS ARE SOLD

Get the most from your study.

Customize your Bible study time with a guided experience.

In this 8-session study with Scarlet Hiltibidal, learn that when we trust the Lord rather than fearing the brokenness in our world, we are able to take hold of the perfect peace that is only available in Him.

In this study you'll:

* Learn how to fight your anxiety with the Word of God so you can take hold of the abundant life Jesus has purchased for you.

* Realize you're not alone in your struggle with anxiety by prioritizing community and confession over isolation.

* Practice bringing your anxieties to God and come to know prayer as a pathway to peace.

Video Access (included in this Bible study book)

* Promo (1:38)

* Session One: Introduction—Anxious to Be Here (10:05)

* Session Two: Anxious David (10:04)

* Session Three: Anxious Jonah (8:45)

* Session Four: Anxious Moses (5:54)

* Session Five: Anxious Esther (9:21)

* Session Six: Anxious Prayer (6:34)

* Session Seven: Anxious Reader (7:36)

* Session Eight: Anxious Together (7:29)

ADDITIONAL RESOURCES

Visit **lifeway.com/anxious** to explore the entire study family—Bible study book with video access, eBook with video access, and teen girls' Bible study—along with a free session sample, video clips, and church promotional material.